RAIL JOURNEYS

DAVID ROSS

amber
BOOKS

Published by
Amber Books Ltd
United House
North Road
London
N7 9DP
United Kingdom
www.amberbooks.co.uk
Instagram: amberbooksltd
Facebook: www.facebook.com/amberbooks
Twitter: @amberbooks
Pinterest: amberbooksltd

Project Editor: Michael Spilling
Designer: Mark Batley
Picture Research: Terry Forshaw and Justin Willsdon

ISBN: 978-1-78274-919-6

Printed in China

Contents

Introduction 6

North America 8

South America 54

Europe 88

Africa 152

Asia 188

Picture Credits 224

Introduction

From a few short lines in Britain, the United States, France and Germany in the 1820s and 1830s, the world's railway networks expanded enormously. By 1910, the combined systems totalled over half a million route miles. The advent of motor vehicles pushed railways into decline through the 20th century, but the need for clean energy and better use of natural resources has given rail transport a renewed significance. Railways today fulfil a range of needs. They remain the most efficient way of transporting freight overland for long distances, the longest being the 'New Silk Road' between China and Germany, over 11,000km (6875 miles). Cities and city-clusters are extending rapid-transit rail systems to reduce traffic congestion and atmospheric pollution. But railways also play a completely different role. They offer a form of time travel – evoking a period more gracious, more leisurely, more calm than today. All over the world there are 'heritage' railways in pleasant or historic countryside, and accessible to all. Steam locomotives are often used, and their appeal plays an important part.

This celebration of railway journeys gives a reassuring sense of continuity to our lives, giving glimpses of bygone pleasures as well as offering a promising way to a sustainable future.

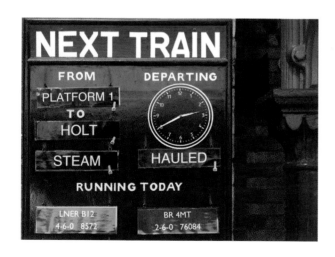

ABOVE:
Sheringham, Norfolk, is one of three stations on the North Norfolk Railway, a heritage steam railway line that is just 8.45km (5.25 miles) long.

OPPOSITE:
A passenger train progresses along the scenic White Pass & Yukon Route in British Columbia, Canada.

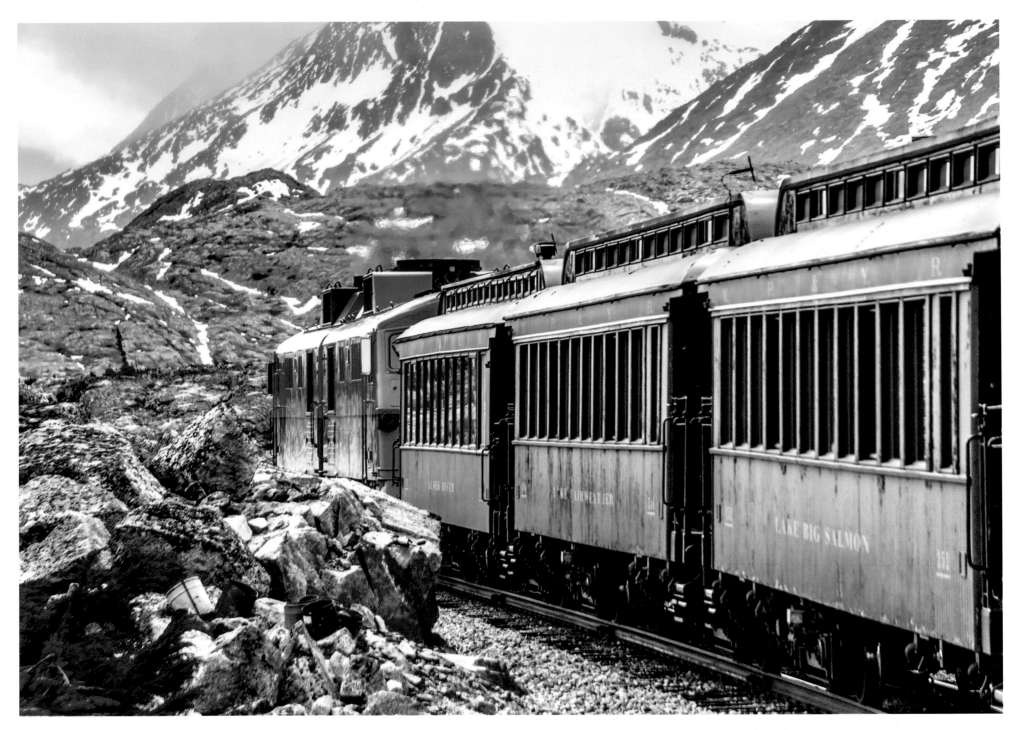

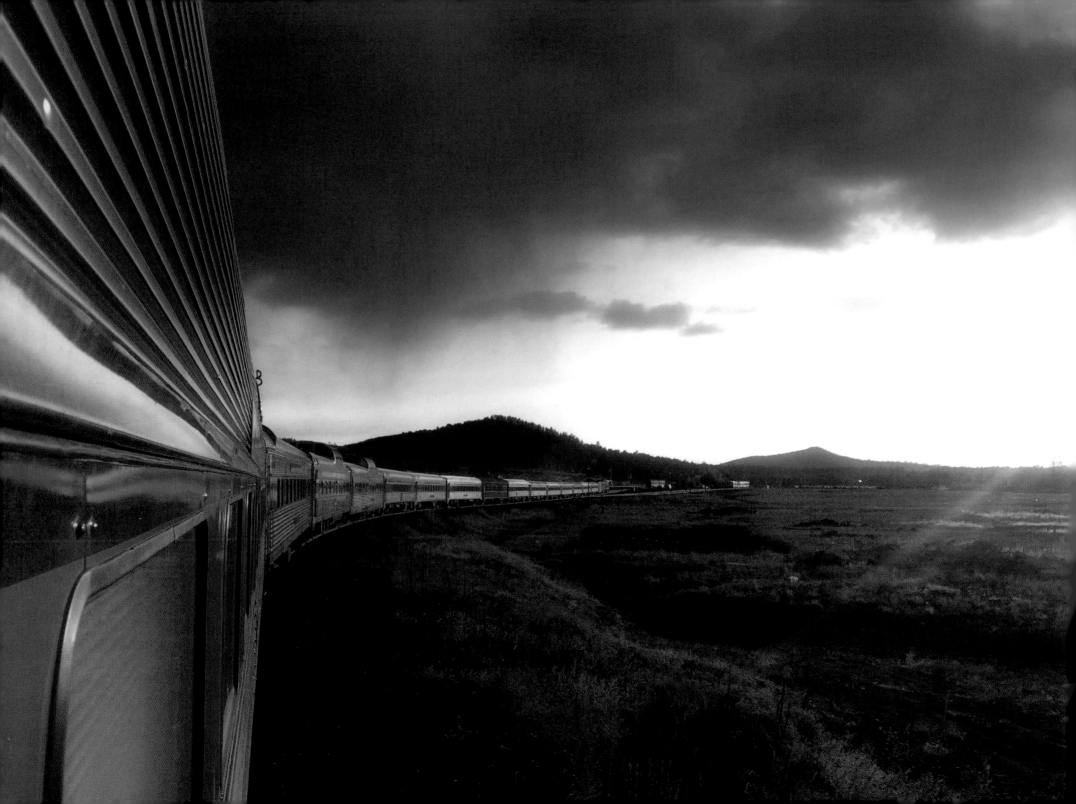

North America

For many decades the transcontinental train epitomised a key aspect of modern American history: the ways in which a relatively small number of people took over, developed and politically unified a vast extent of territory. The steam railway made the United States of America the richest nation on Earth, and the Confederation of Canada a working reality. That contribution is not forgotten in the age of the airplane and the transcontinental highway.

At one time, forecasters predicted that railways would become a thing of the past, left behind by road vehicles and aircraft, but railroads remain very much a part of North American life. Much of the landscape was inviting for railway builders. Vast prairies and broad river valleys afforded easy routes, while abundant forests provided fuel for the early wood-burning locomotives with their enormous spark-arresting funnels. But there were were mountains, rocky coasts, swampland and wide river crossings that had to be faced as well. Hard work for the railway builders, and for steam locomotive crews, but of course for the passenger the more difficult the terrain, the better the view – except when the line entered a tunnel or a snowshed.

North America still offers a great variety of train rides, from the Alaskan coast to the Mexican desert, and from mighty trains like the Rocky Mountaineer to the tiny train that crawls up Mount Washington in New Hampshire.

OPPOSITE:
Grand Canyon Railway, Arizona, USA
Built as a 104km (65-mile) branch of the Santa Fe Railroad in 1901, the line provided tourist access to the South Rim of the Grand Canyon in the pre-motor era. Closed in 1974, it was reopened in September 1989 as a tourist attraction in its own right, with classic rolling stock.

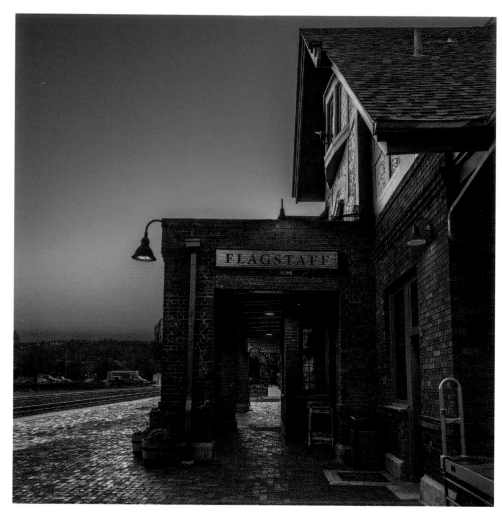

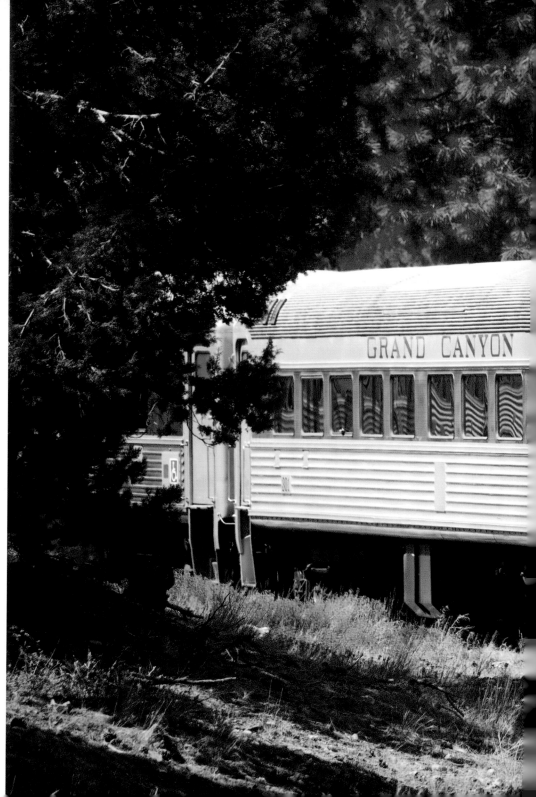

ABOVE:
Flagstaff Station, Arizona, USA
The Atchison, Topeka and Santa Fe Railway built the station at Flagstaff in 1926. In 'Tudor Revival' style, the historic building functions as the town's Visitor Centre as well as a stopping point on the Amtrak system.

RIGHT:
Grand Canyon Railway, Arizona, USA
Locomotive F40FH was built by General Motors Electromotive Division (EMD) in 1977 and acquired by Grand Canyon Railway in 2003. It is one of three primemovers on the line, hauling a variety of classic rolling stock on the trip from Williams to the Canyon.

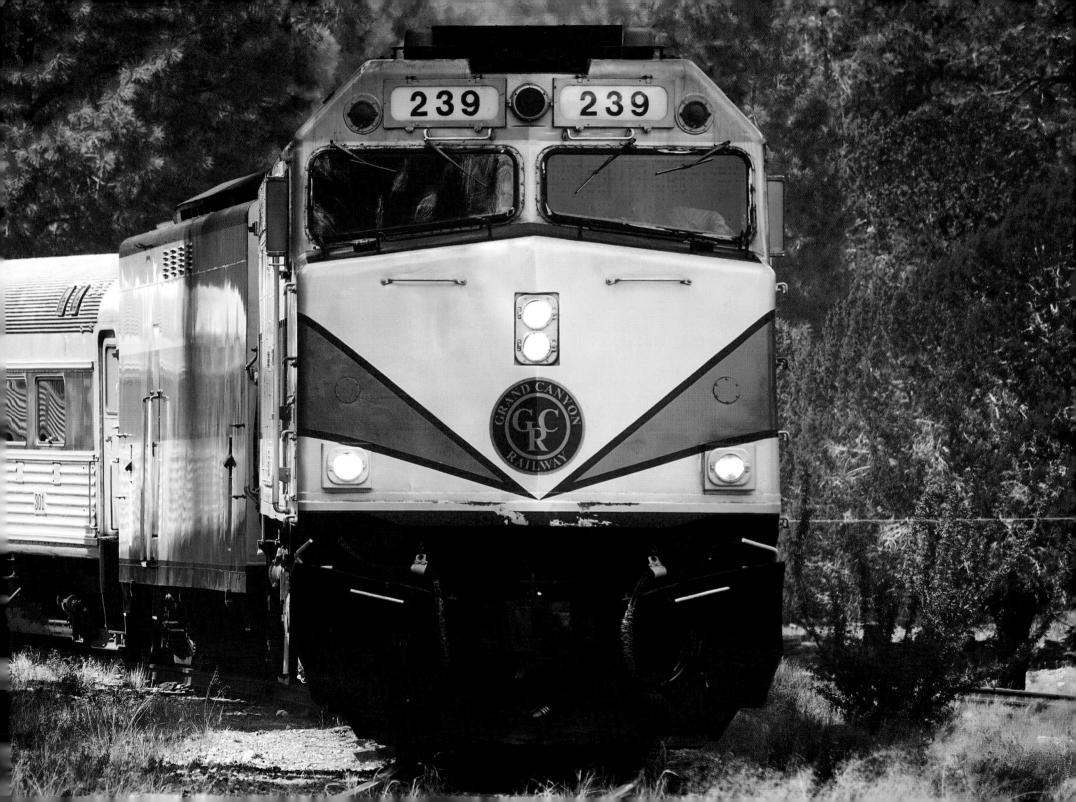

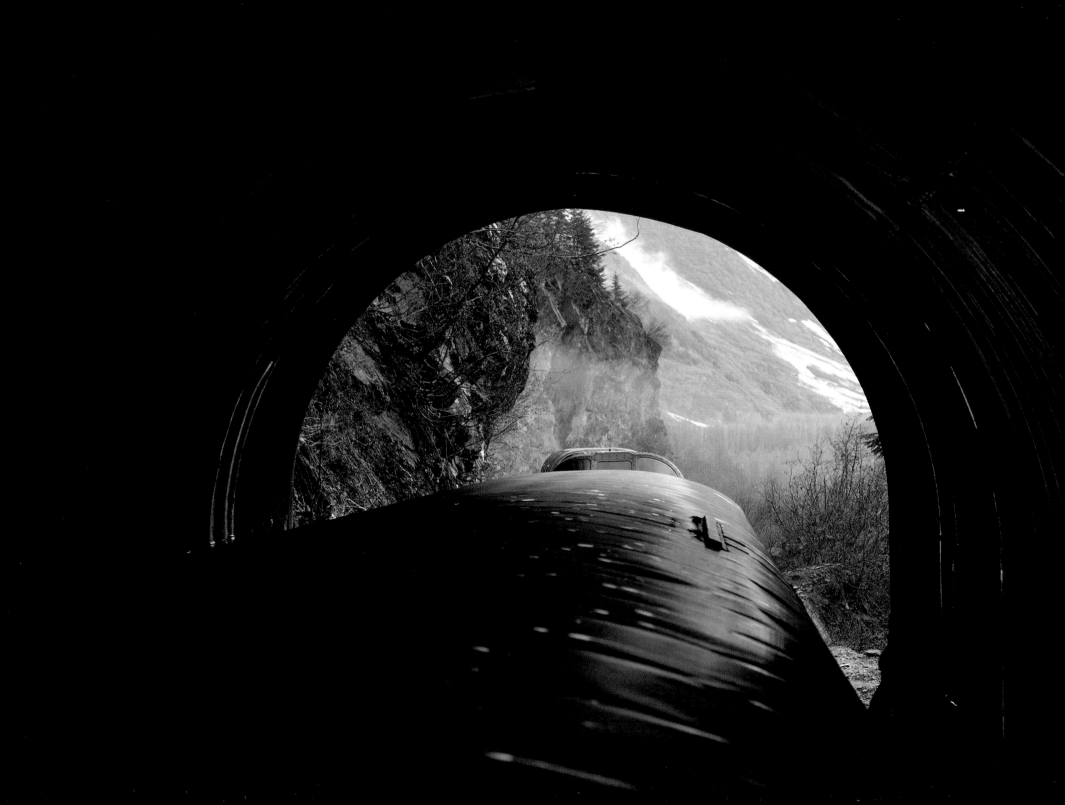

PREVIOUS PAGES:
Grand Canyon Railway, Arizona, USA
A backwards view down the single-track line across the level terrain from the rear platform of a train returning from Grand Canyon to Williams.

OPPOSITE:
Alaska Railroad, USA
The Alaska Railroad's 752km (470-mile) main line links Seward and Fairbanks, carrying both freight and passenger services. Here the 'Coastal Classic' excursion train from Anchorage to Resurrection Bay traverses a tunnel on this scenic route.

RIGHT:
Alaska Railroad, USA
High clearances on the Alaska Railroad allow for the line's Ultradome and Goldstar Dome cars, which also have open platforms on the upper level.

OVERLEAF:
Alaska Railroad, USA
The AR's Coastal Classic runs on the north shore of Turnagain Arm, hauled by EMD GP40-2 No 3013. The railroad is owned by the State of Alaska and is one of the few non-Amtrak lines to operate regular passenger services.

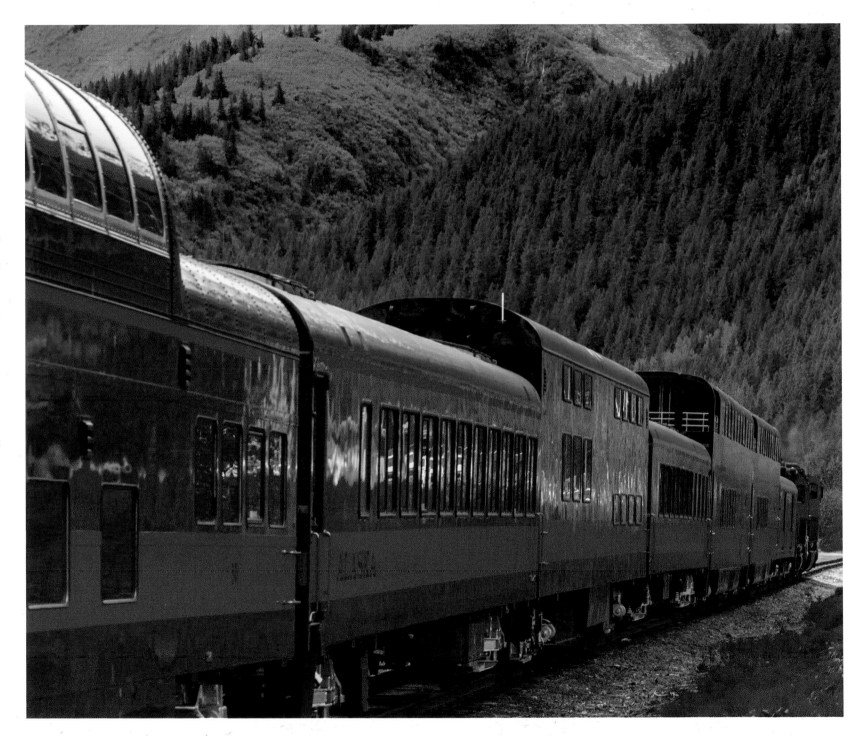

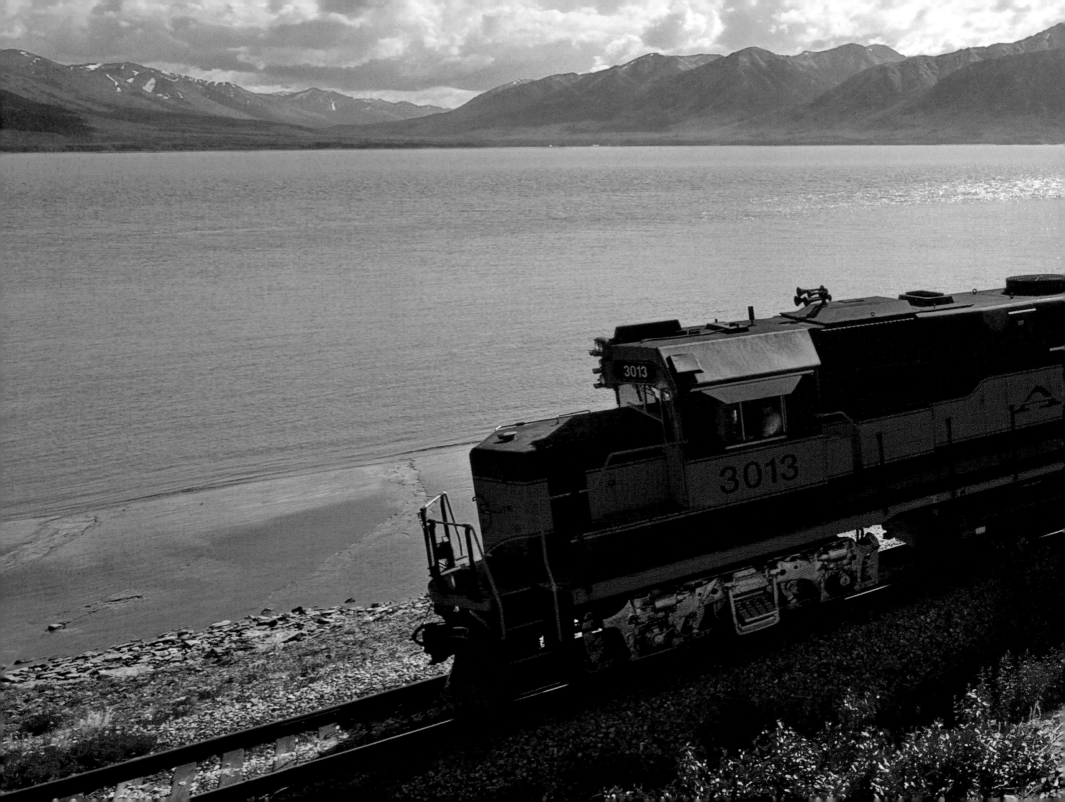

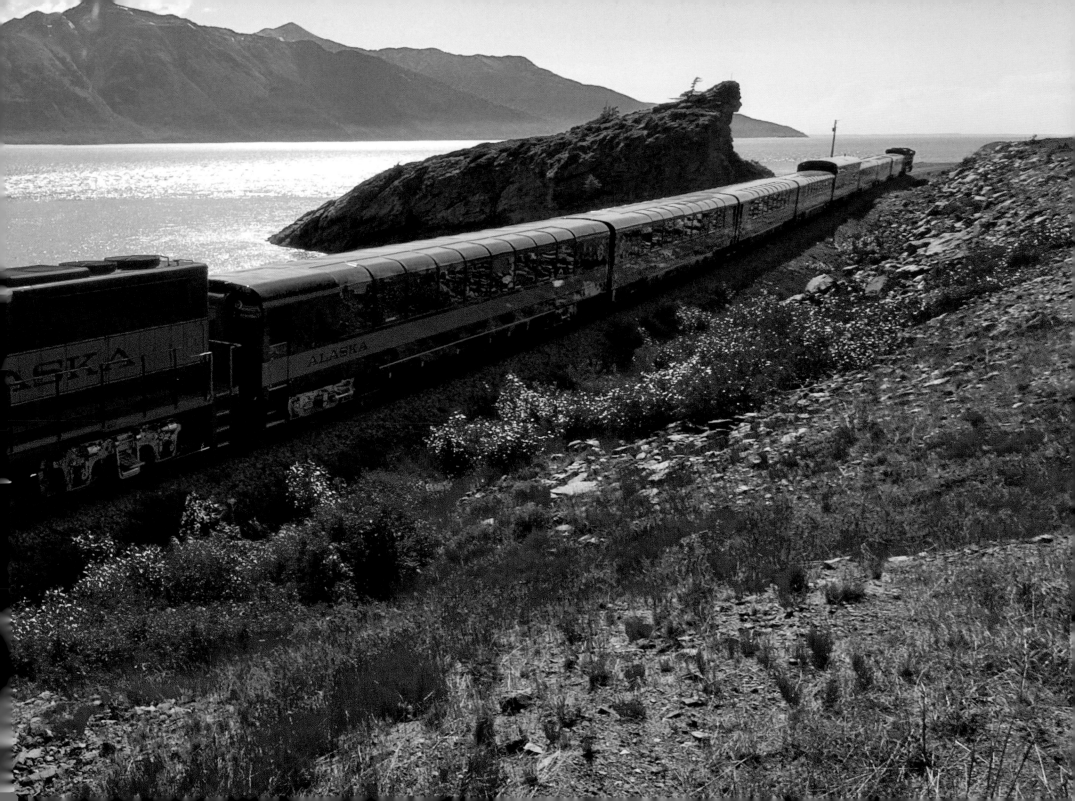

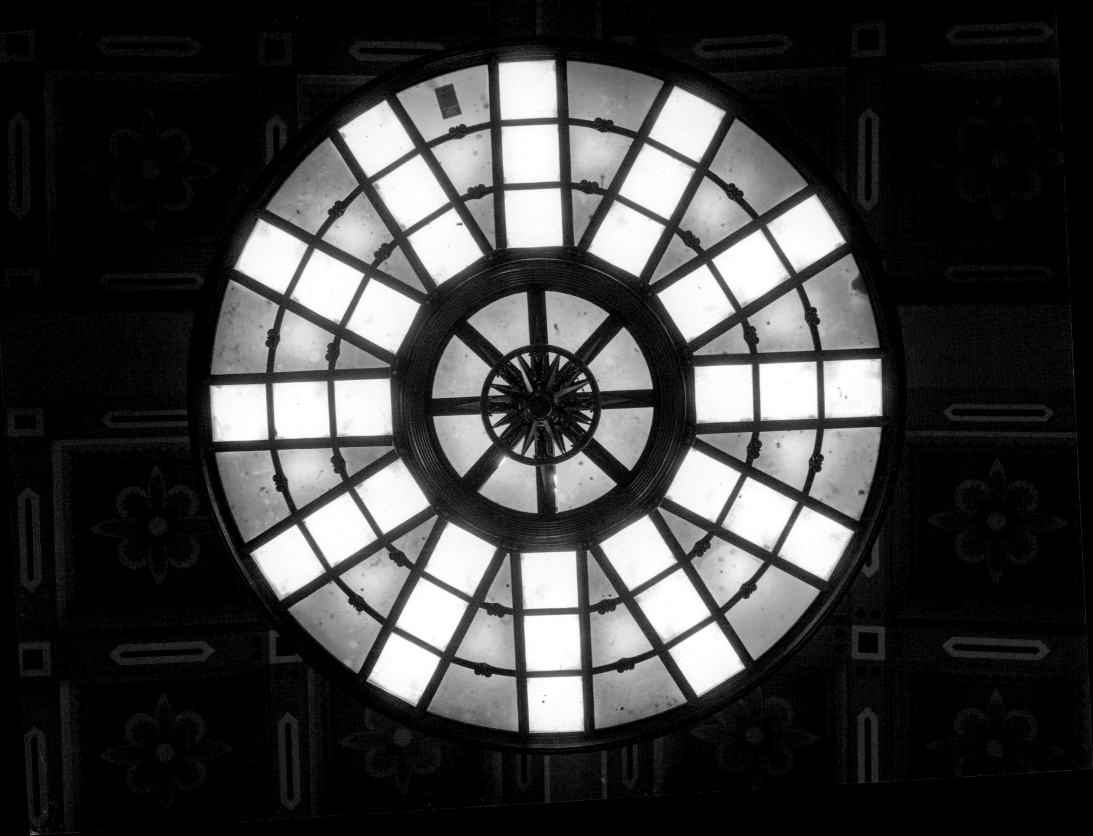

OPPOSITE PAGE AND LEFT:
Union Station, Los Angeles, California, USA
Completed in 1939 and now owned by LA Metro, the station shows the influence of Art Deco in such details as the ceiling lights in its great hall, as well as in the wealth of tiling. Spanish Colonial and Mission Revival influences create an unusual combination for a major terminus of garden patios and palm courtyards. Attention to detail helps the traveller to feel secure and comfortable: station signage went far beyond the purely utilitarian.

BOTTOM LEFT:
Union Station, Kansas City, Missouri, USA
The station in the cityscape – distinctive lighting picks out the terminus, which opened in 1914 and is now an important science education centre. After a period of disuse from 1985 to 2002, it again provides passenger services to other major cities.

BOTTOM RIGHT:
Albuquerque Station, New Mexico, USA
As the relief sculpture shows, Albuquerque's old station was both a railroad and a Greyhound bus depot. Now rebuilt on a larger scale, the station remains an intermodal hub and perpetuates the Mission Revival style of its predecessor.

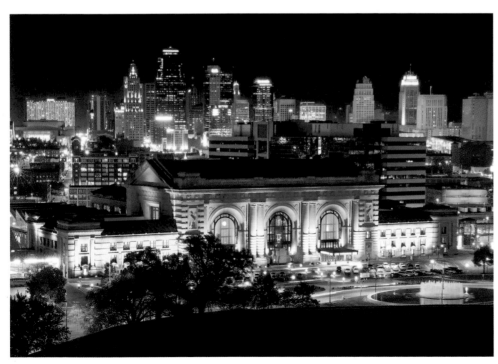

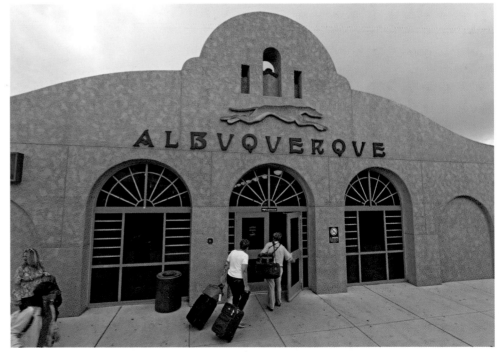

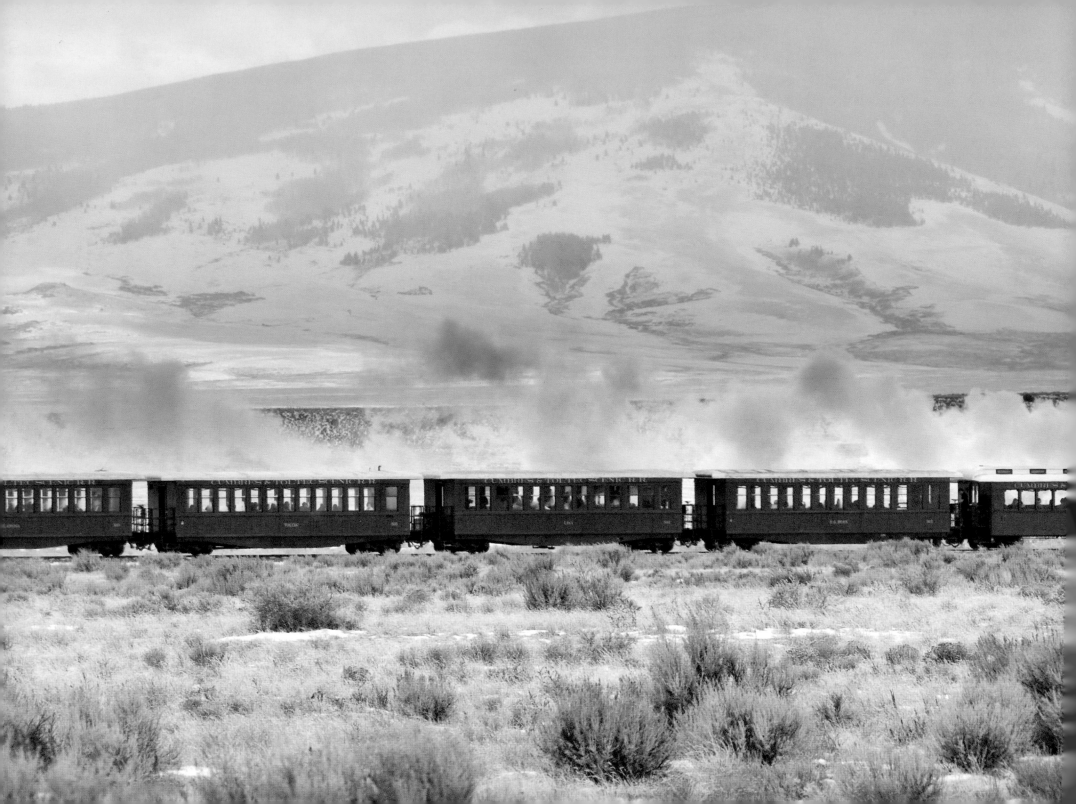

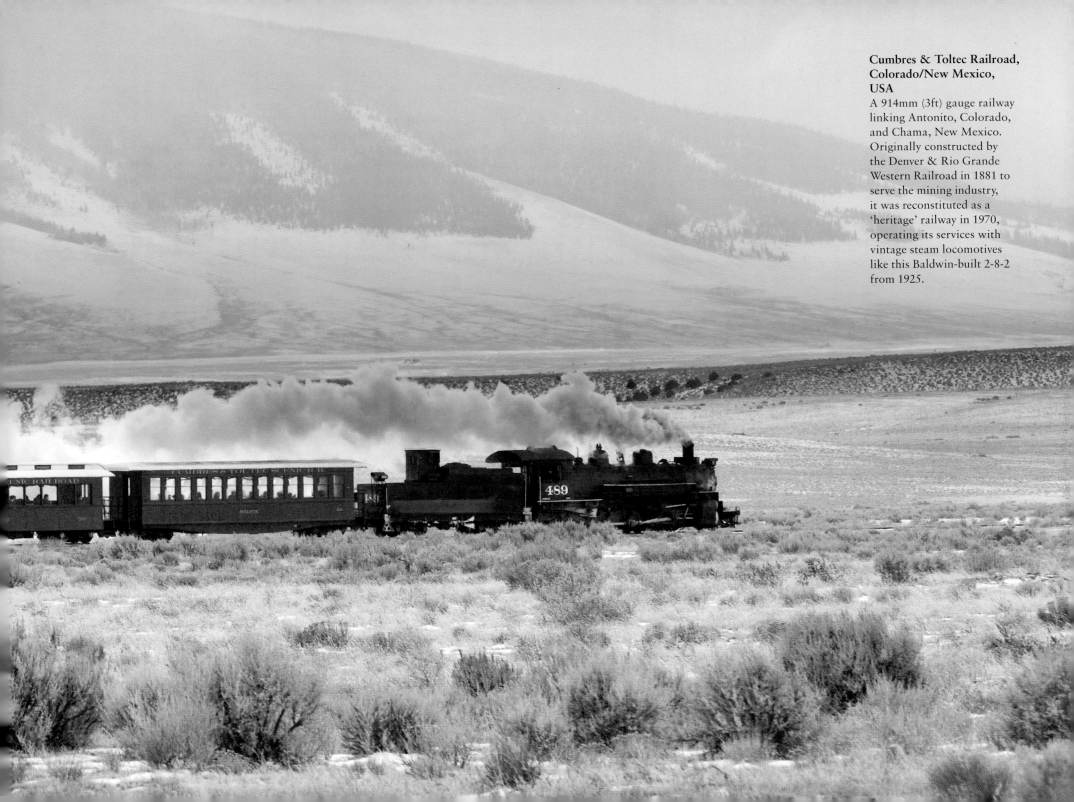

Cumbres & Toltec Railroad, Colorado/New Mexico, USA
A 914mm (3ft) gauge railway linking Antonito, Colorado, and Chama, New Mexico. Originally constructed by the Denver & Rio Grande Western Railroad in 1881 to serve the mining industry, it was reconstituted as a 'heritage' railway in 1970, operating its services with vintage steam locomotives like this Baldwin-built 2-8-2 from 1925.

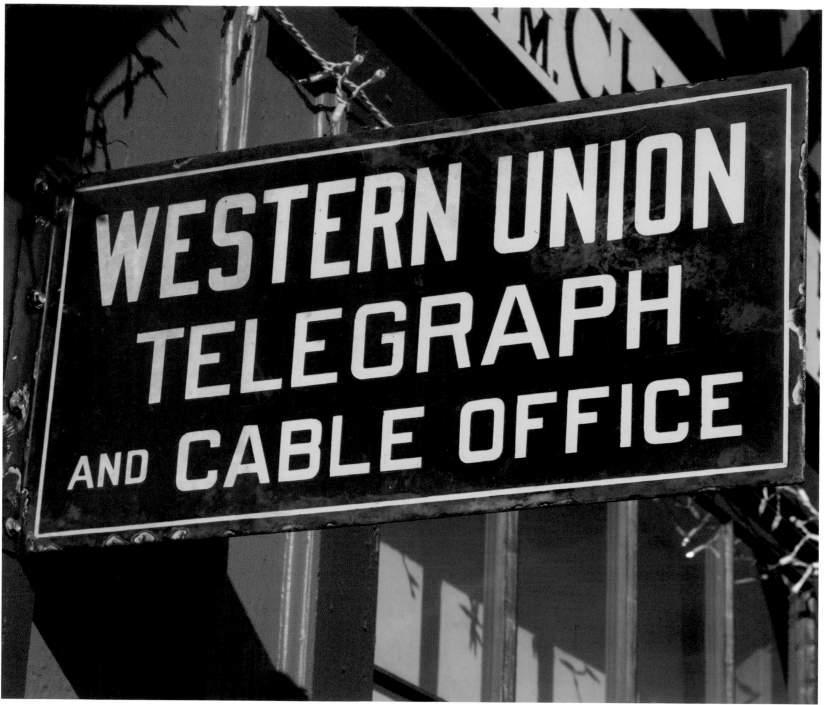

LEFT:
Cumbres & Toltec Railroad, Chama Terminus, New Mexico, USA
Railway companies made useful extra income by accepting telegraph business and most stations of any size had a telegraph office.

OPPOSITE:
Cumbres Pass Station, Cumbres & Toltec Railroad
Trains past and present are shown on the departures board. The Cumbres & Toltec runs a single train daily each way along its 102.4km (64-mile) route.

TRAIN BULLETIN
DENVER & RIO GRANDE WESTERN RAILROAD

DIRECTION	TRAIN NO.	TRAIN NAME	DESTINATION	LEAVE	REMARKS
EASTBOUND	#216	THE SAN JUAN	OSIER & ALAMOSA	4:05 PM	
WESTBOUND	#215	THE SAN JUAN	CHAMA & DURANGO	11:15 AM	

Date: July 1, 1950 (Last Train January 31, 1951)

CUMBRES & TOLTEC SCENIC RAILROAD

DIRECTION	TRAIN NO.	TRAIN NAME	DESTINATION	LEAVE	REMARKS
EASTBOUND	#2	COLO-NM EXPRESS	OSIER & ANTONITO	11:10 AM	Daily
WESTBOUND	#3	COLO-NM EXPRESS	CHAMA	2:45 PM	Daily
		EXTRA			

Date: June, 20__ Season: June – October

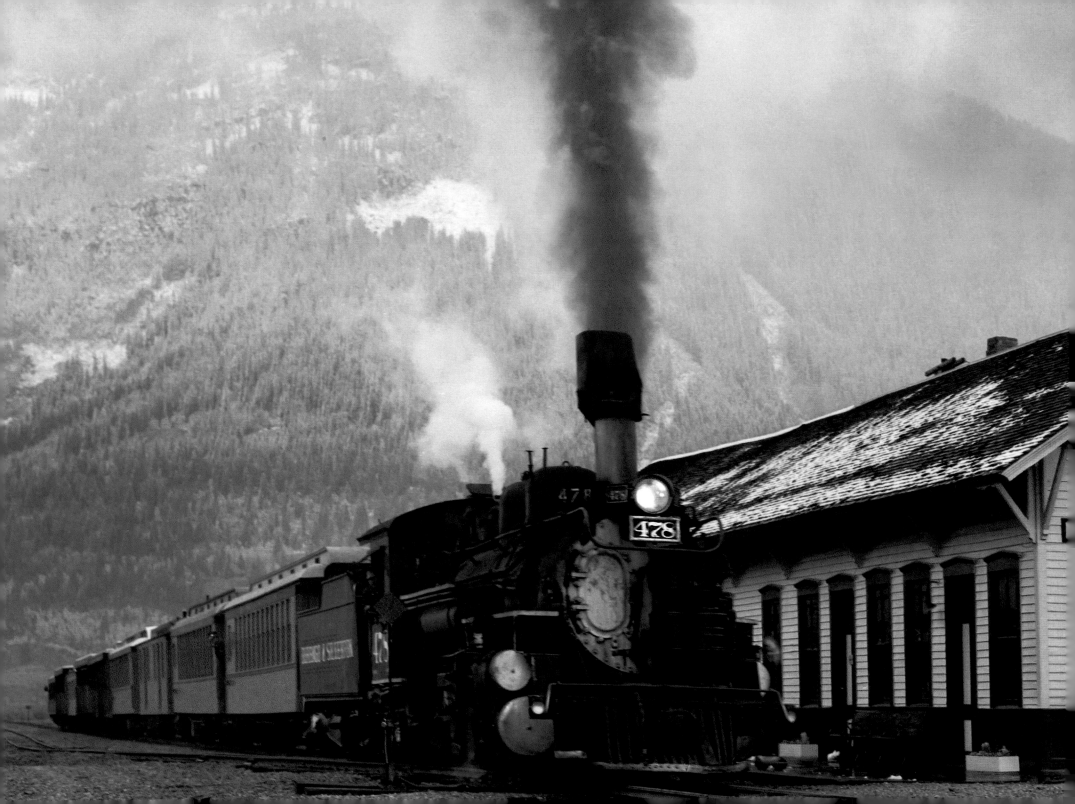

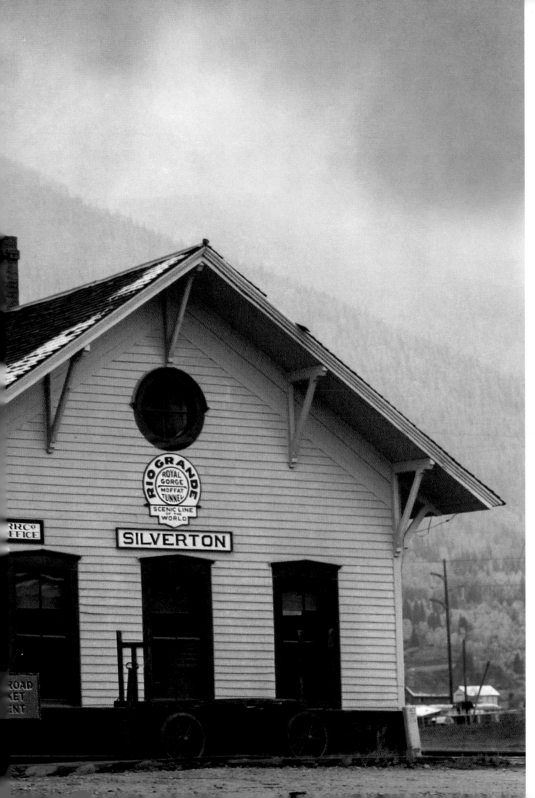

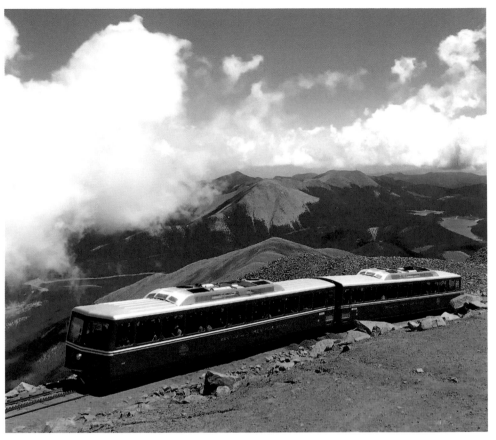

Silverton Depot, Colorado, USA

The 914mm (3ft) gauge branch of the Denver & Rio Grande Railway to Silverton from Durango opened in 1882, primarily for transport of ore and precious metals. It has operated continuously since then using steam power. Locomotive 478 was one of 10 K-28 2-8-2s built for the line by Alco in Schenectady in 1923.

Manitou and Pikes Peak Cog Railway, Colorado, USA

Locally known as The Cog, this is the highest railway in North America, reaching the 4302m (14,115ft) summit of Pikes Peak. It opened in June 1891 using specially-designed locomotives and a central cogged rack to assist climbing and prevent runaways. Currently undergoing refurbishment, it will reopen in 2021.

Dayton Historic Depot, Dayton, Washington, USA
The oldest extant railway station in Washington State, built in 1881, the timber and shingled depot building is nowadays a museum. Though no trains have passed by since 1971, it exudes the atmosphere of steam railroading.

Railroad Crossing, Seattle, Washington, USA
This crossing sign could be anywhere in the USA. Its electric signal lights show it to be a modern one, but the crossed arms above are a design almost as old as the American railroad itself.

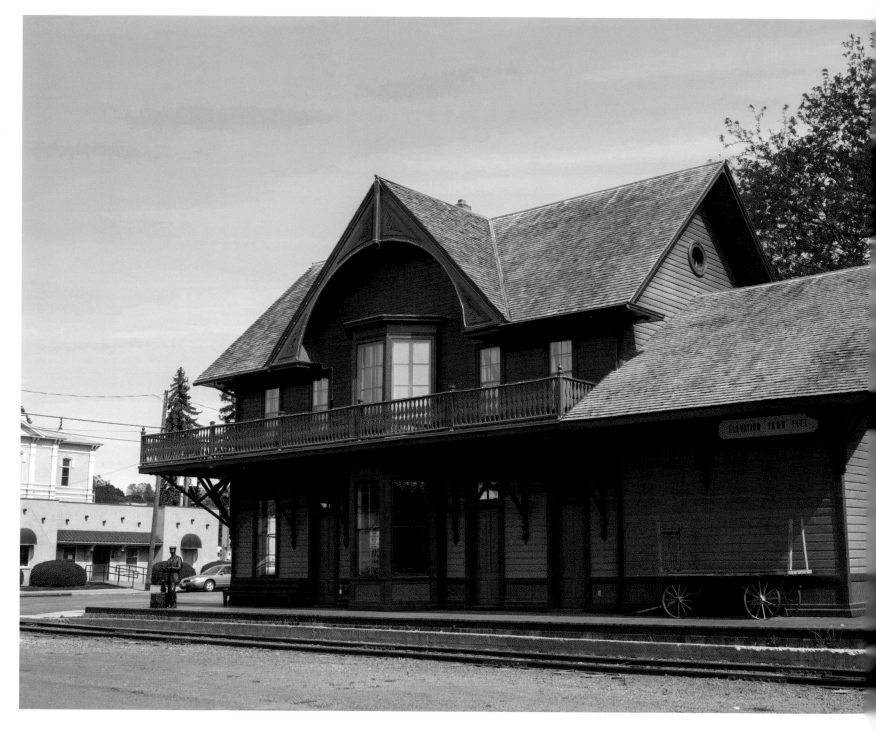

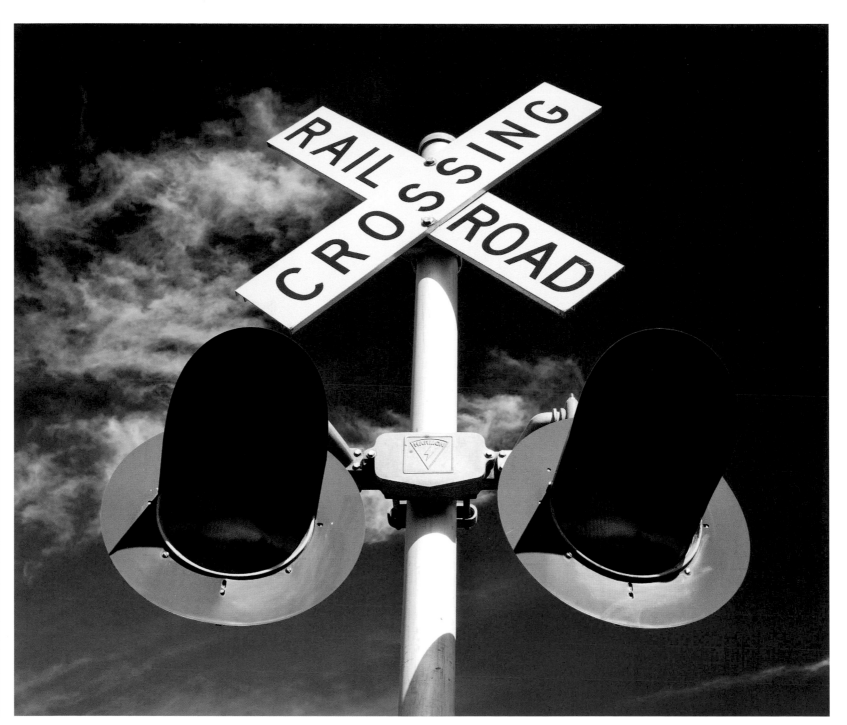

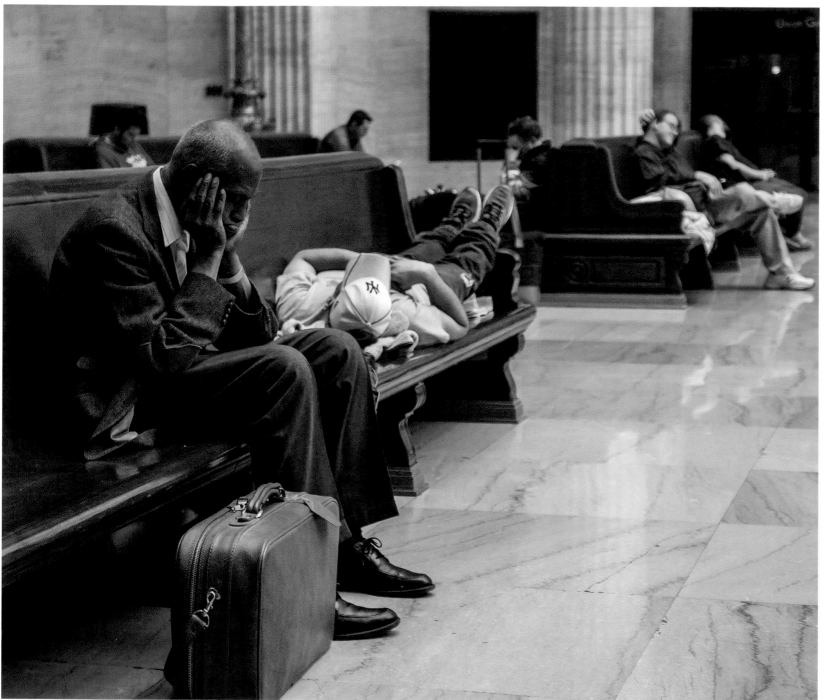

LEFT:

Union Station, Chicago, Illinois, USA
Built by four railroads, Union Station has always been a place for changing trains – and long layovers. These dozing travellers are oblivious to the splendours of the Great Hall, with its 34m (112ft) high glass vault, pillars and statues.

OPPOSITE TOP:

Union Station, Chicago
The original lettering and ironwork of the station reflect the year of completion, 1925, when Art Deco was very much in vogue, and the distinctive lettering is still used as the station's logo.

OPPOSITE BOTTOM:

Entrance, Union Station, Chicago
Designated a Chicago Landmark in 2002, the vast station has undergone many alterations over the years. While some parts, notably the Great Hall, have been restored to their original appearance, the entrance on South Canal Street displays a 21st century approach but still retains a sense of spaciousness.

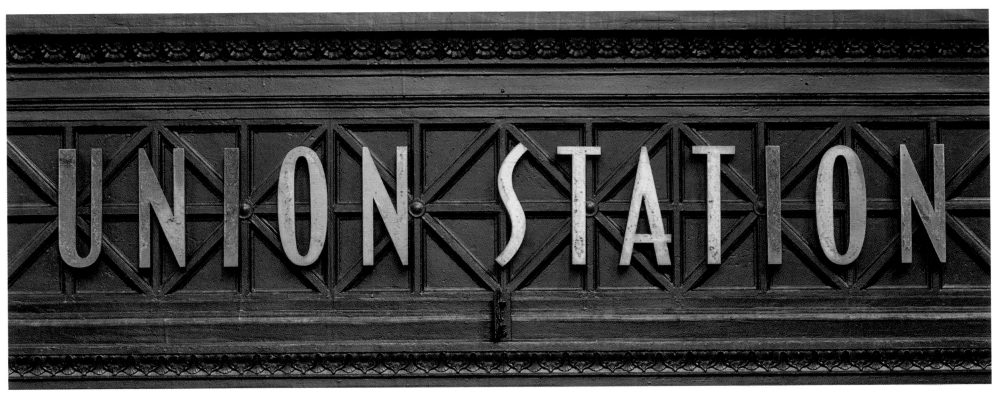

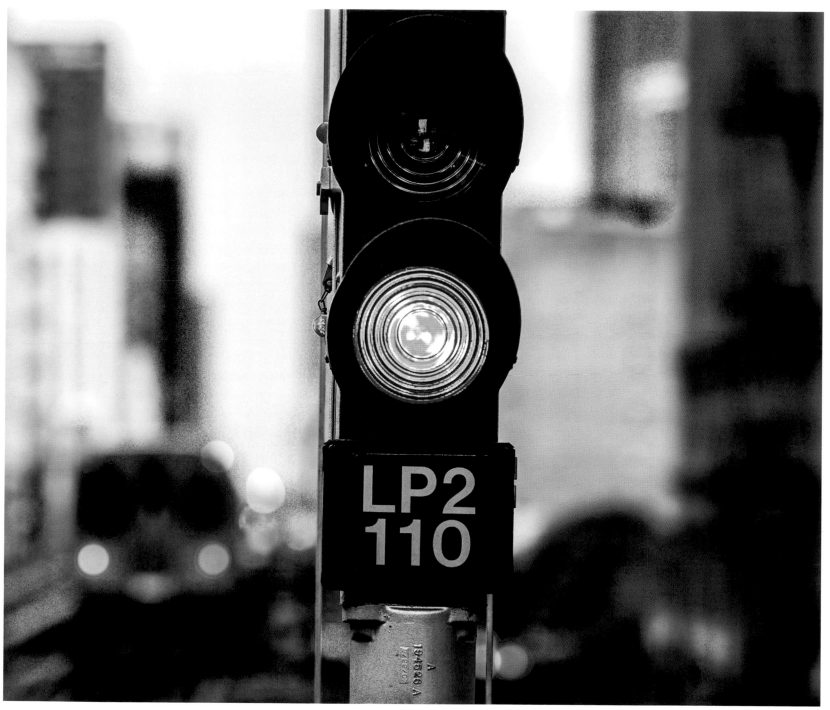

LEFT:

Chicago, Illinois, USA
A signal light shows a clear path on Chicago's elevated railway. The 'L' began operations with steam power in 1893. Operated since 1947 by the Chicago Transit Authority, it is now the only city centre elevated railway in the USA.

OPPOSITE (BOTH):

Union Station, Chicago, Illinois, USA
There is more than a hint of Renaissance Rome about this grand staircase in Chicago's Union Station, leading from Canal Street down into the Great Hall. Its original architect, Daniel Burnham, was determined to make the station a focal point in his ambitious plan for the entire city, though he died 13 years before its completion.

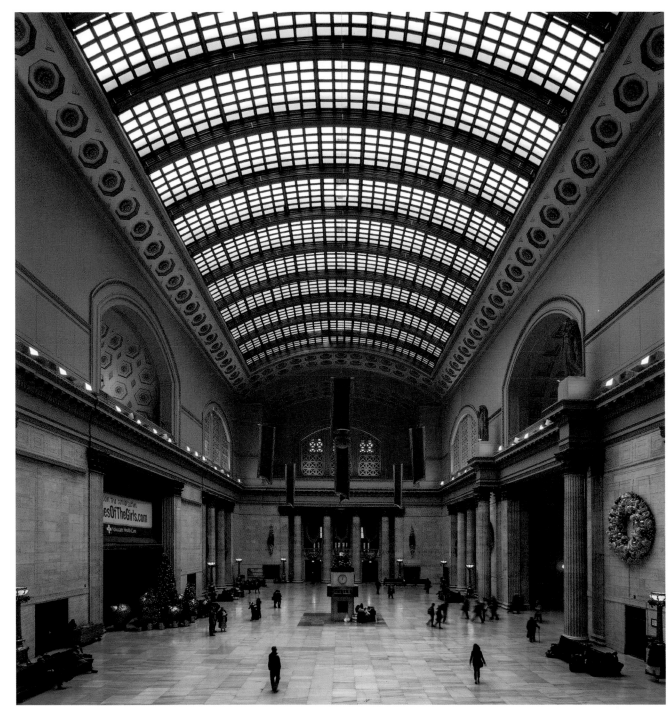

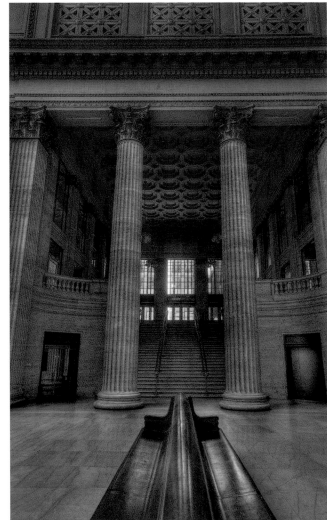

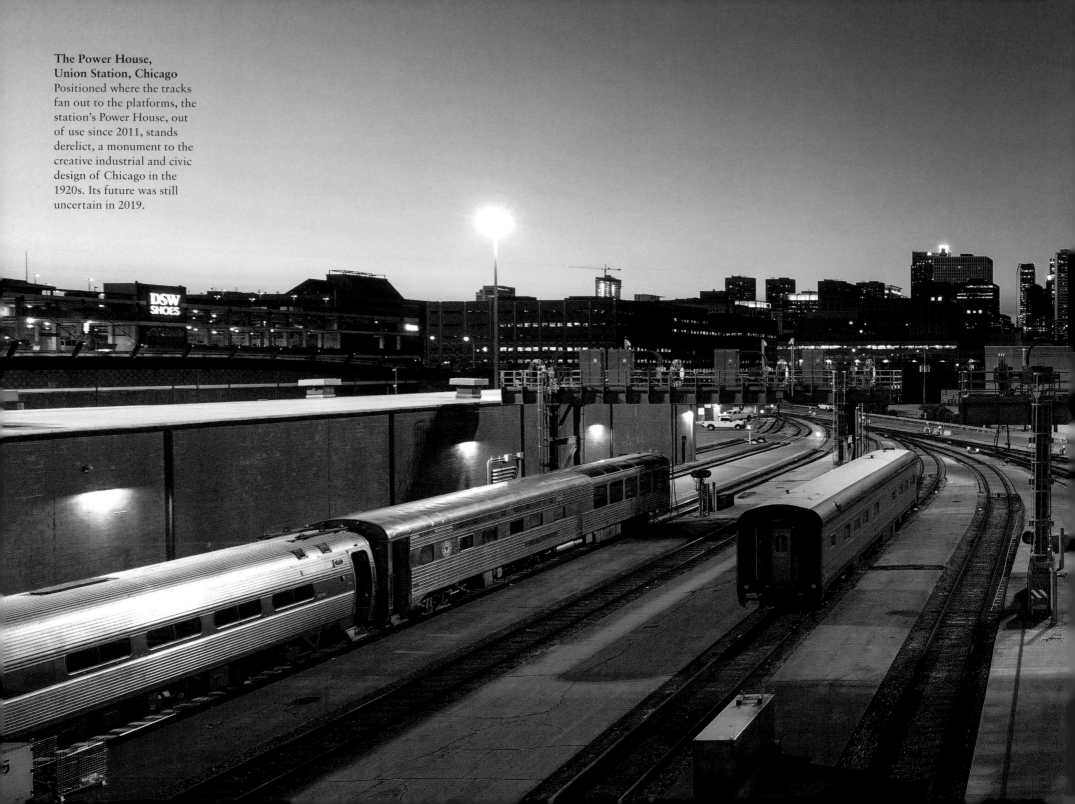

**The Power House,
Union Station, Chicago**
Positioned where the tracks
fan out to the platforms, the
station's Power House, out
of use since 2011, stands
derelict, a monument to the
creative industrial and civic
design of Chicago in the
1920s. Its future was still
uncertain in 2019.

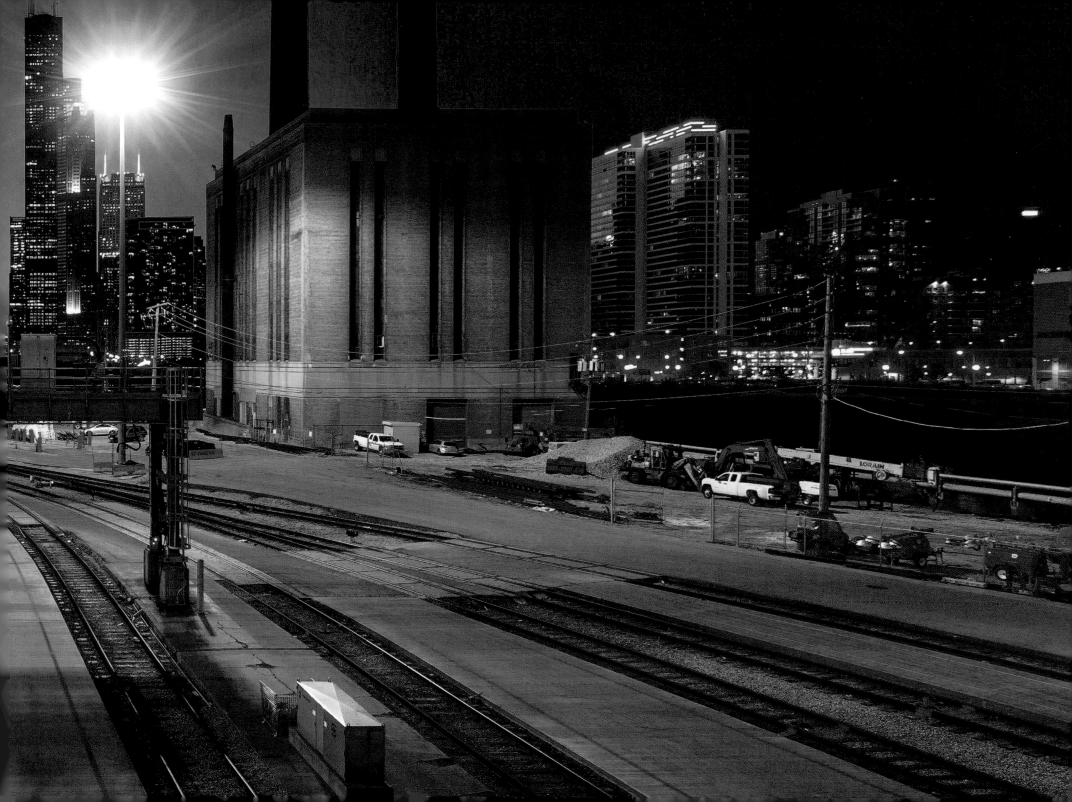

OPPOSITE:

Pennsylvania Railroad Suburban Station, Philadelphia, USA

Not a station in the suburbs, but one for the suburbs – this striking Art Deco building is the downtown terminus of the city's suburban sytem. Opened in 1930, it stands above the tracks, which are below ground level.

RIGHT:

Gettysburg Railroad Station, Pennsylvania, USA

The station was five years old when President Lincoln arrived here on 18 November 1863 to deliver his 'Gettysburg Address' on the following day. Passenger services have not used it since 1942 and it now serves as a museum, part of the Gettysburg arts and history complex.

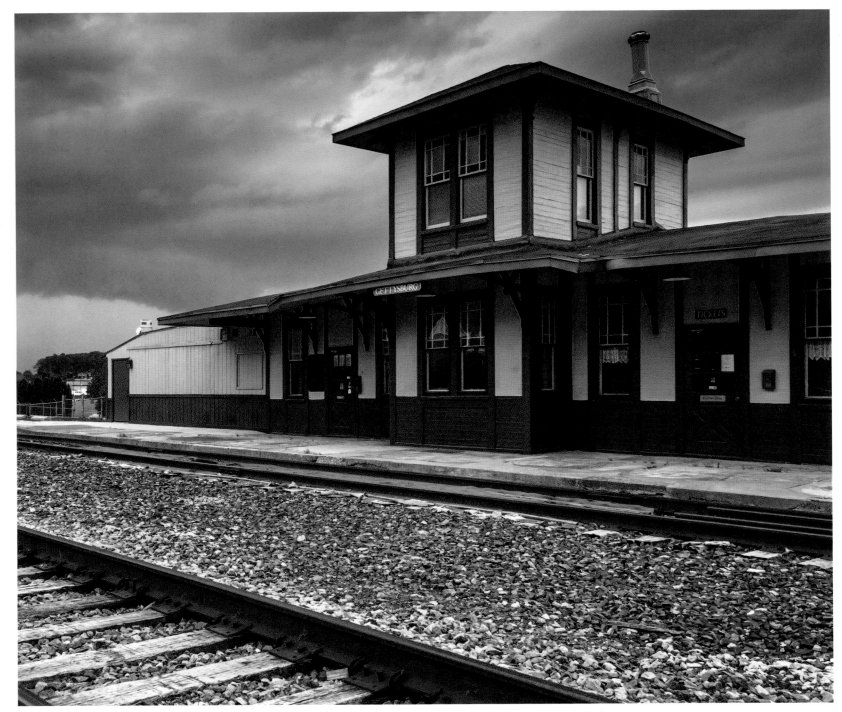

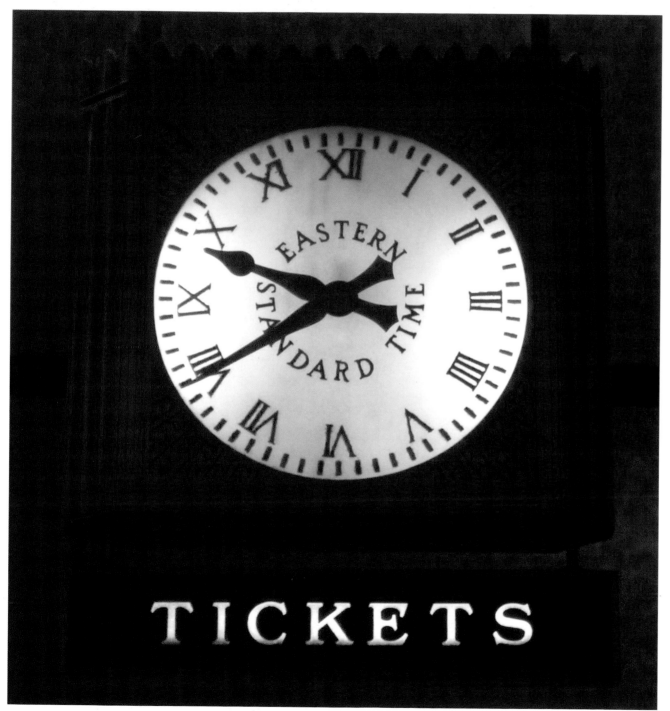

TICKETS

30th Street Station, Philadelphia, Pennsylvania, USA
An Art Deco clock suspended from the ceiling and lighting units are retained in the ticket hall of Philadelphia's main line station. An eclectic blend of neo-classical and modernist design, the station is used by over 100 long-distance trains every day.

Grand Central Station, New York, USA
The four-faced brass clock above the information booth is a traditional meeting point for New Yorkers. Its faces, two feet wide, are made of opal glass. It is topped by the acorn motif of the Vanderbilt family, commemorating Cornelius Vanderbilt (1794–1877), President of the New York Central Railroad, who had the first terminal built here.

Grand Central Station, New York, USA
Grand Central Station is no longer a transcontinental terminus but a bustling commuter hub, and a destination in in its own right as one of the city's most remarkable and historic buildings. Opened in 1913 to replace its 1871 predecessor, it has 67 million users a year.

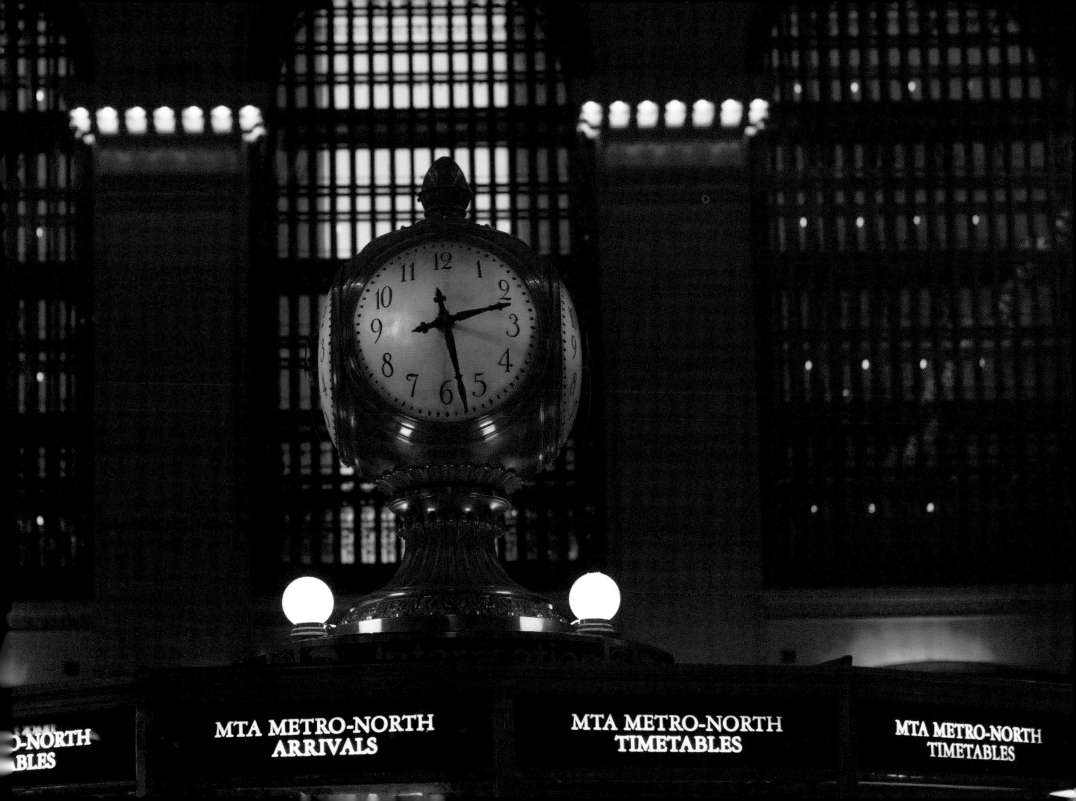

MTA METRO-NORTH
ARRIVALS

MTA METRO-NORTH
TIMETABLES

MTA METRO-NORTH
TIMETABLES

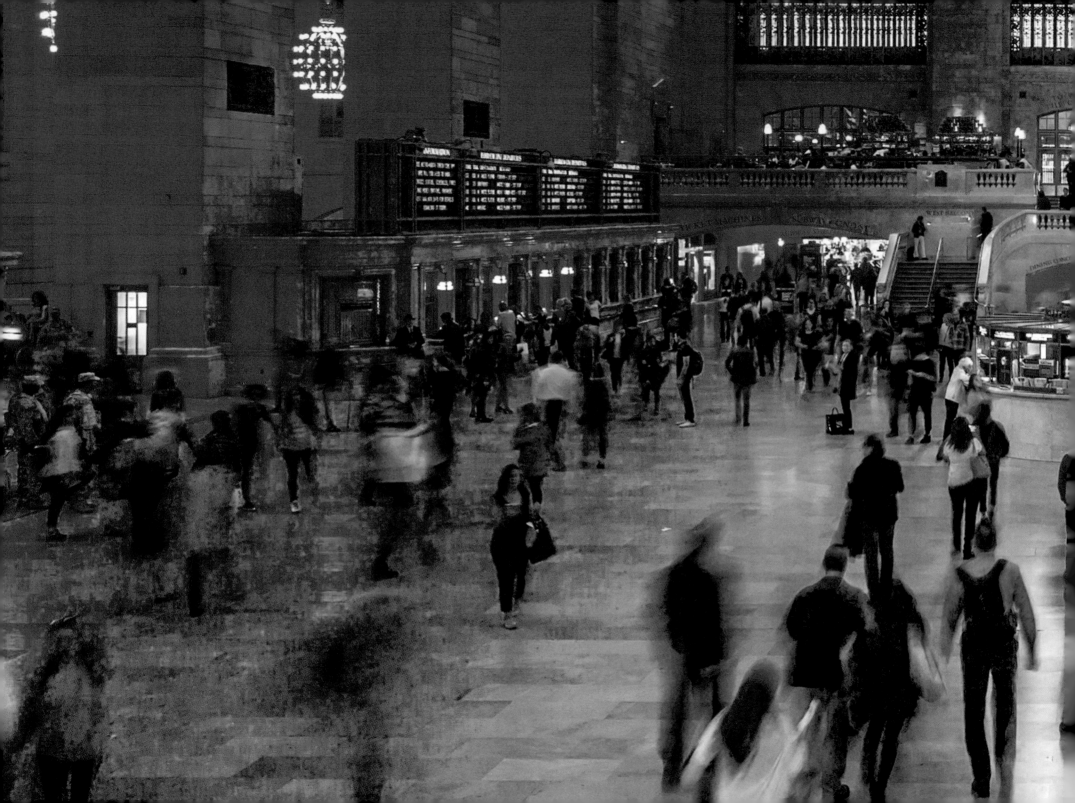

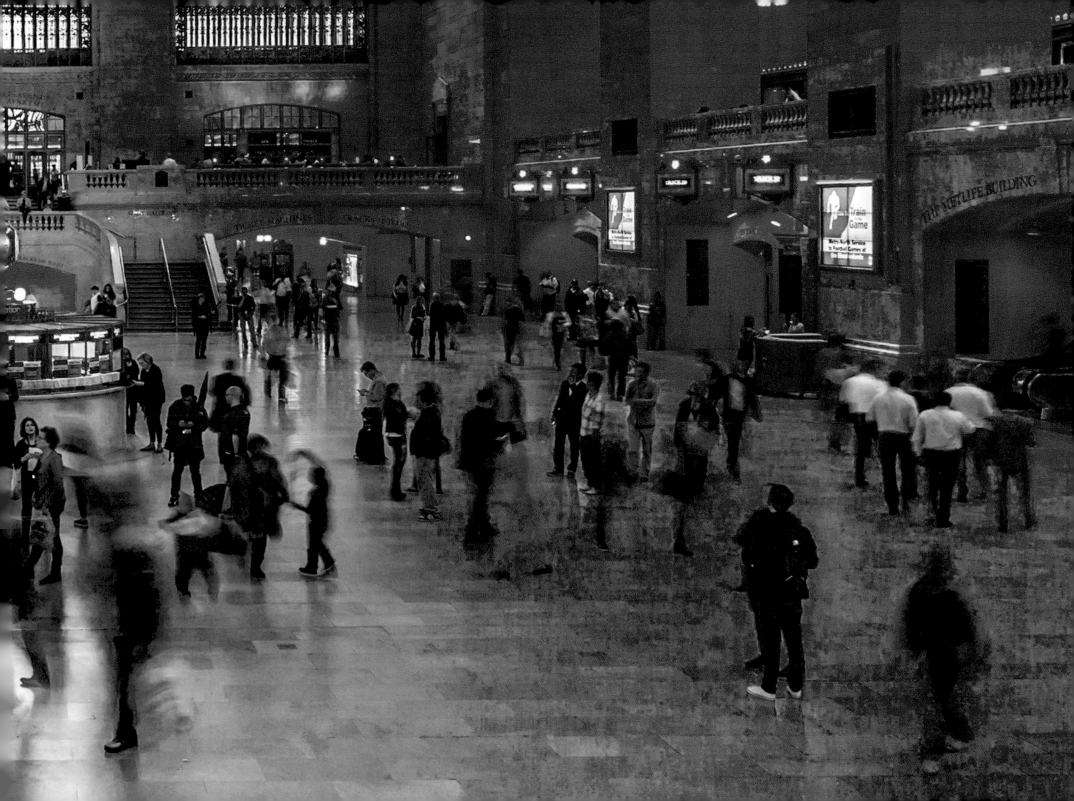

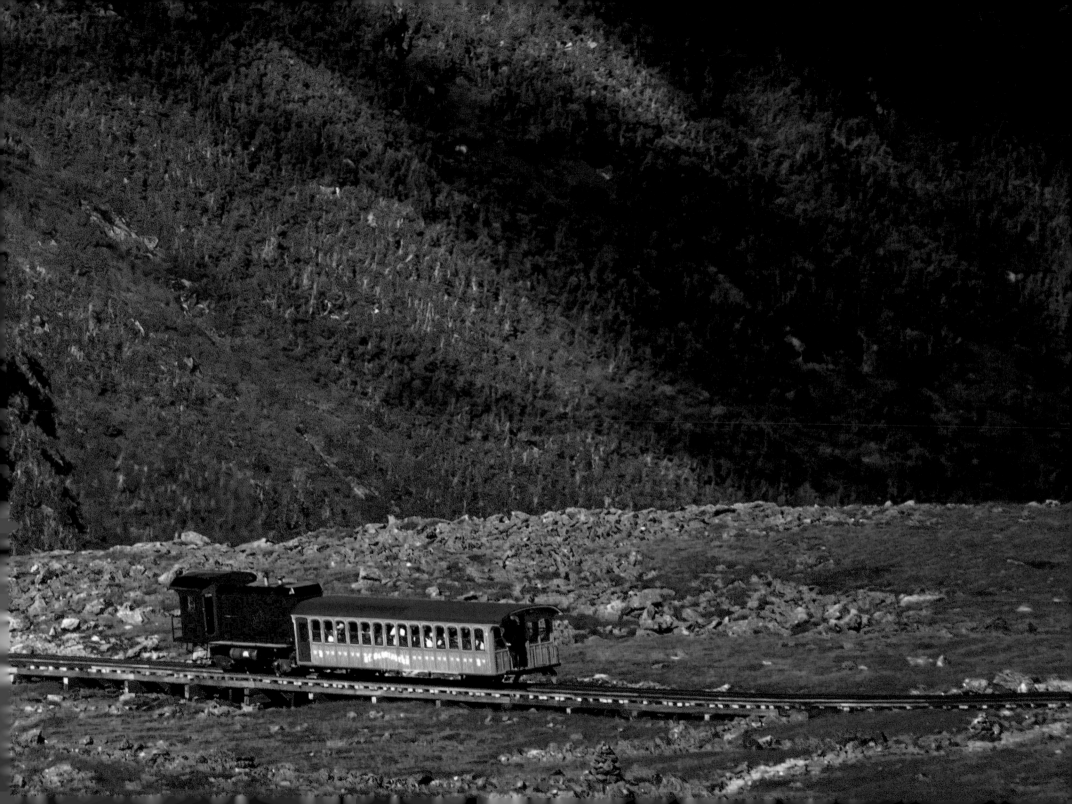

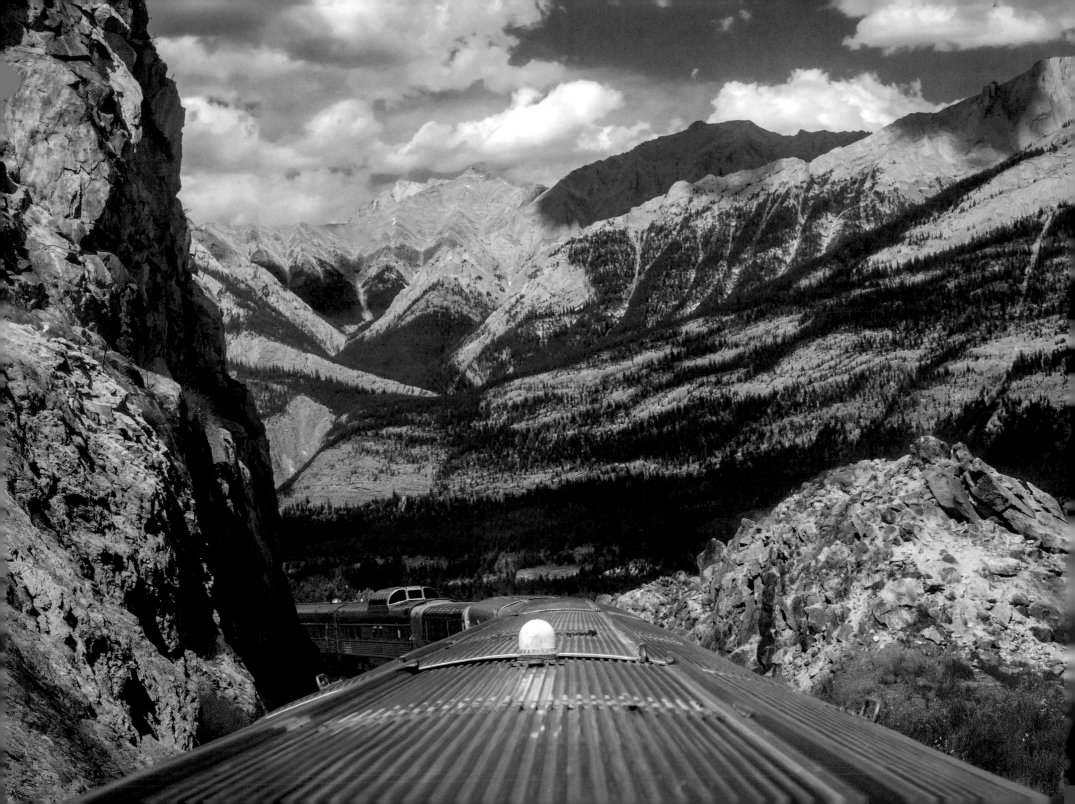

Mount Washington Cog Railway, New Hampshire, USA
Opened in 1869, this cog railway climbs to the 1916m (6288ft) summit. Nowadays worked by biodiesel locomotives, it retains two veteran steam locos. The world's first cog railway up a mountain, it is still among the steepest, with a maximum grade of 37.41%.

OPPOSITE:
Rocky Mountains, Canada
Stainless steel roofs and awesome mountains make the view from a vistadome car as a train climbs a grade in the Rockies. The 'Canadian' runs from Toronto via Jasper to Vancouver. The 4466km (2791-mile) journey involves four nights on the train.

RIGHT:
Rocky Mountains, Canada
A Burlington Northern Santa Fe (BNSF) mixed freight traverses the mountains. This railfreight company is the result of successive mergers of 390 earlier railroads. Locomotive 5819 is a General Electric diesel-electric type ES44AC.

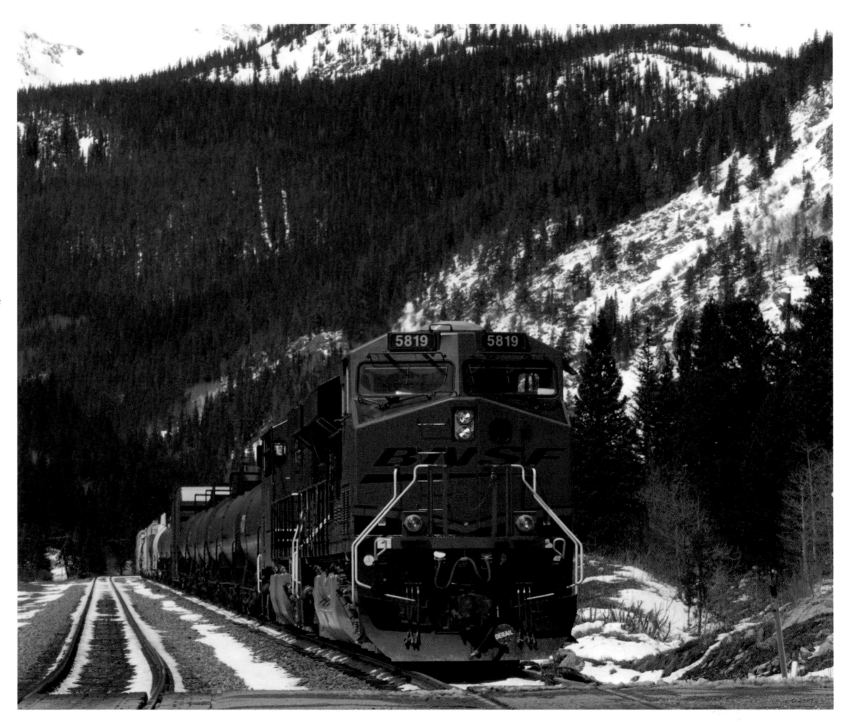

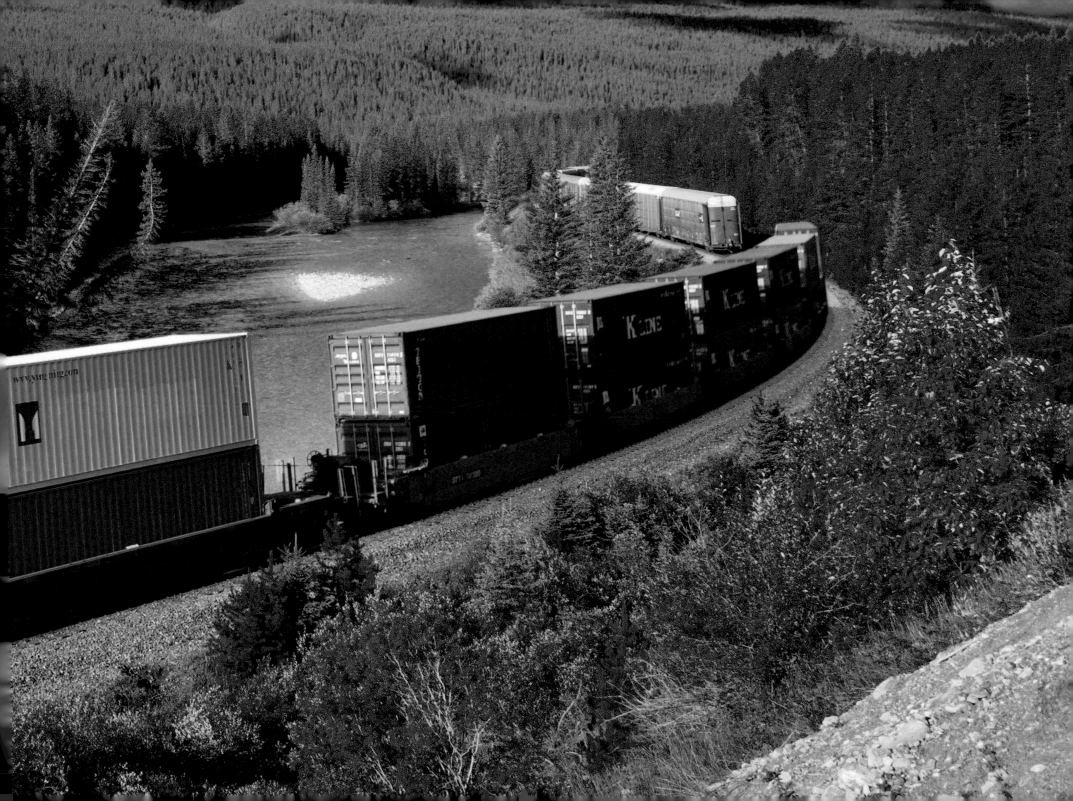

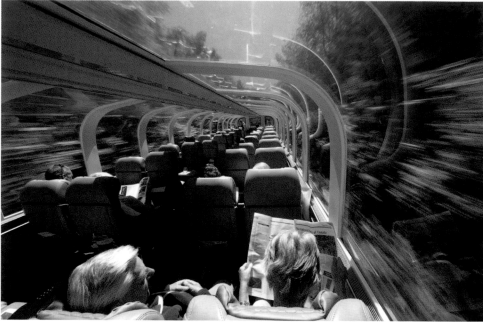

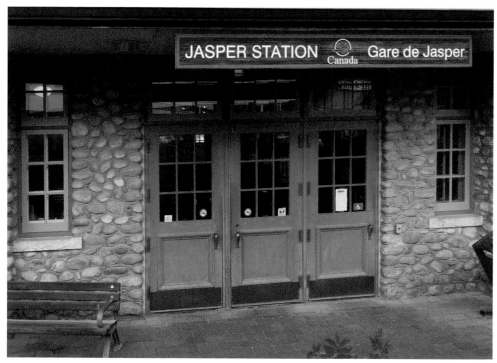

PREVIOUS PAGES:

Banff National Park, Canada

A long line of double-stacked containers snakes through Morant's Curve, a classic spot for railway photographers, on the Bow River near Lake Louise in the Banff National Park. This is the Canadian Pacific route, now used only by freight trains.

TOP LEFT:

Rocky Mountaineer, Canada

These cruise trains run from April to October on scenic routes through the Rockies and the Coastal Range. Trips typically last three days. Here one of the services crosses the North Thompson River, between Kamloops and Jasper.

TOP RIGHT:

Rocky Mountaineer, Canada

The all-glass upper structure of the 'Rocky Mountaineer's' single-deck cars allows for full appreciation of the lofty mountain scenery traversed by the train.

BOTTOM RIGHT:

Jasper Station, Alberta, Canada

Built by the Canadian National Railway in 1926 after its predecessor burned down, Jasper station, with its attractive Arts and Crafts design, is an important regional transport hub and gateway to the Jasper National Park. At 1060m (3572ft) above sea level, the station handles VIA Rail and Rocky Mountaineer trains.

OPPOSITE:

Rocky Mountaineer, Jasper

A pair of EMD GP40 2LW diesel-electric locomotives head a train at Jasper. With a combined 6000hp they are easily capable of hauling heavy trains over the mountain routes. Dating from the mid-1970s, these locomotives have been upgraded and modernized to today's requirements.

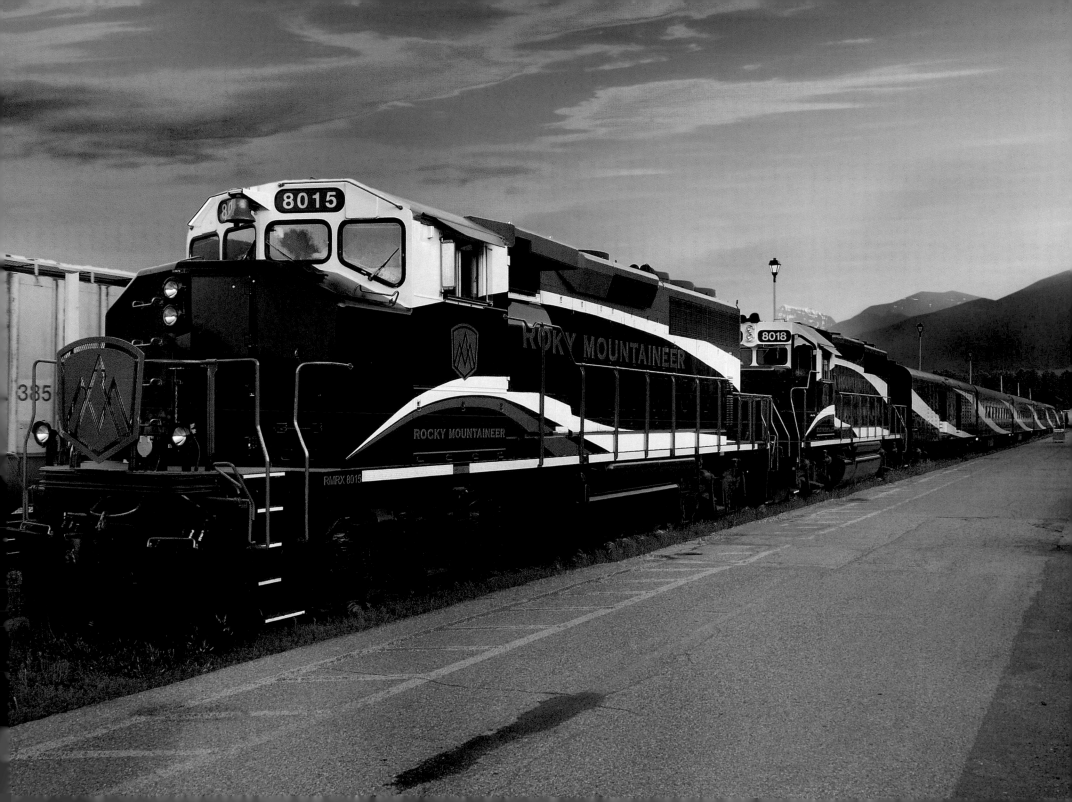

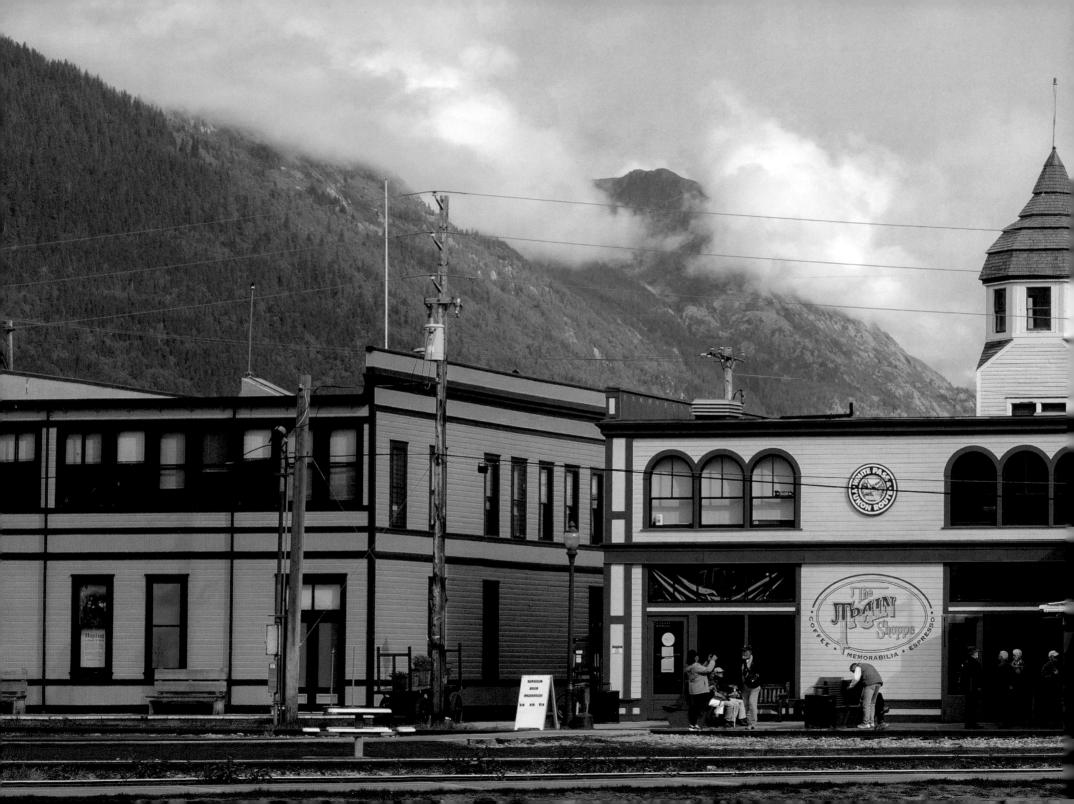

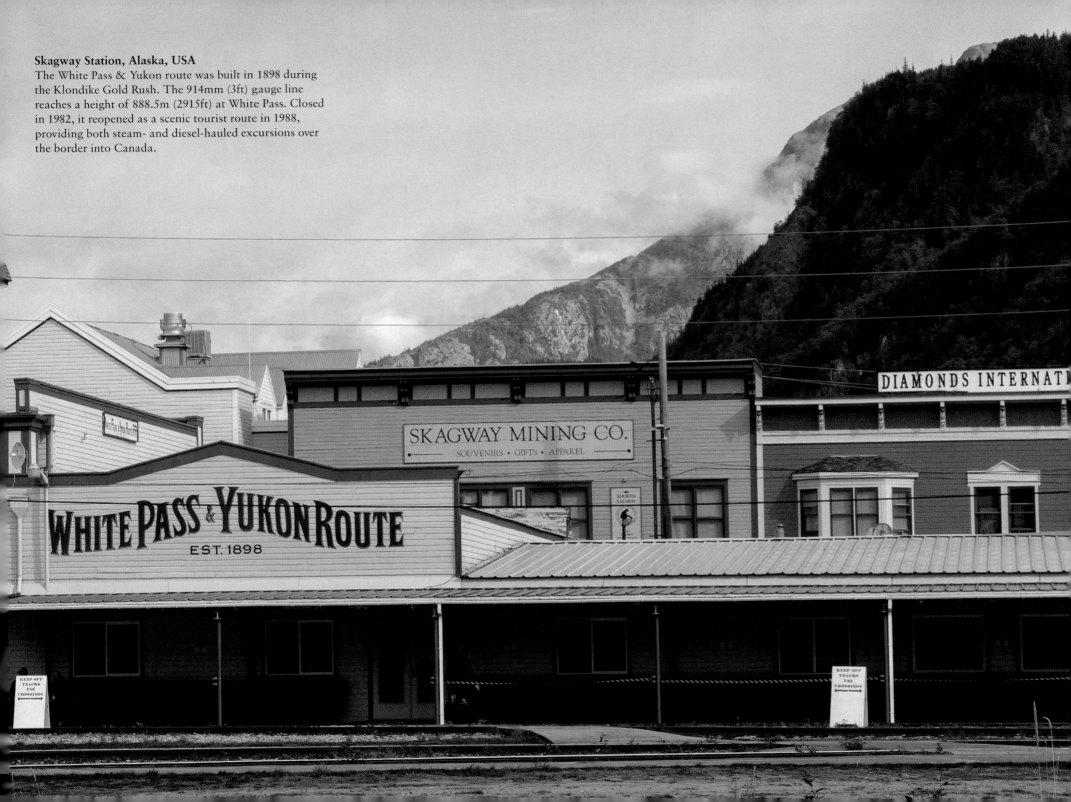

Skagway Station, Alaska, USA
The White Pass & Yukon route was built in 1898 during the Klondike Gold Rush. The 914mm (3ft) gauge line reaches a height of 888.5m (2915ft) at White Pass. Closed in 1982, it reopened as a scenic tourist route in 1988, providing both steam- and diesel-hauled excursions over the border into Canada.

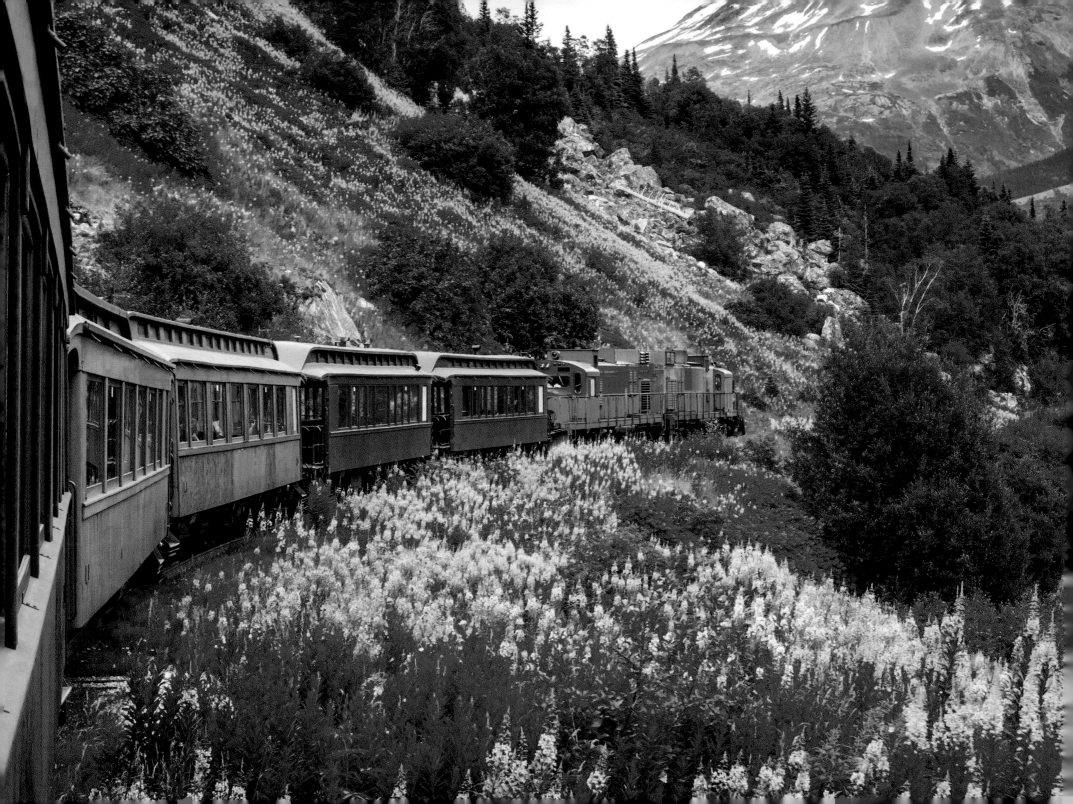

LEFT:
White Pass & Yukon Route, Alaska, USA
Vintage wooden cars trundle behind a pair of diesel-electrics on the way up to White Pass. Trestle bridges, tunnels, cross-water causeways and curving viaducts are all features of the route.

RIGHT:
White Pass & Yukon Route, Alaska, USA
A First Nation symbolic bird design adorns the front of WP&Y locomotive No. 99, built by General Electric in 1966 and re-engined in 2010. The 11 locomotives of Class 90 are known as 'Shovelnose' for their distinctive appearance.

OVERLEAF:
Albuquerque, New Mexico, USA
The two-decker Rail Runner Express runs through picturesque and historic Pueblo country between Belen, Albuquerque and Santa Fe. Its name derives from New Mexico's state bird, the road-runner. It is a 21st-century service, introduced in 2006. Motive power is an MPXpress 36PH-3C.

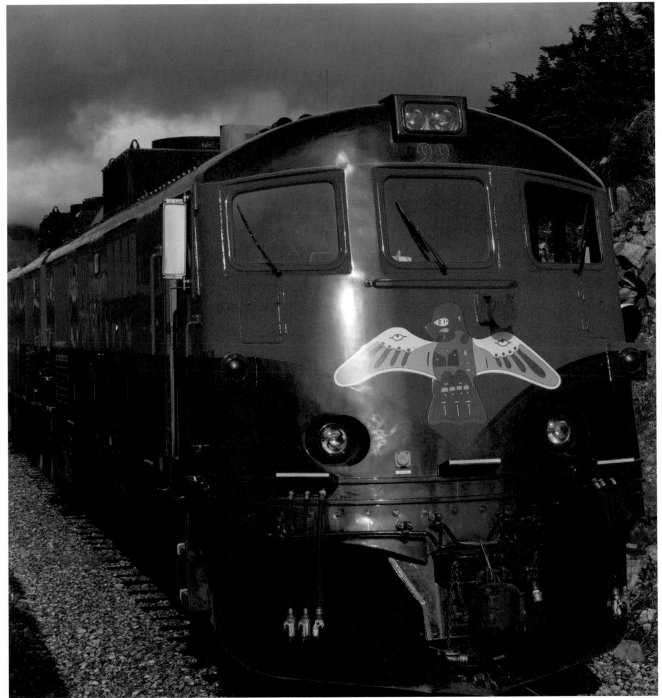

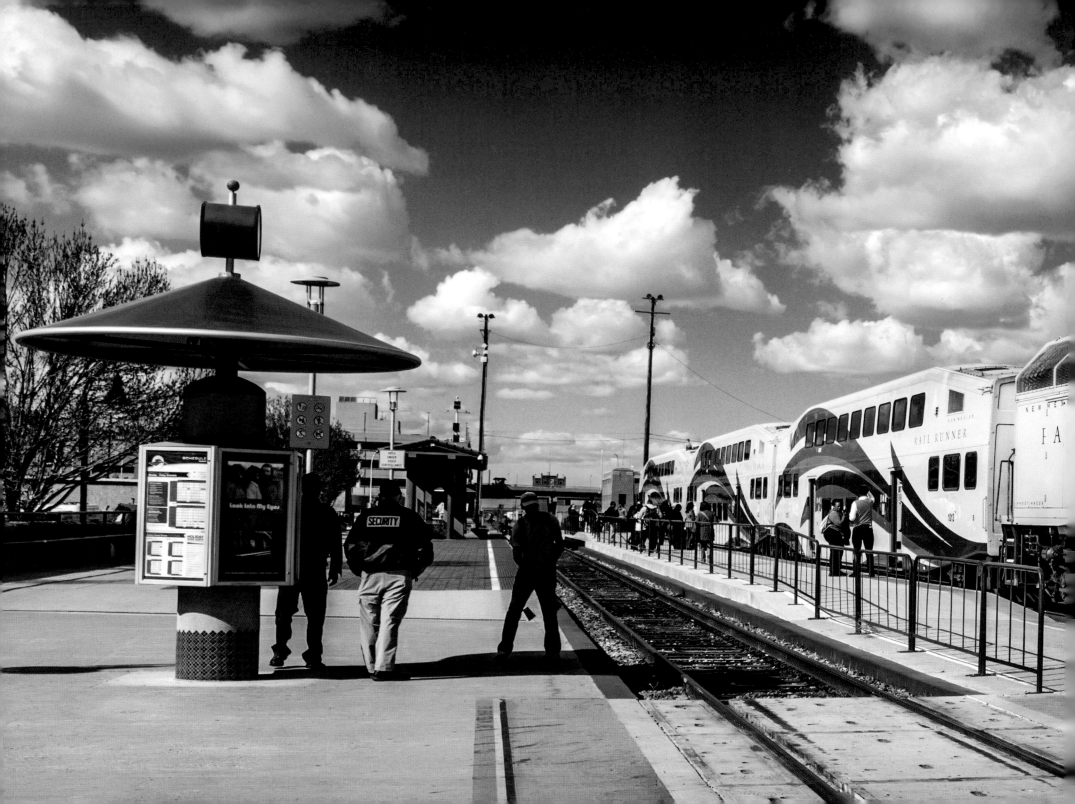

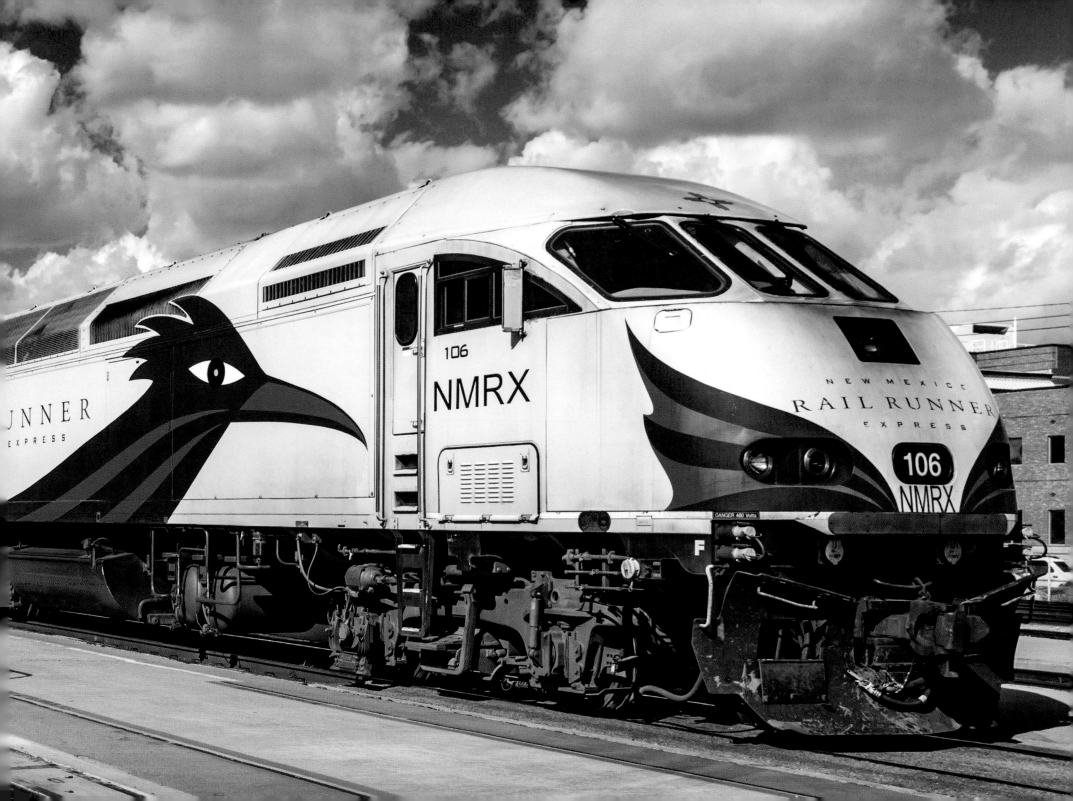

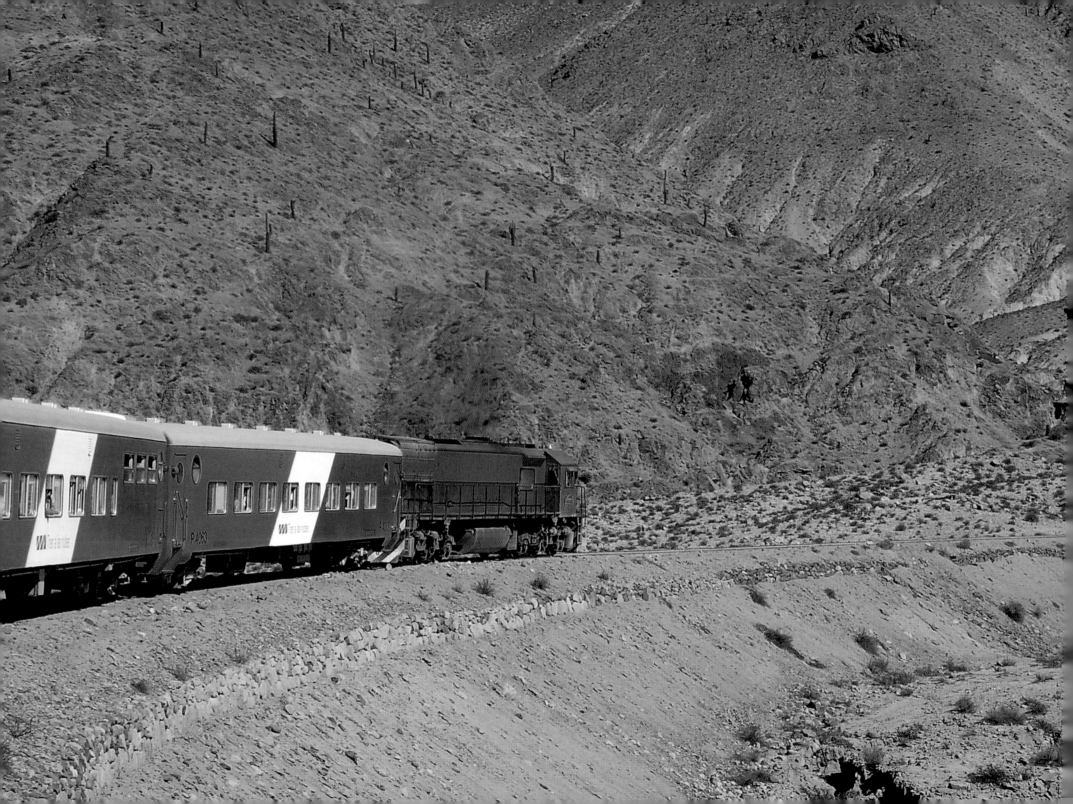

South America

The physical and political geography of the South American continent did not make an easy basis for railway construction, with the exception of the great flats of the Argentinian pampas. The first lines were relatively short, beginning with a sugar-carrying railway in British Guiana in 1848 and a mineral line in Chile in 1851. Trans-Andean railways were heroic ventures and mostly heroic failures, including one pioneering electrified line. While many lines have survived, and the growth of cities has required the construction of rapid transit systems, there are few long-distance services. Different rail gauges in different countries, national rivalries, and economic complications have prevented a genuine continental-wide network from developing.

After 1945 railways were neglected assets, many became disused and some countries became a hunting ground for aficionados of antique steam locomotives exported from Britain and Germany. Something of a revival has taken place in recent decades and working railways can compare with any in the world for efficiency. São Paulo's metro system is generally accepted as one of the finest, but there are fascinating railway journeys to be made in many areas, from Bolivian and Peruvian high altitude lines to one of the last regular steam lines, in Patagonia.

OPPOSITE:

Tren a las Nubes, Salta Province, Argentina
Climbing from Salta at 1187m (3894ft) above sea level to
La Polvorilla at 4220m (13,845ft), the 'Train to the Clouds'
negotiates two zigzags, two spiral tunnels and some
spectacular viaducts. The fifth-highest railway in the world of
1000mm (3ft 3in) gauge, it was not completed until 1948.

OVERLEAF:

La Polvorilla Viaduct, Salta Province, Argentina
The world's highest railway viaduct, this curving structure
stands 20.7m (70ft) high at the 4182m (13,720ft) level at the
Tren a las Nubes terminal point. The train carries oxygen
cylinders and medical aid for cases of altitude sickness.

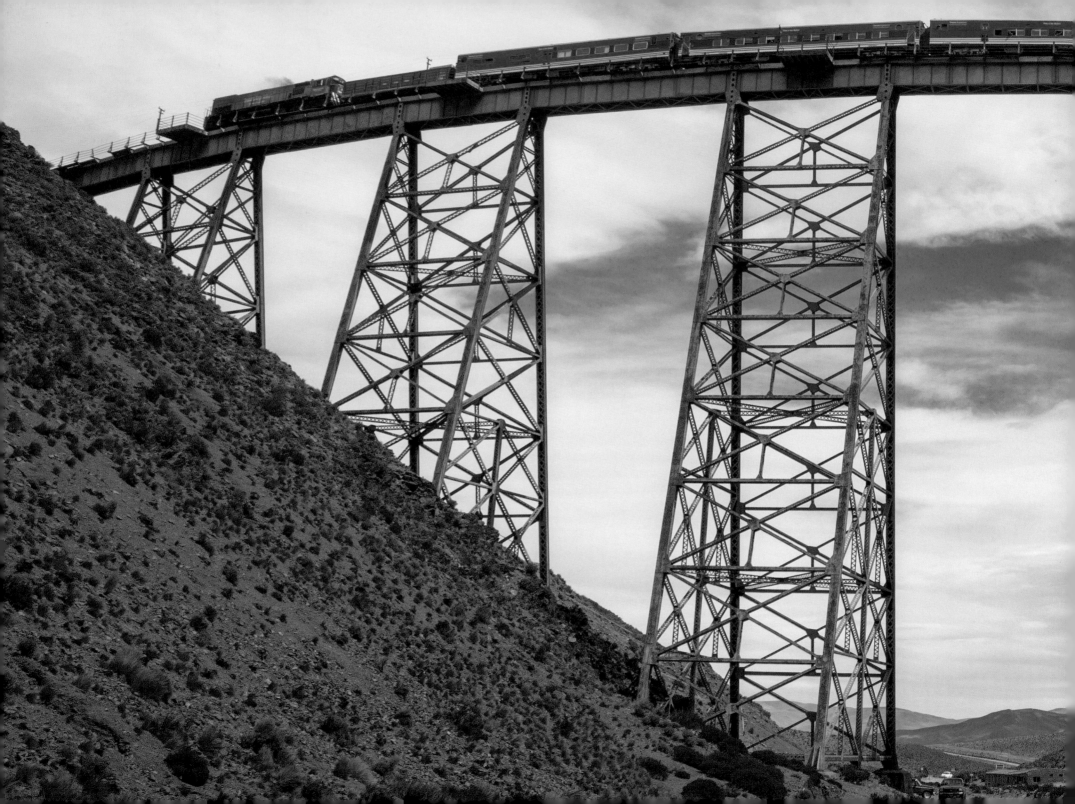

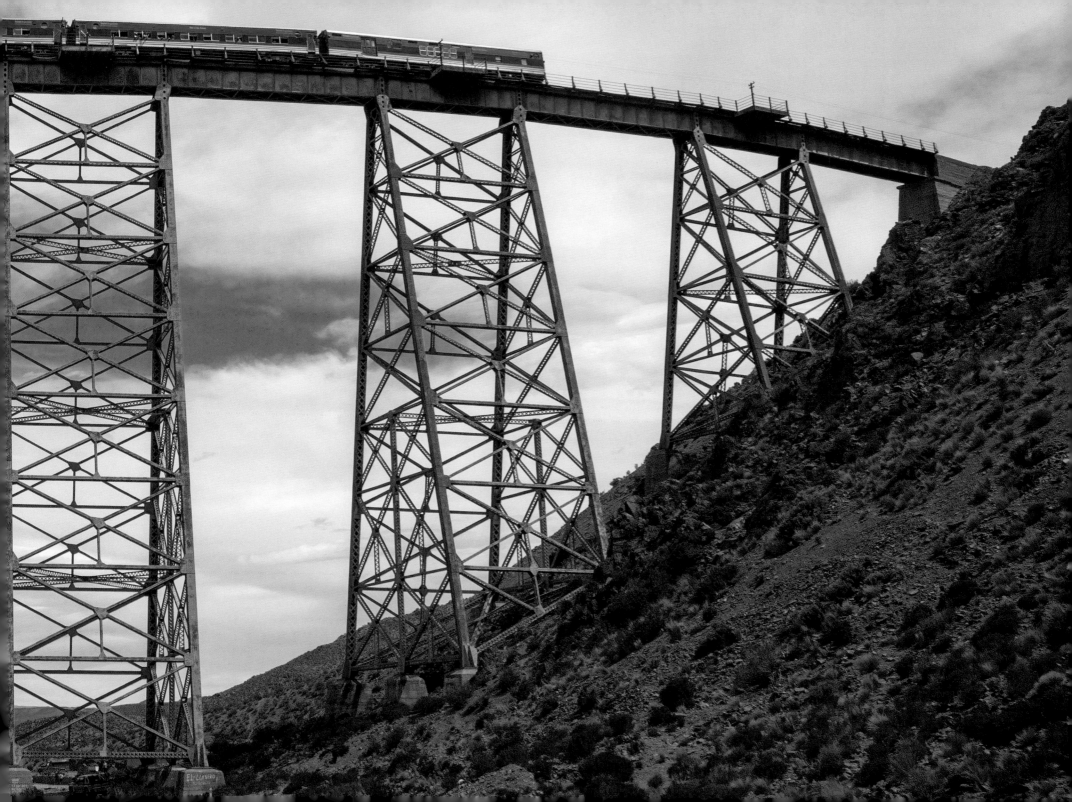

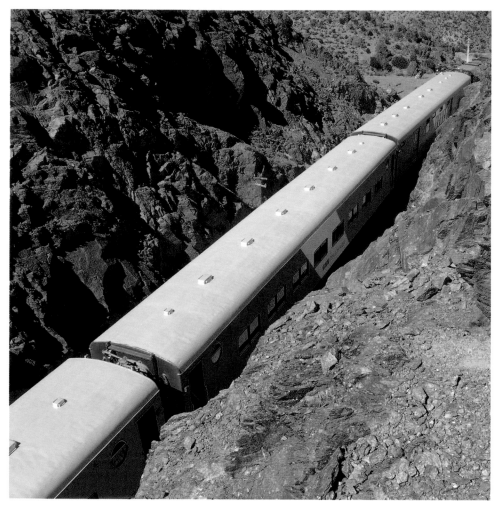

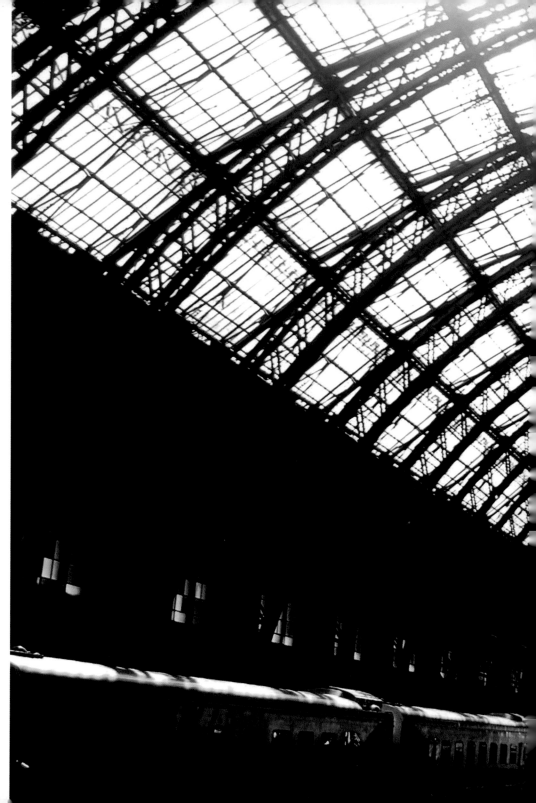

ABOVE:
La Polvorilla, Salta Province, Argentina
At La Polvorilla, the 'Train to the Clouds' reverses direction and will return to Salta. The track continues over the border into Chile.

RIGHT:
Retiro Station, Buenos Aires, Argentina
Retiro is actually three stations side by side, but Retiro Mitre, with its double-arched trainshed dating from 1915, is the most striking. From here long-distance trains leave for Rosario and Tucumán, but all three termini have their main business in rapid transit city and local trains.

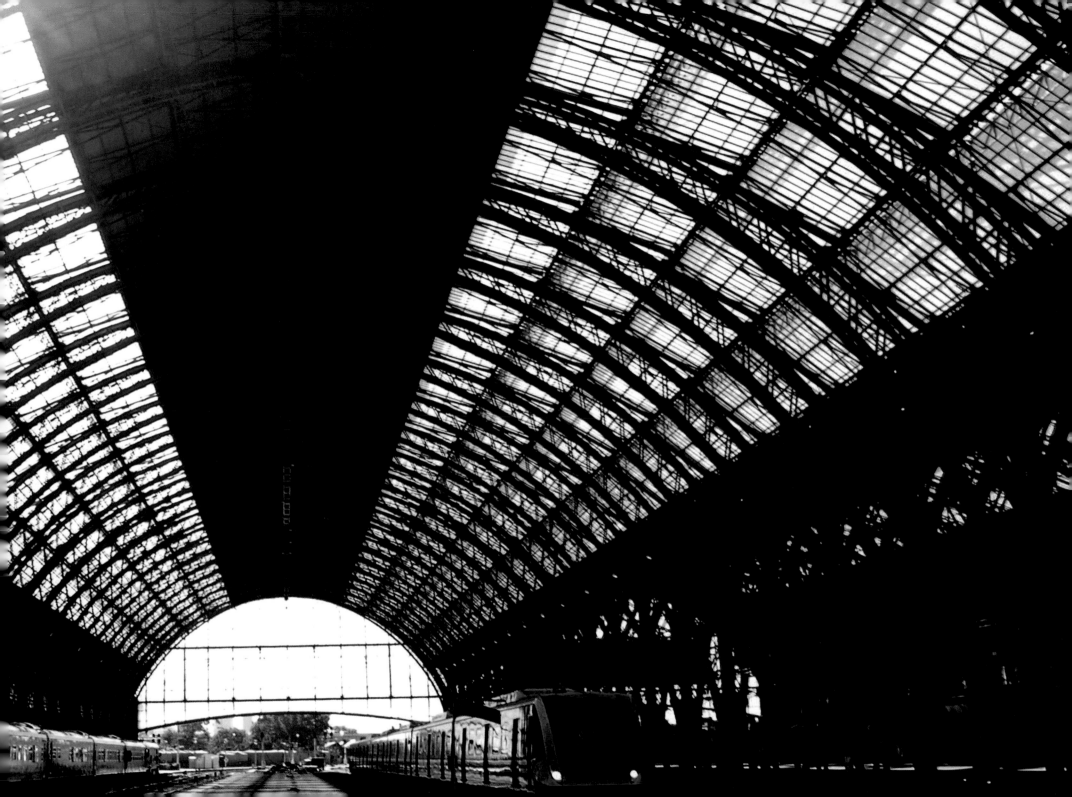

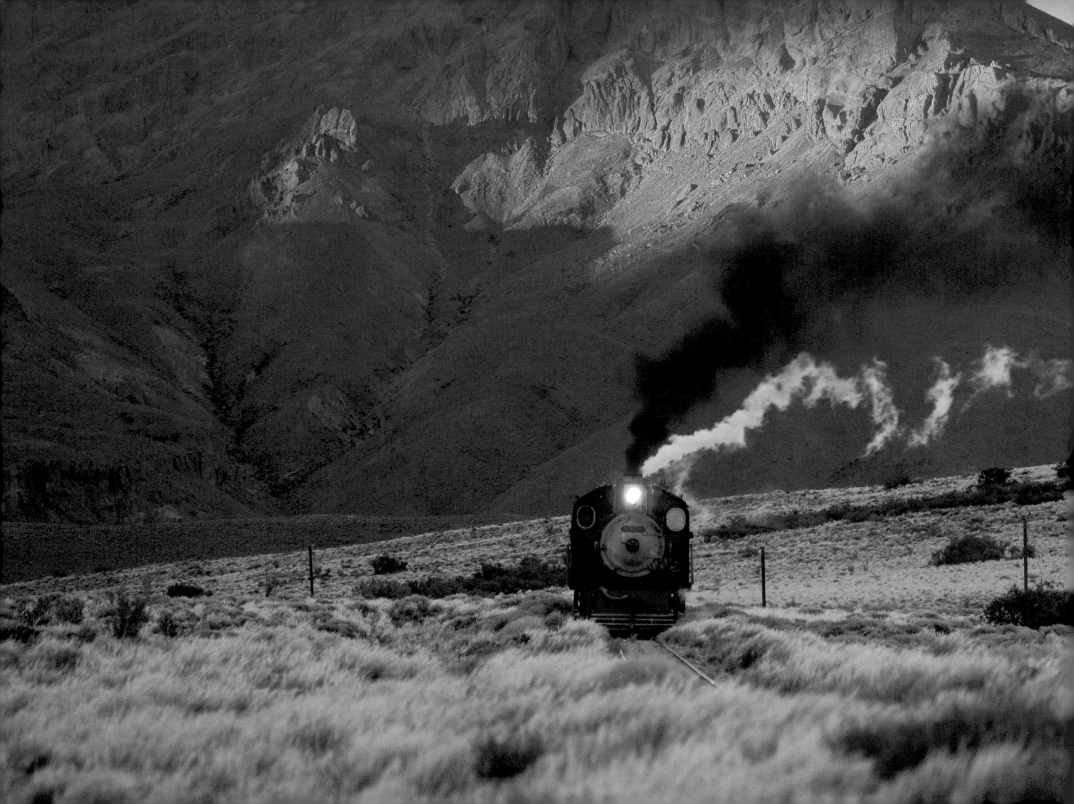

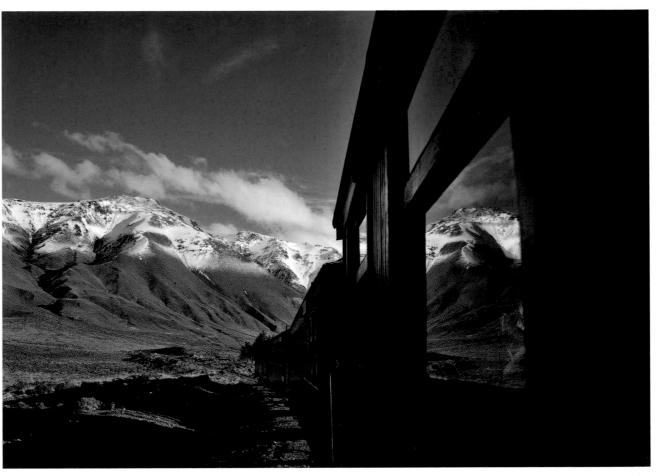

LEFT:

Viejo Expreso Patagónico, Patagonia, Argentina
Once part of a much more extensive narrow-gauge system, a heritage train service still operates on the line known as La Trochita, providing steam-hauled jouneys on sections from Esquel to Nahuel Pan, and El Maaitén and Desvío Thomae.

ABOVE:

Viejo Expreso Patagónico, Patagonia, Argentina
Passing below the Andean Precordillera, the 'Old Patagonian Express' is one of the few railways still worked exclusively by steam, though maintaining its fleet of vintage engines is increasingly difficult.

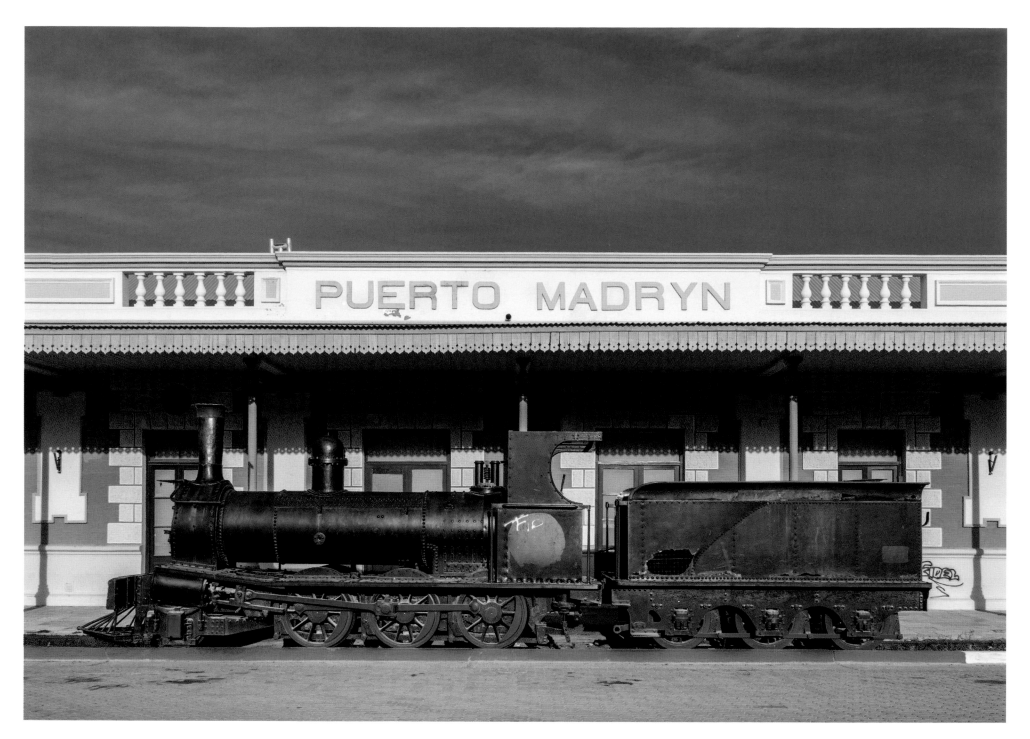

OPPOSITE:

Puerto Madryn, Chubut Province, Argentina
The one-time Central Chubut Railway started by Welsh immigrants terminated at this seaport, but ceased operations in 1958. The station is now a museum where locomotive No. 3, built in Manchester in 1888, is preserved.

RIGHT:

Antofagasta, Chile
A train control instrument in the old railway station in Antofagasta. Drivers required a special token to enter each section of the single track line, which the machine would not release if the section was already occupied by a train coming the other way.

OVERLEAF:

Salar de Uyuni, Bolivia
Rail tracks cross the world's largest salt flat in this arid region of Bolivia. The town of Uyuni is a junction of four lines and is famous among railway enthusiasts for its 'cemetery' of abandoned and rusting steam locomotives.

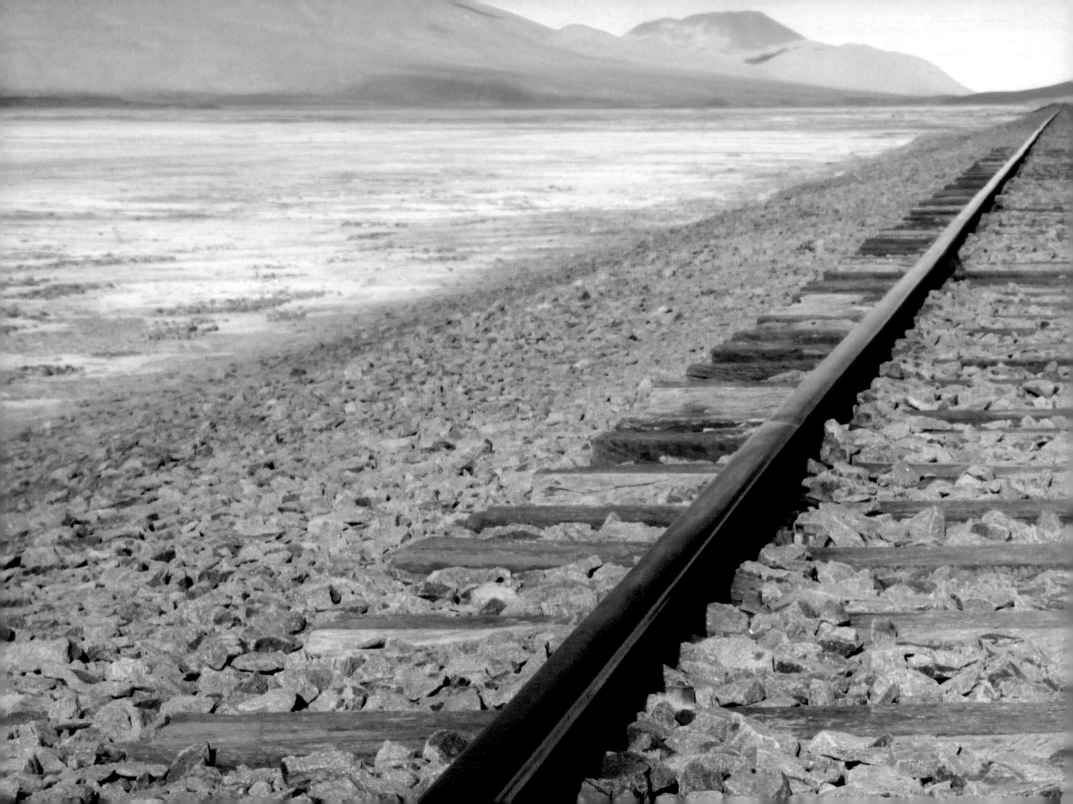

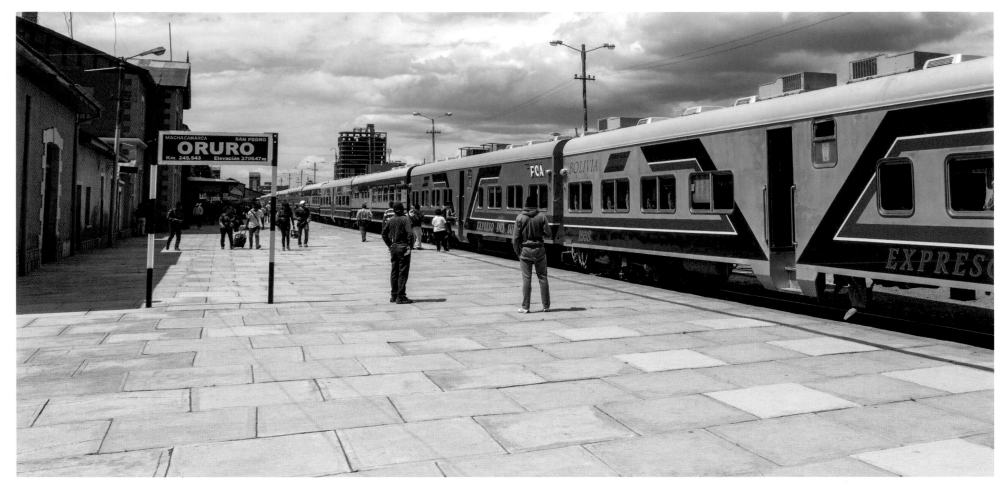

ABOVE:

Oruro Station, Bolivia
Oruro, 3735m (12,254ft) above sea level, is the terminus for trains from Uyuni and Villazon. The modern coaches of the Expreso del Sur (Southern Express) stand ready for the journey across the Bolivian altiplano to Uyuni.

OPPOSITE:

Expreso del Sur, Bolivia
Bolivia's mountain valleys offer a variety of different landscapes to the salt flats and the dry scrublands of the altiplano. Here the train passes through a region of trees and farmland. The locomotive is a Hitachi Bo-Bo-Bo of late 1970s construction.

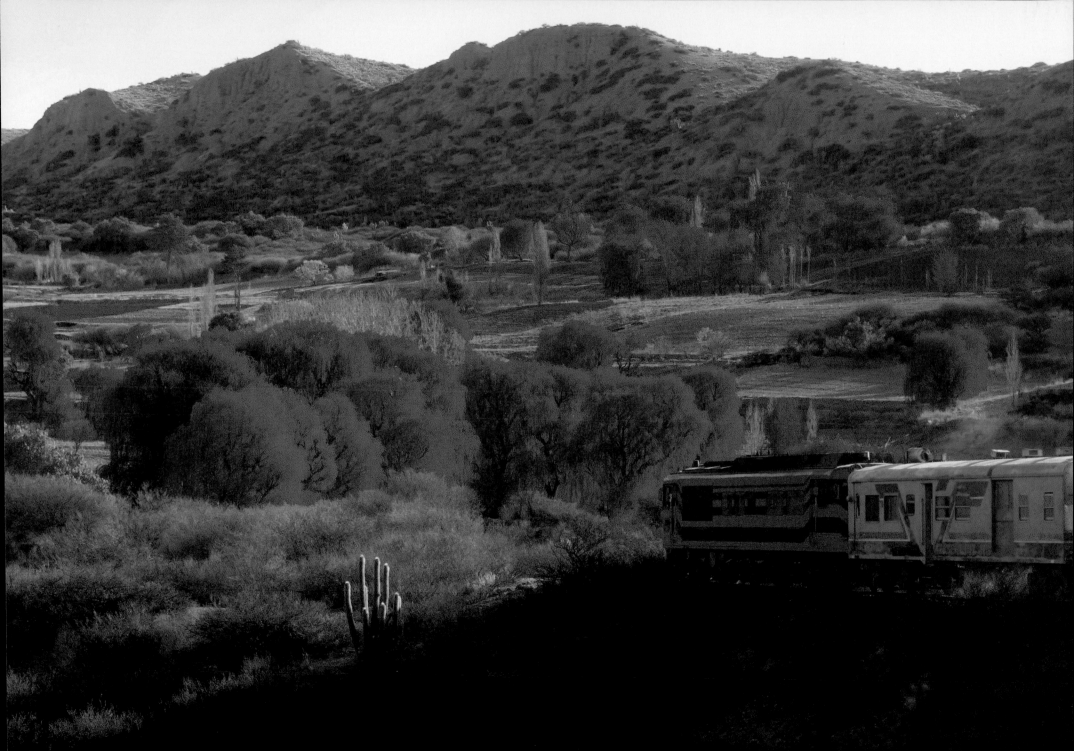

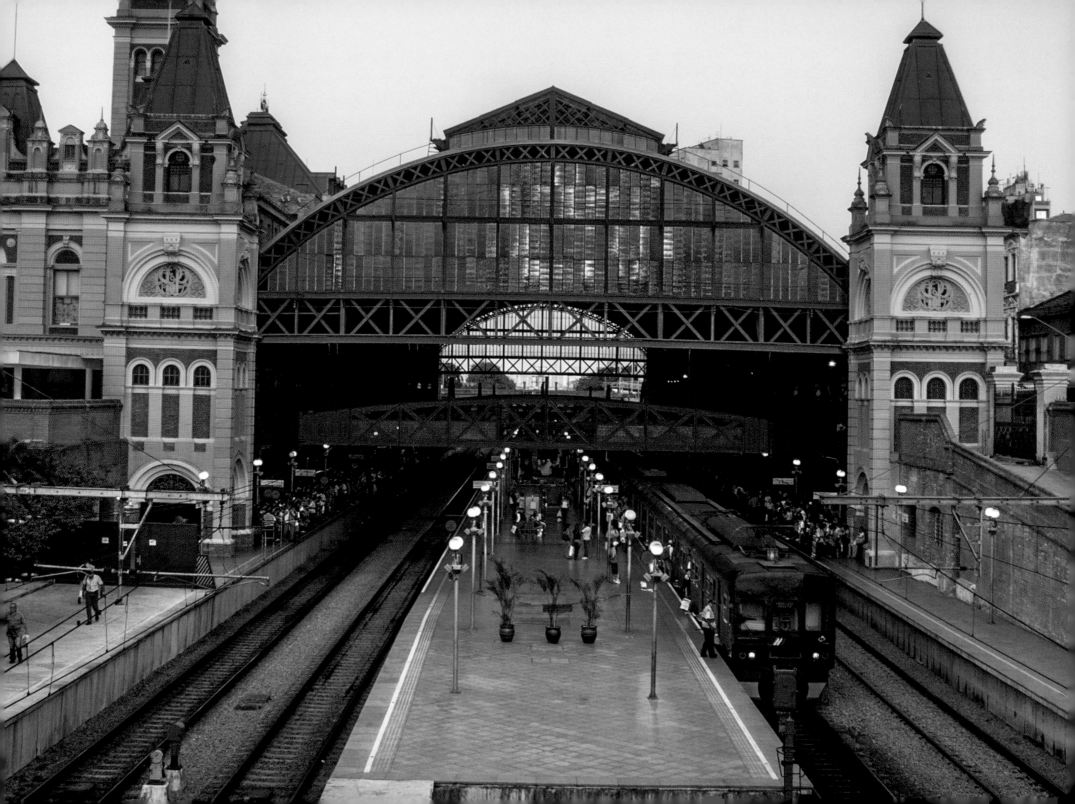

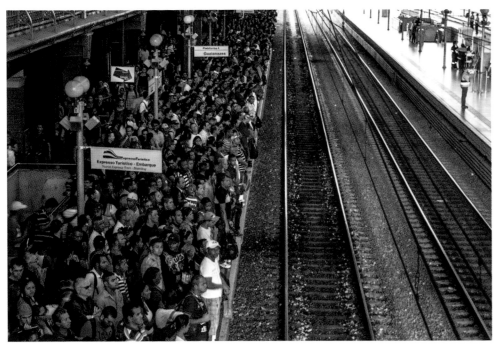

OPPOSITE:
São Paulo, Brazil
Dating back to 1867, Estação da Luz is a busy commuter station in the São Paulo metropolitan area. The six lines of the system form the largest urban rail transport network in South America, carrying 5.2 million people every day.

LEFT:
São Paulo, Brazil
Rush-hour passengers await a train at Luz station. The system's 1600mm (5ft 3in) gauge enables trains to be a little wider than in many other rapid-transit city regions: even so, it's going to be a squeeze when the train arrives.

BOTTOM LEFT:
Serra Verde Express, Paraná State, Brazil
Running between Curitiba and Morretes in south-east Brazil, this heritage train provides a luxurious ride through dense and mountainous Atlantic rainforest. The line was originally built in 1880–85 to carry grain.

BOTTOM RIGHT:
Serra Verde Express, Paraná State, Brazil
Nowadays an assortment of vintage carriages carry passengers in style on this section of the line, whose entire length is 610km (381 miles). In the course of the four-hour journey the train loses, or gains, 1000m (3300ft) of altitude.

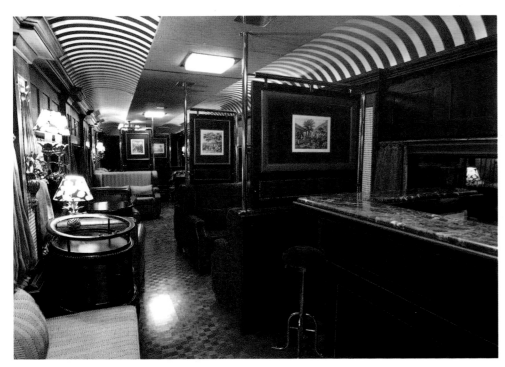

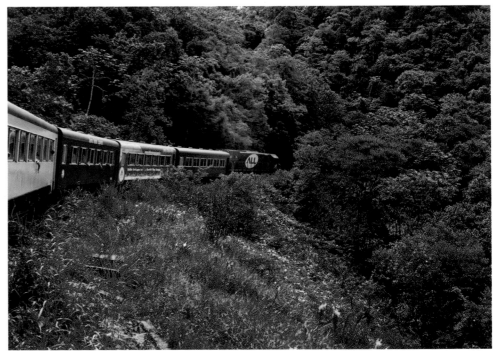

P E R

U R A I L

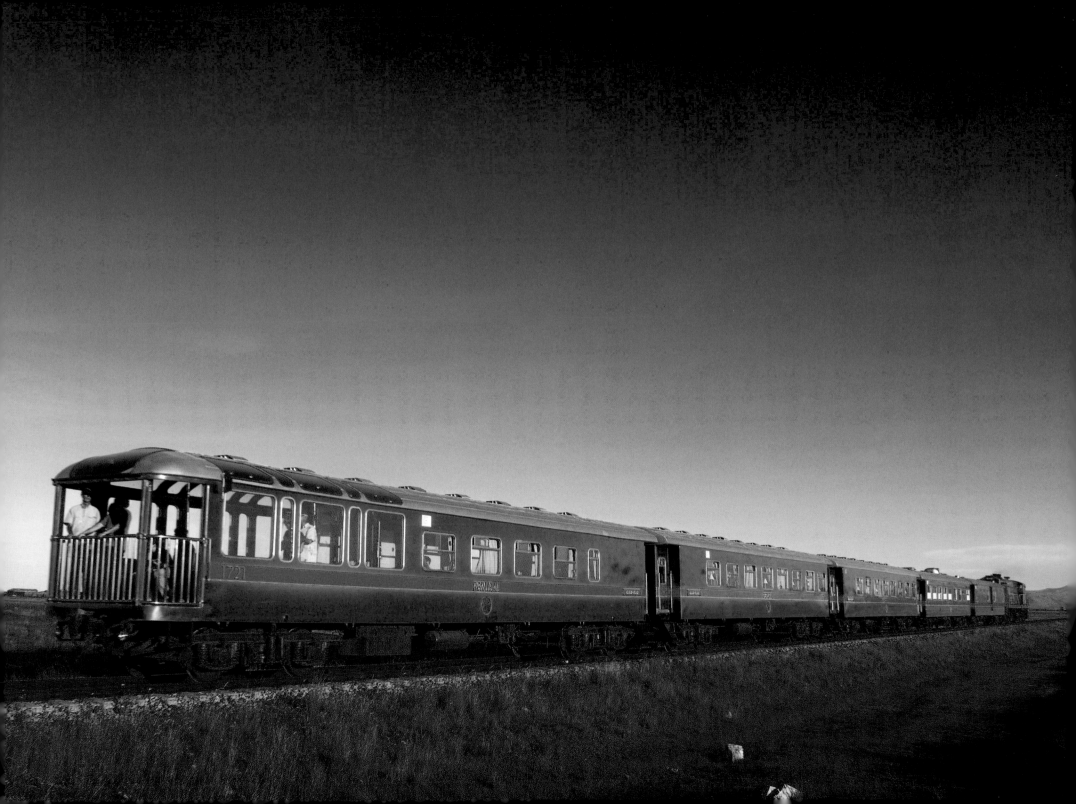

Cuzco, Peru
Perurail cars stand ready
at Poroy, outside Cuzco,
to transport passengers to
Aguas Calientes, at the base
of the ascent to the Inca
city of Machu Picchu. The
914mm (3ft) gauge line offers
three classes of passenger
accommodation for the three-
and-a-half hour journey.

OPPOSITE:
Cuzco, Peru
Perurail's pre-2017 'Andean
Explorer' train in open
country near Cuzco. It ran
between Cuzco and Puno
on Lake Titicaca, a 10-hour
journey. The rear carriage
is a bar car with an
observation platform.
The 'Andean Explorer' is now
an overnight service.

RIGHT:
Cuzco, Peru
The Cuzco-Puno line is
single track, and trains wait
at crossing loops to enable
oncoming traffic to pass.
Modernized control does
not require the former
apparatus of signals and
telegraph wires.

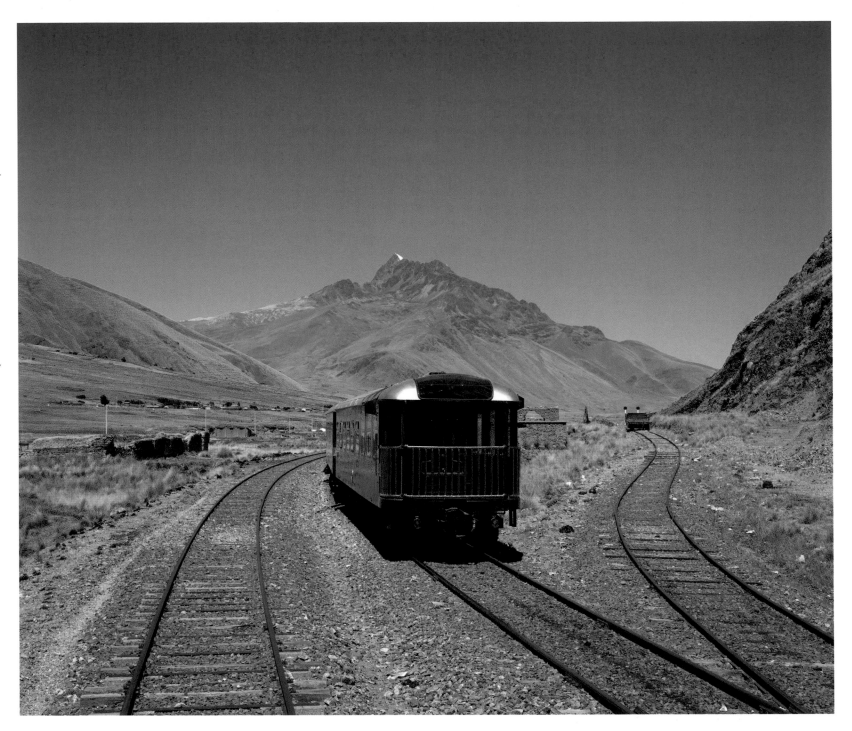

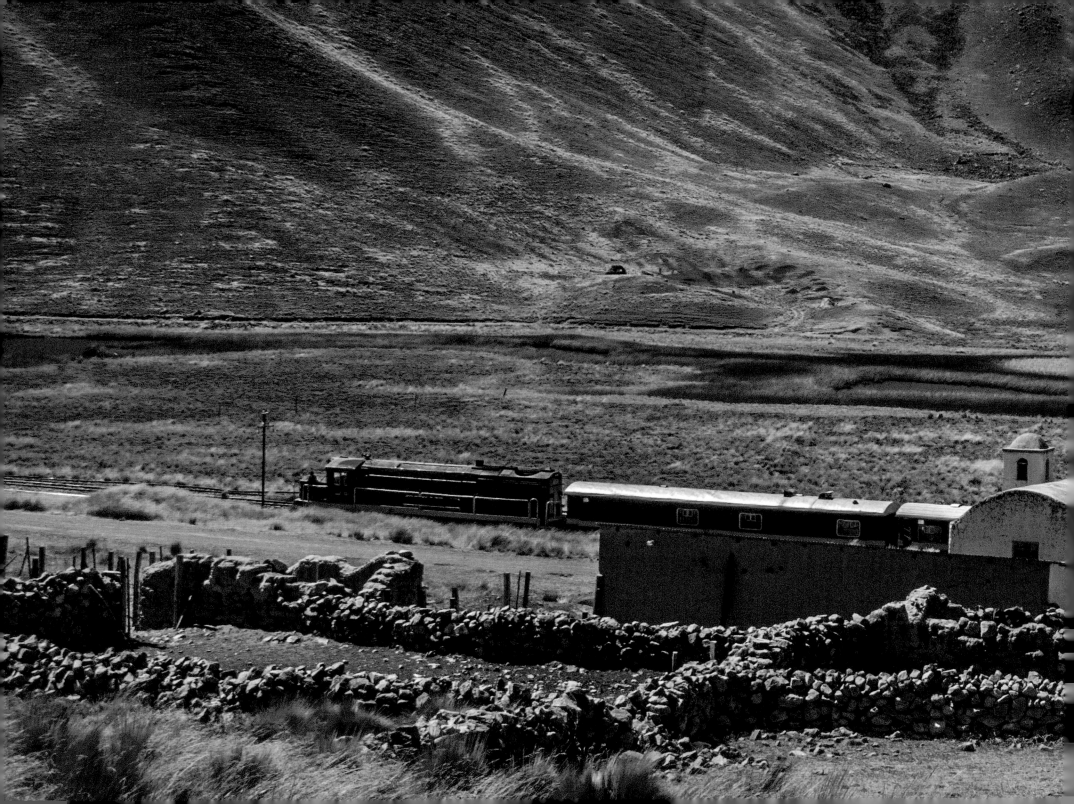

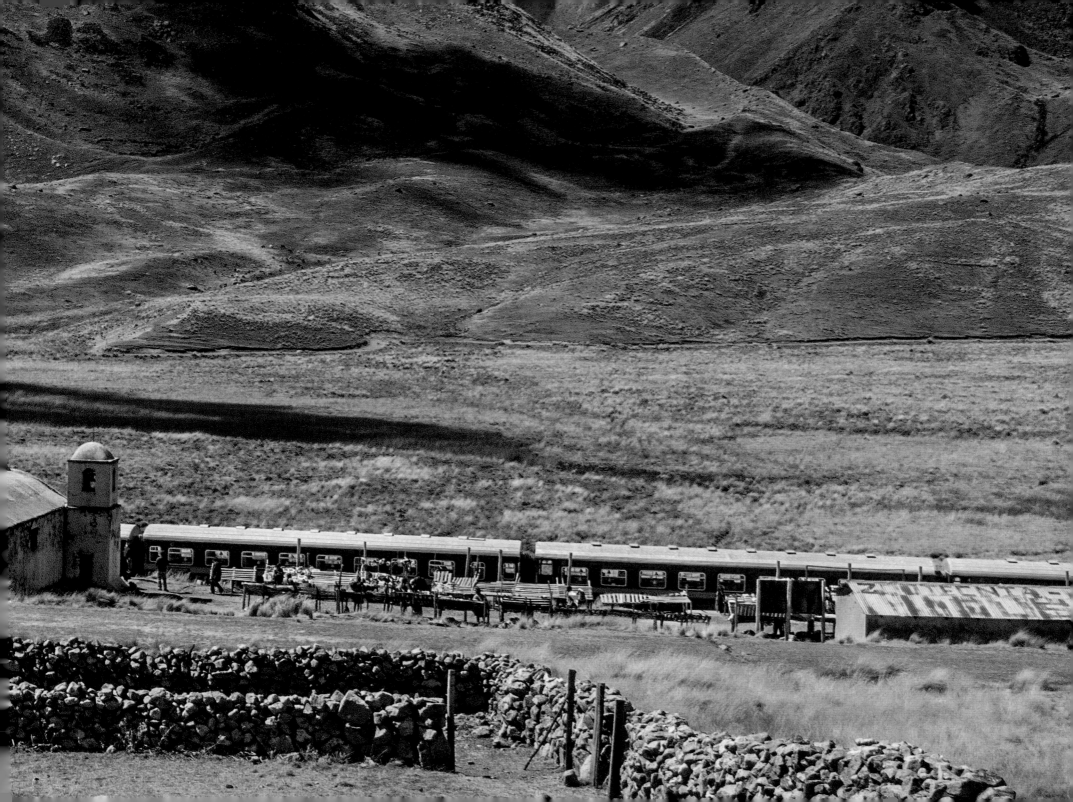

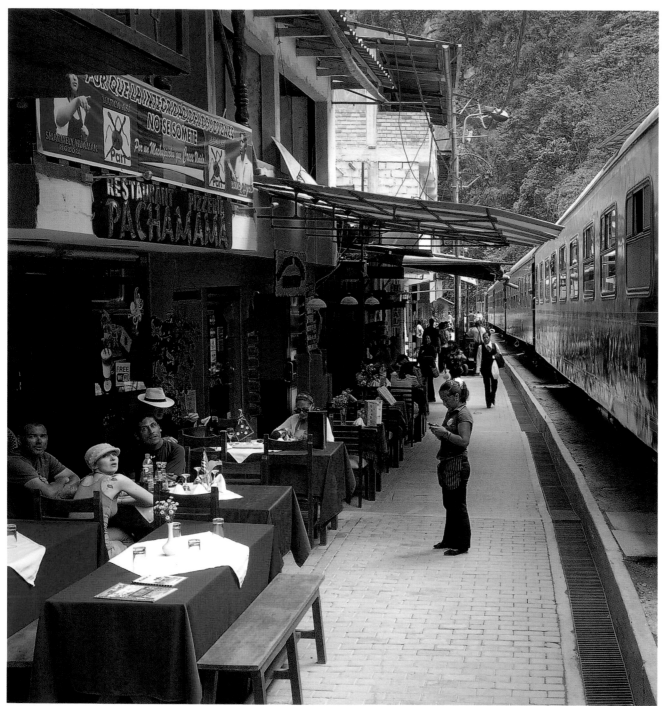

PREVIOUS PAGES:
Abra la Raya, Peru
The Puno-Cuzco train halts at Abra la Raya, summit of the line at 4350m (14,271ft), to enable tourists to take photographs and perhaps visit the local market. Streams on one side descend to the Amazon and on the other to landlocked Lake Titicaca.

LEFT:
Aguas Calientes, Urubamba Province, Peru
In Aguas Calientes, the main street is the railway line. This is where the trains bringing visitors to Machu Picchu terminate, though the line goes on beyond the village. Passengers formerly got on and off here in the centre, but Perurail trains use Machu Picchu station at the edge of the village.

OPPOSITE:
Aguas Calientes, Urubamba Province, Peru
The railway is a local lifeline in every way. Two diesel-electric Perurail switching engines sort freight wagons in this car-free village. No. 356 is an ALCo DL535B built in 1963 and No. 482 is an ALCo DL535A of 1966.

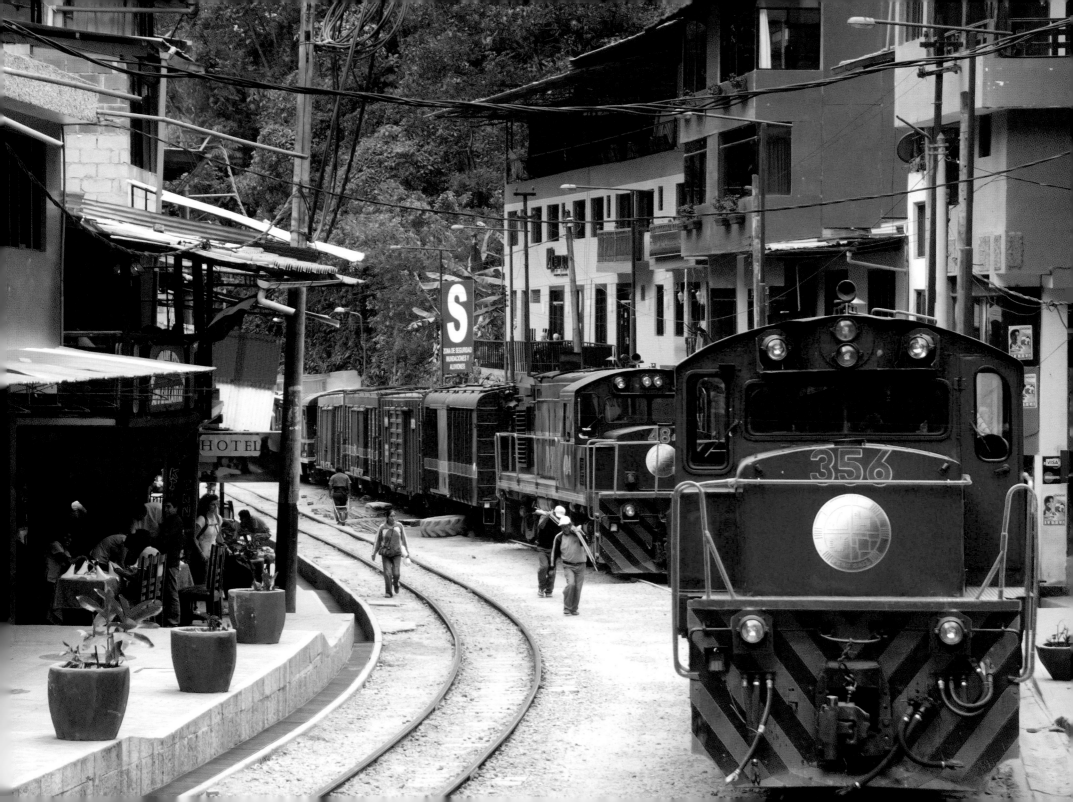

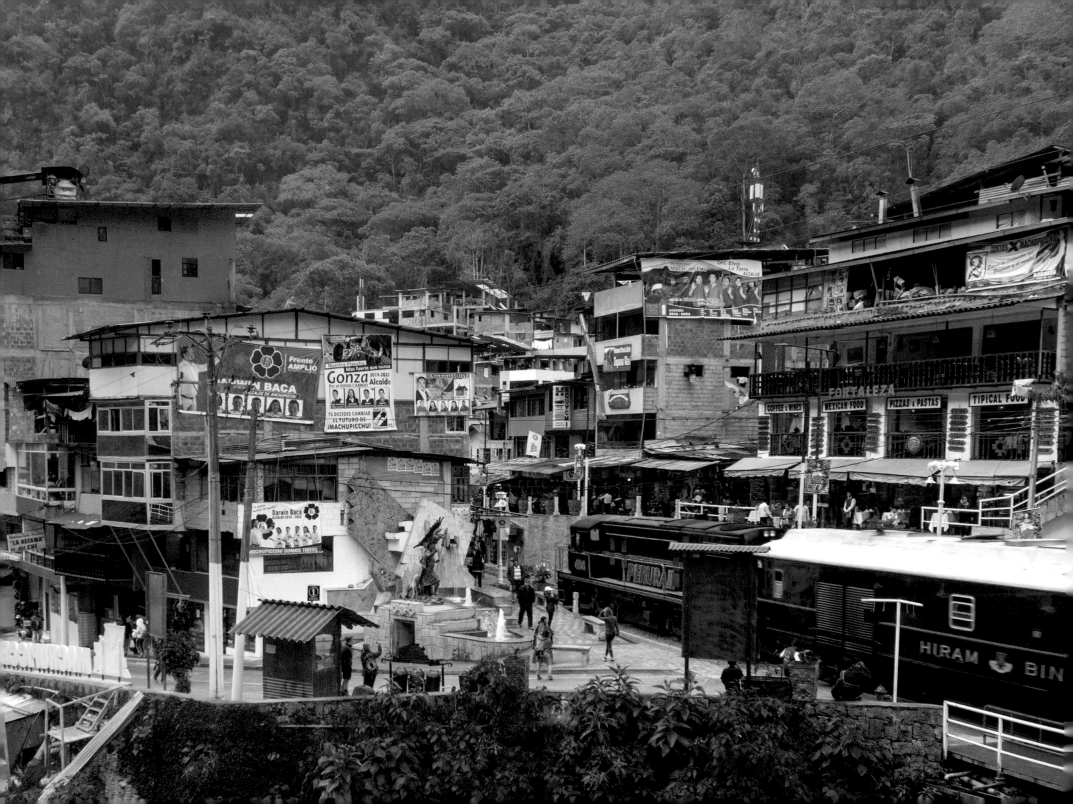

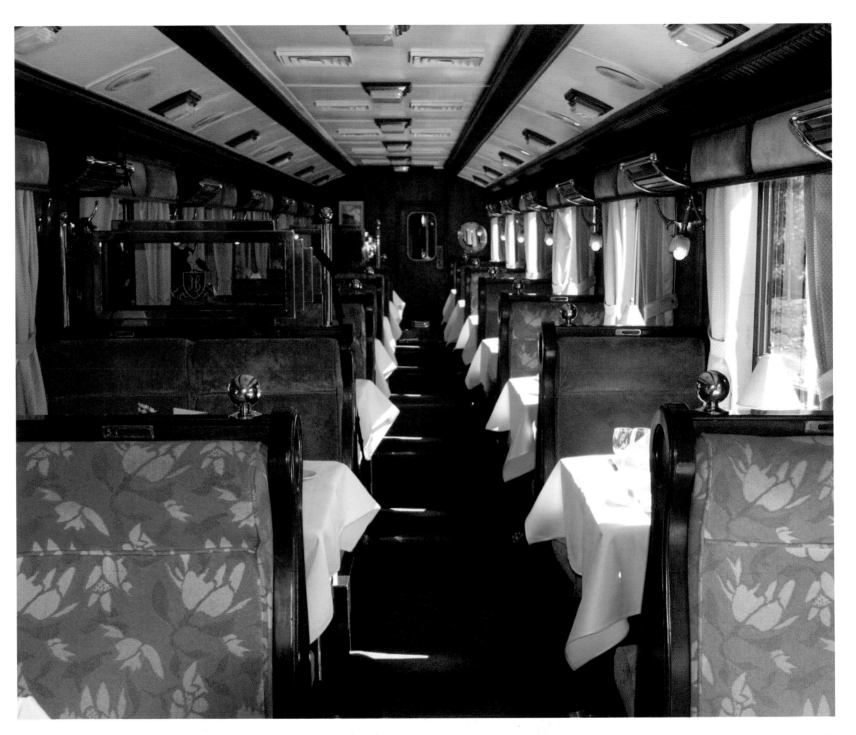

OPPOSITE:

**Aguas Calientes, Urubamba
Province, Peru**

Named for the 'discoverer'
of Machu Picchu, the 'Hiram
Bingham' is the luxury service
on the Cuzco-Macchu route,
with Pullman-style passenger
cars and dining facilities.
Movement of trains through
the village is a routine sight
for the inhabitants.

RIGHT:

**On board the 'Hiram
Bingham', Cuzco-Machu
Picchu**

Perurail's top class train
offers fine dining, live music
and even dancing, as well
as skylight windows for
mountain views and an open
observation car deck.

OVERLEAF:

**The Serra Verde Express,
Curitiba, Brazil**

Expensive fabrics, plush
leather, inlaid wood, wall
lights and framed pictures
give a classic 'club-car'
atmosphere to this carriage
on the Serra Verde express
– a vivid contrast to the
wild nature of the landscape
traversed by the train.

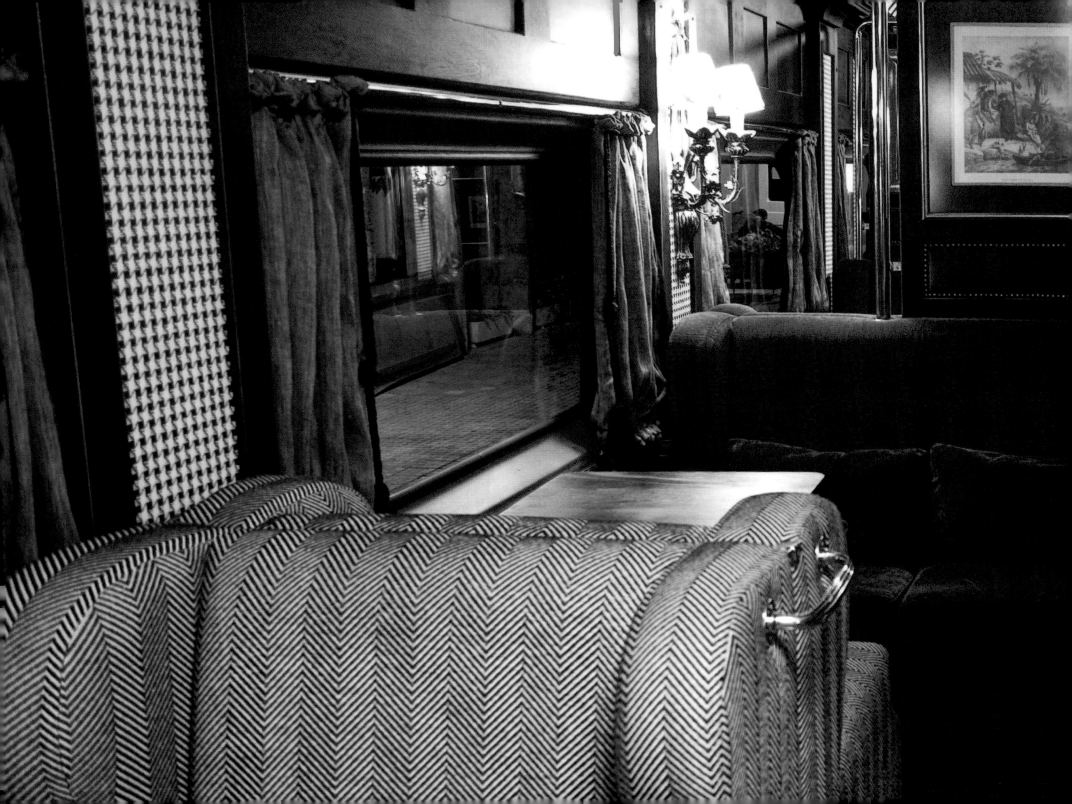

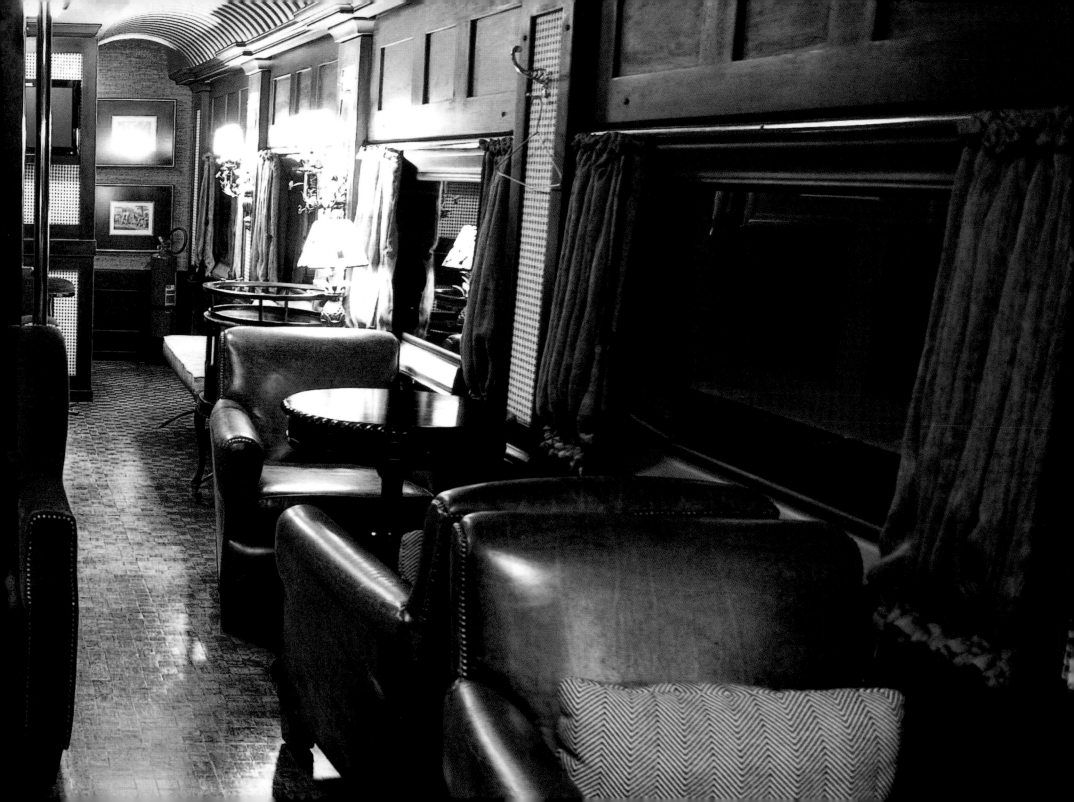

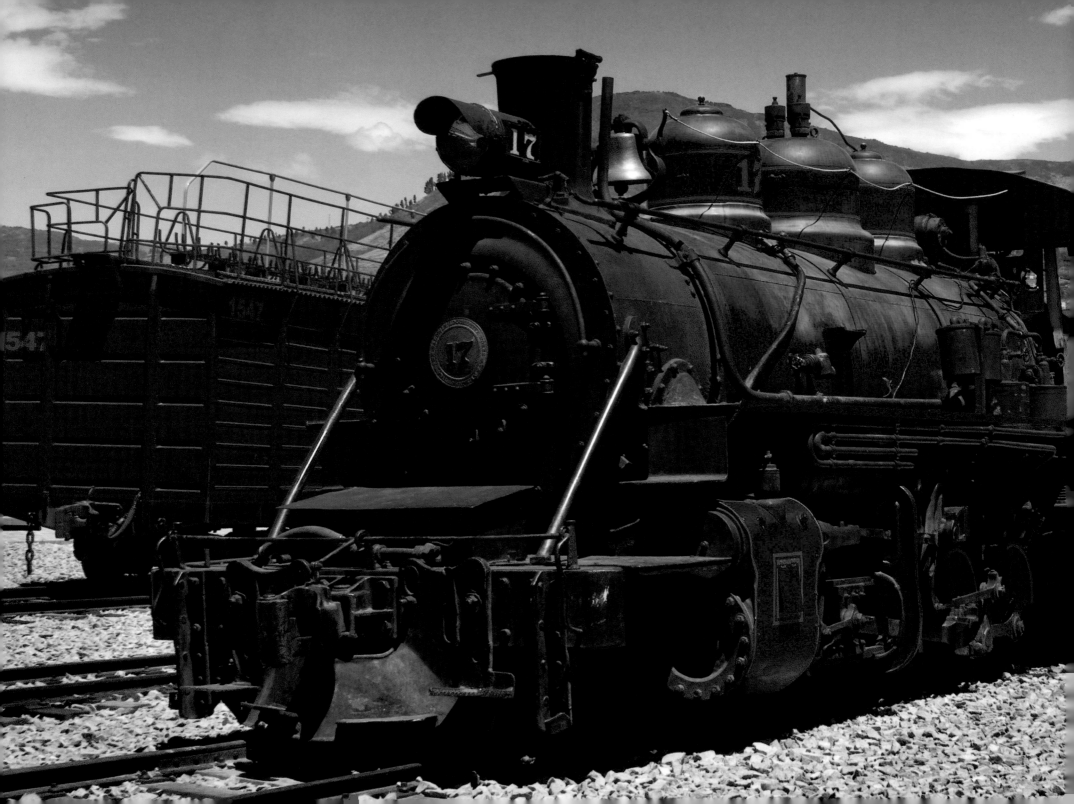

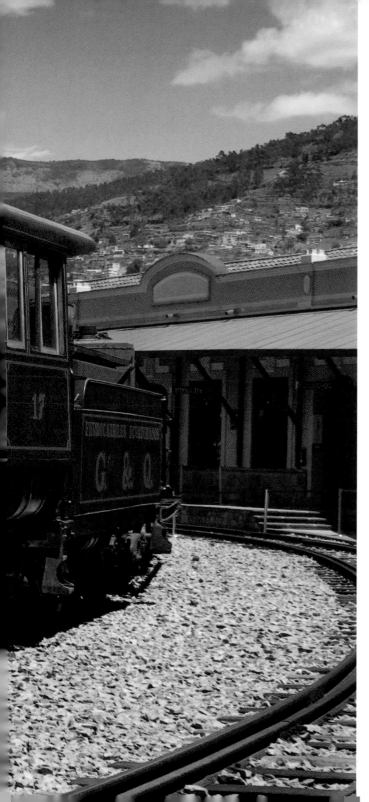

LEFT:
Guayaquil & Quito Railway, Ecuador
Built by Baldwin Locomotive Works (BLW) in Philadelphia in 1935, 2-8-0 locomotive No. 17 is part of the fleet of vintage engines operating cruise trains on the magnificently scenic line between the port city of Guayaquil and the capital, Quito, 9350ft (2850m) above sea level.

RIGHT:
Guayaquil & Quito Railway, Ecuador
Each of the restored carriages on Tren Ecuador's heritage services is designed in a different style. Here the mode is 'neoclassical of the Ecuadorian republican period'.

OVERLEAF:
Nariz del Diablo, Guayaquil & Quito Railway, Ecuador
The 'Devil's Nose' is a double switchback on the line, where the train reverses direction twice in order to gain height on a precipitous slope. Special runs to negotiate this spectacular feature are made from Alausí station.

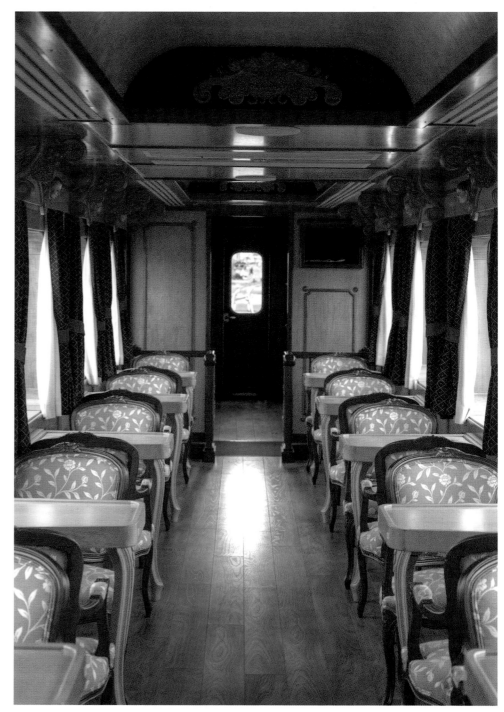

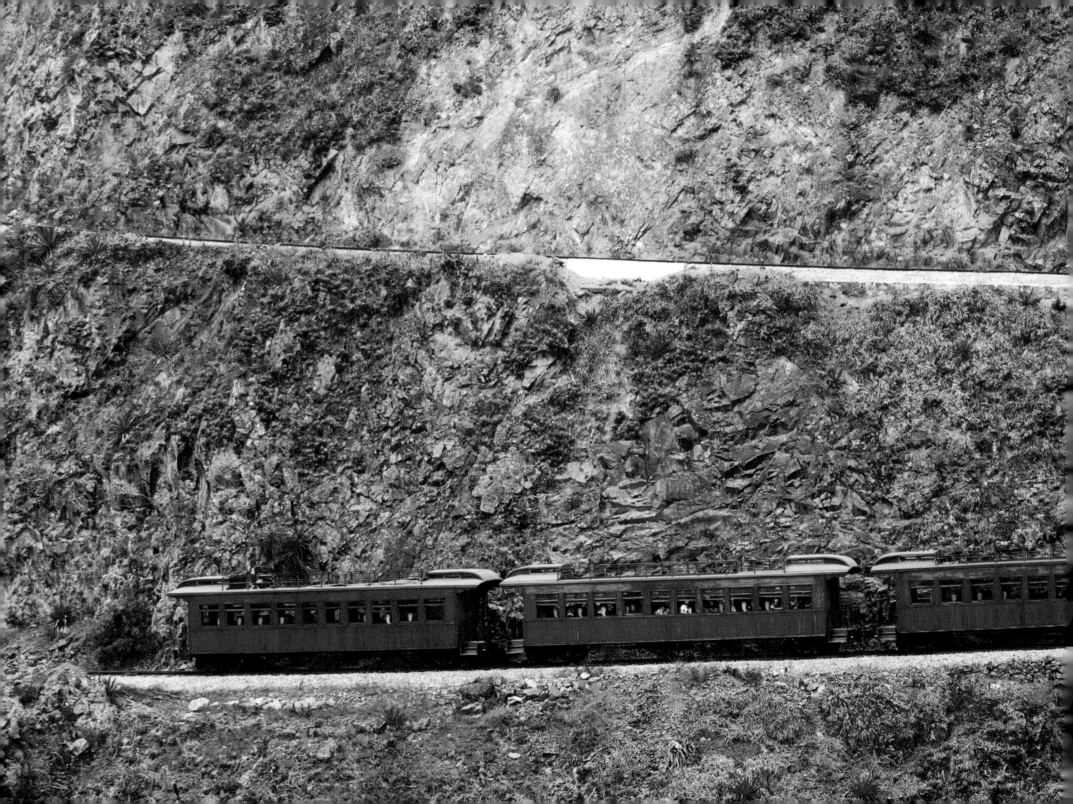

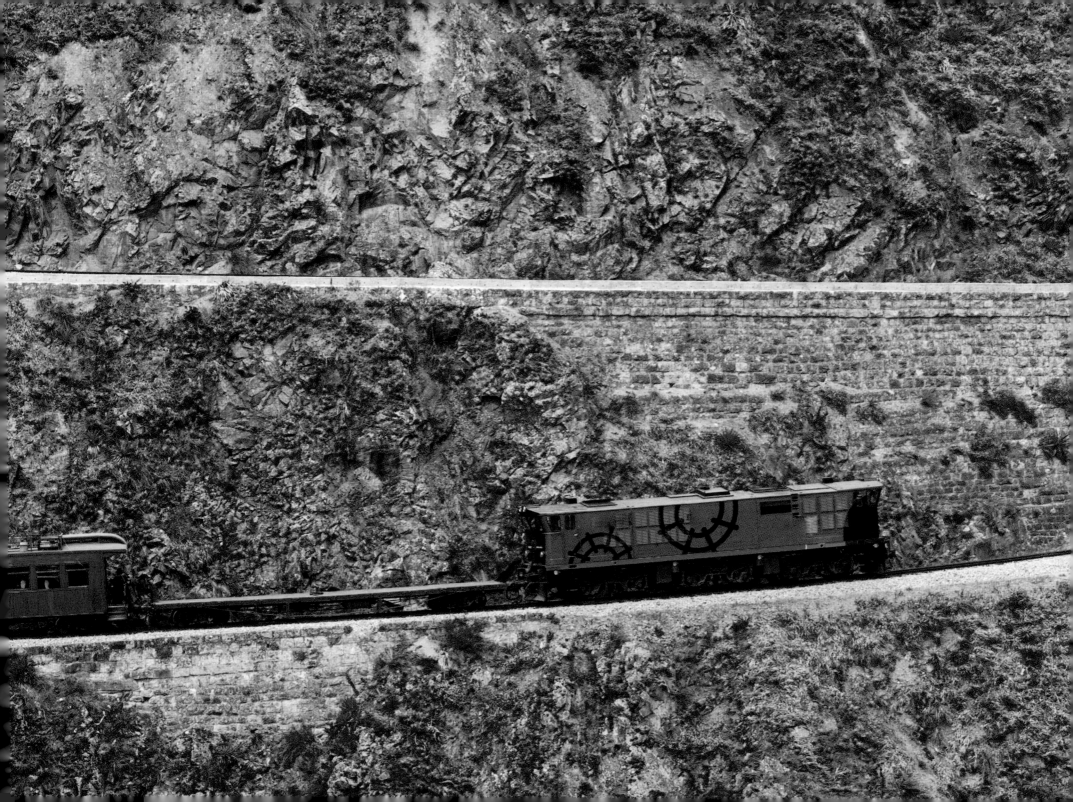

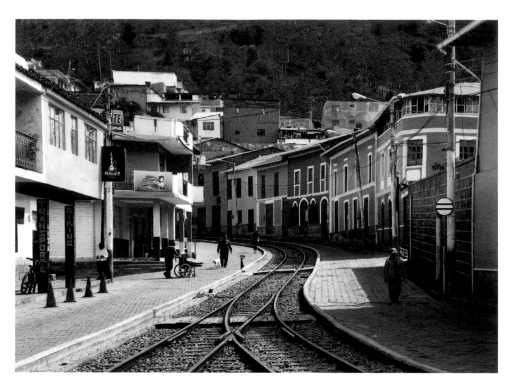

ALAUSÍ

ALTITUD	—	2.340 METROS
DISTANCIA A QUITO	45	DISTANCIA A DURÁN
303 km.		143 km.

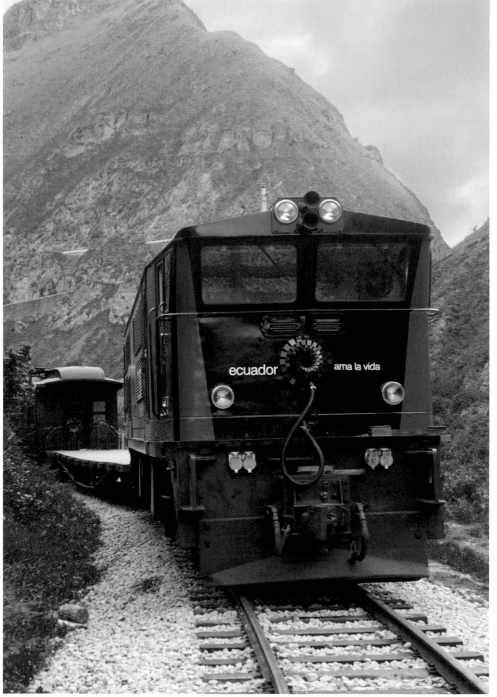

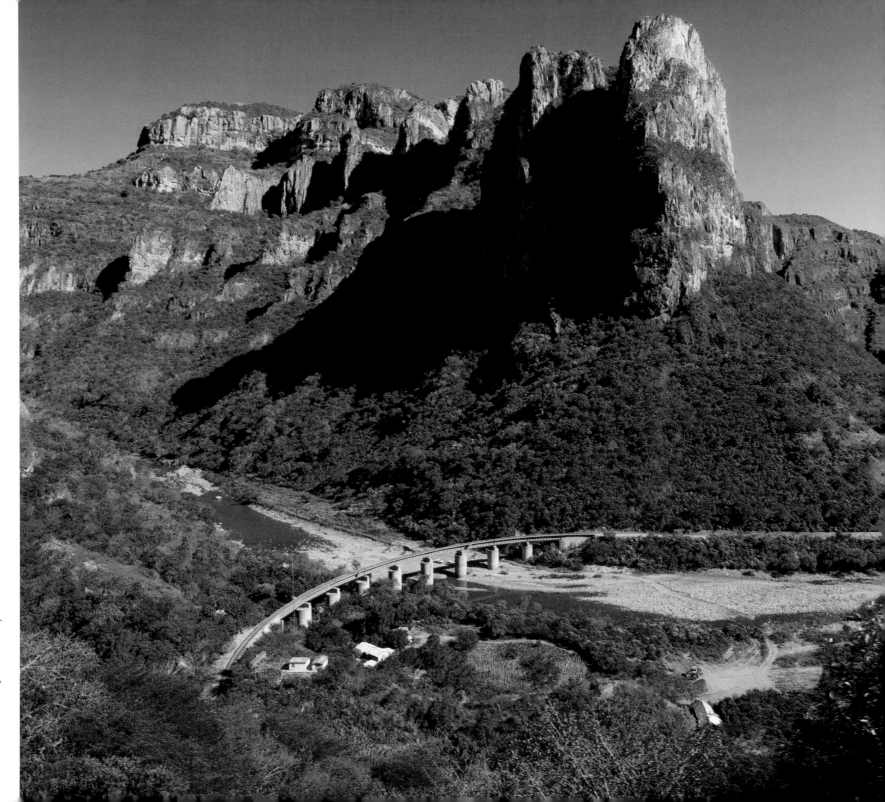

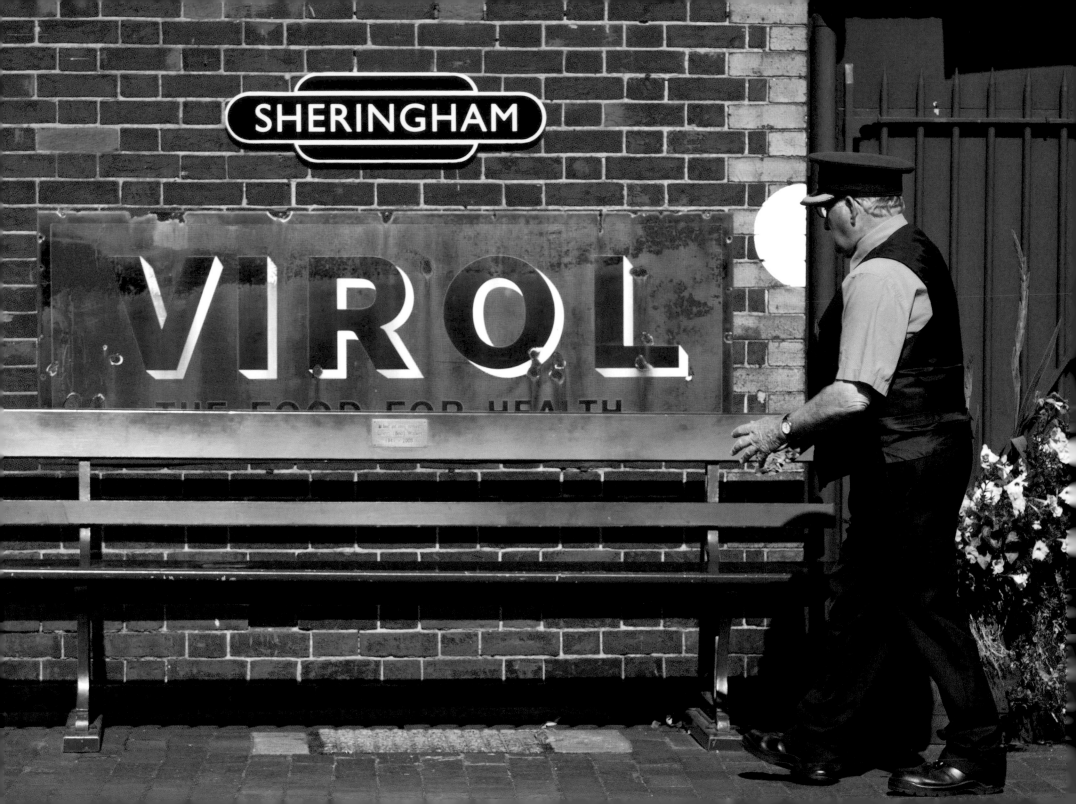

Europe

Europe has the densest and most varied network of railways of any continent. The standard European gauge of 1422mm (56.5 inches), established in England by George Stephenson, has become a world norm for main-line railways. As a result it was much easier to set up an international network in which trains could cross borders. Only in a few cases, such as Spain, did a different gauge prevail, requiring a complicated wheel-change system at border stations or a change of train, usually in the middle of the night, which nobody wanted.

Many nations contributed to the development of the modern railway. Hungary was a pioneer in electrification, as was Italy. France was the first European country to build dedicated high-speed lines. A Belgian, Georges Nagelmackers, founded the business which later became the International Sleeping Car Company. It can be fairly claimed that he is the godfather of the numerous luxury trains described in this book, but more importantly, his company made it easy to arrange travel right across the continent, from the Hook of Holland to Rome, or from Paris through Vienna and Belgrade to Istanbul. Great advances have been made in recent years in standardizing electricity supply, signalling and safety systems so that trains can pass from one country to the next. The Eurail Pass is a ticket that enables travel via 38 train and ferry companies in 31 countries – only privately-run 'heritage railways' are excluded, but they offer their own world of historical reconstruction and nostalgic travel.

OPPOSITE:

Sheringham Station, Norfolk, England
A preserved station on the heritage North Norfolk Railway, known as the 'Poppy Line'. From April to October the line runs steam trains along part of the one-time Midland & Great Northern Railway between Sheringham and Holt.

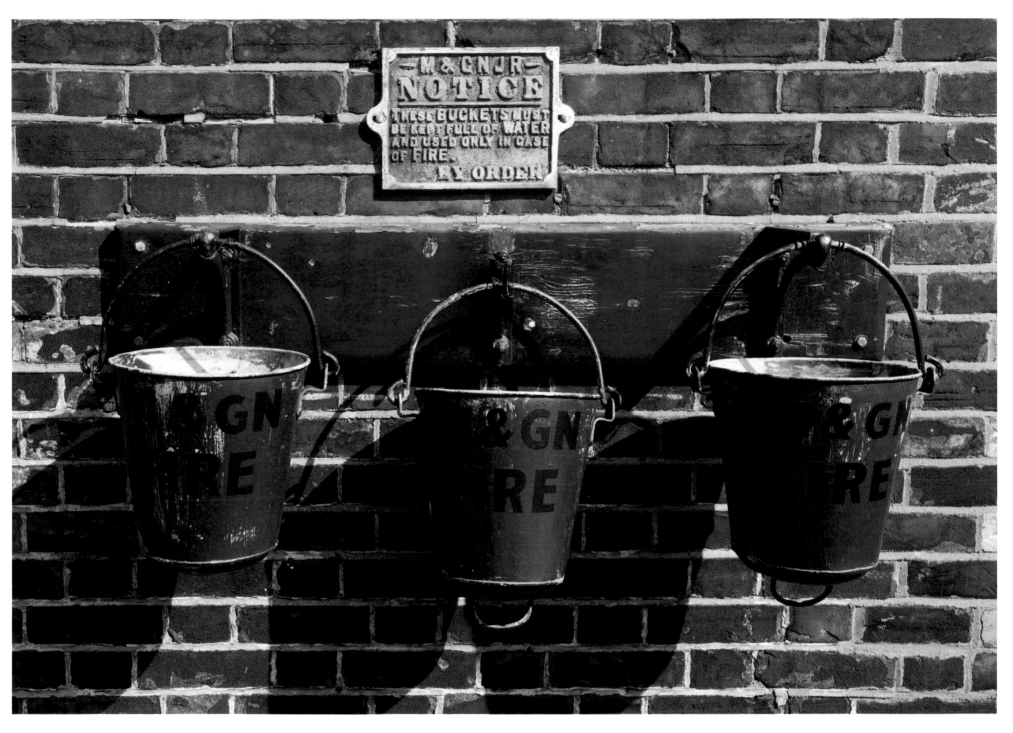

OPPOSITE:

Sheringham Station, Norfolk, England
The Midland & Great Northern Railway's fire precautions. Fires at stations were quite frequent, as many had wooden or part-wooden buildings, heated by coal fires.

BOTTOM LEFT:

County School Station, Norfolk, England
Built in 1886 to serve a school, this rural station also served as the junction for a branch line to Wroxham. In 1964 passenger services ended. County School is now owned by the Mid-Norfolk Railway.

RIGHT:

County School Station, Norfolk, England
Old-style advertising on the station building. In the 1880s England had over 100 railway companies, many struggling to make a profit. Selling advertising space brought in useful extra income.

BOTTOM RIGHT:

County School Station, Norfolk, England
The modest building nevertheless shows some attention to architectural detail, with courses of stonework above and below window level, fretwork barge-boards and careful detail on the chimney stacks all giving it character and instantly proclaiming 'railway station' to the informed eye.

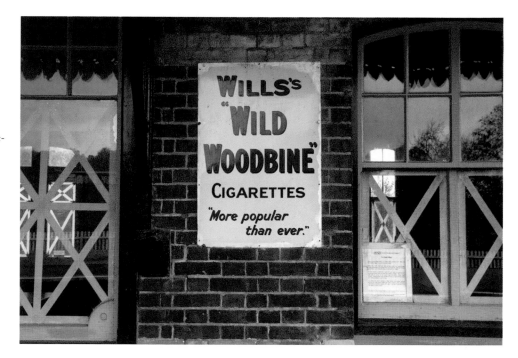

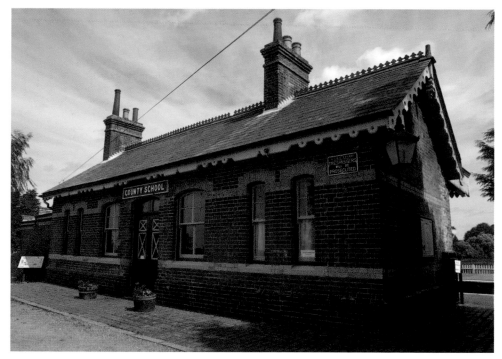

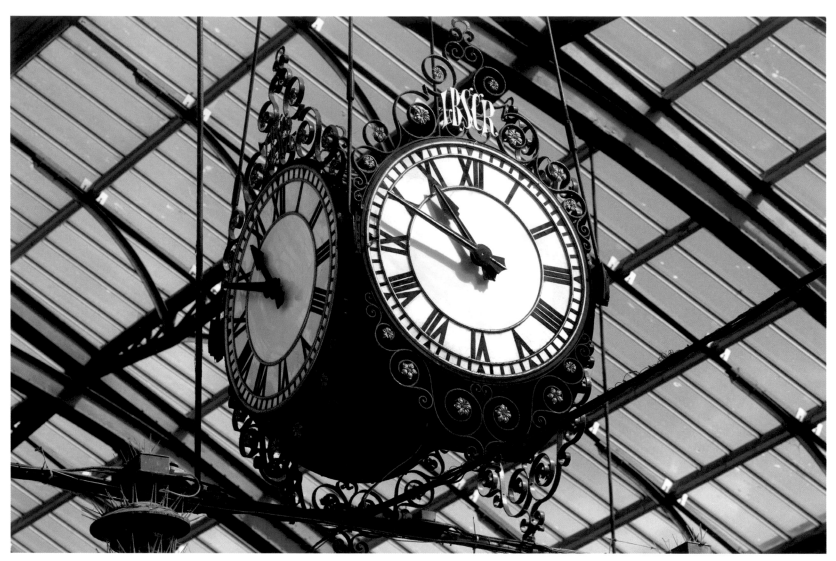
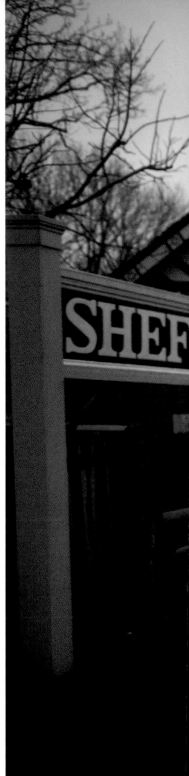

ABOVE:
Brighton Station, Sussex, England
The initials above this four-faced clock at Brighton's railway terminus stand for London, Brighton and South Coast Railway, who installed it some years after absorbing the original builders of the station, the London & Brighton Railway. First opened in 1840, the terminus has been greatly extended and modernized.

OPPOSITE:
Sheffield Park Station, Sussex, England
In the 1950s and 1960s many rural branch lines in England were closed down, often despite local protest. Many have since partially reopened under private auspices. One of the first was the 'Bluebell Line' from Sheffield Park to Horsted Keynes. In 2013 former Southern Railway Class U 2-6-0, No. 1638, headed the first train to East Grinstead since 1958.

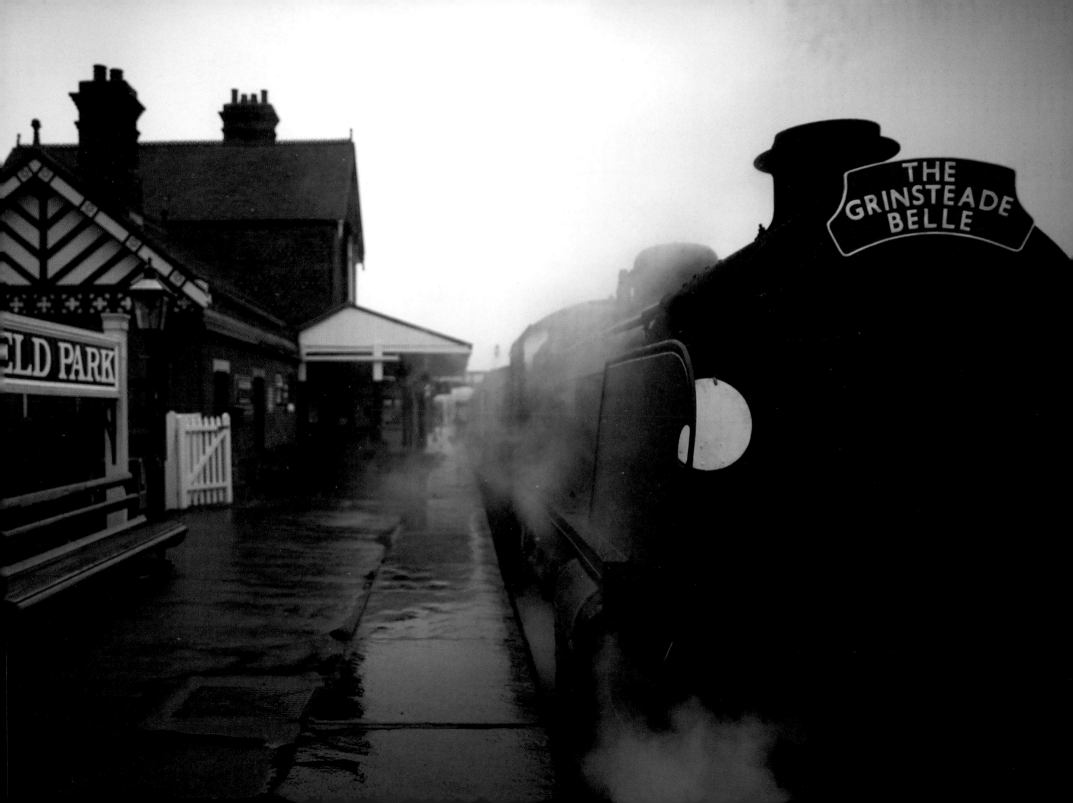

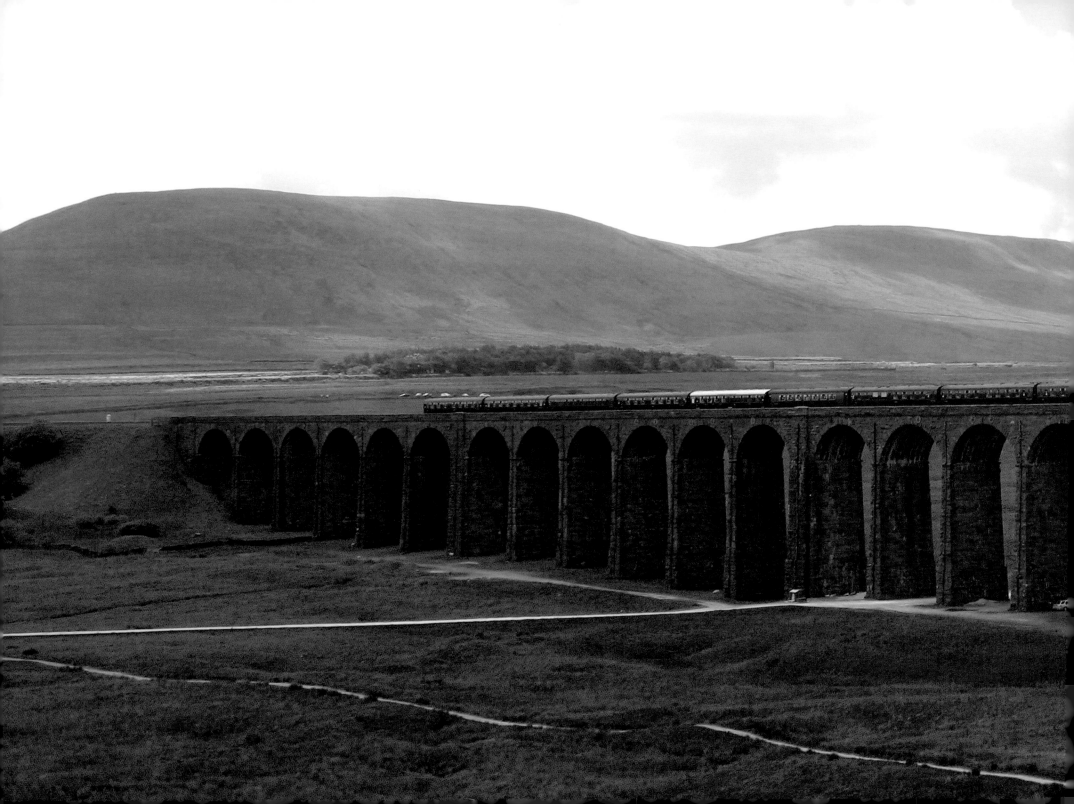

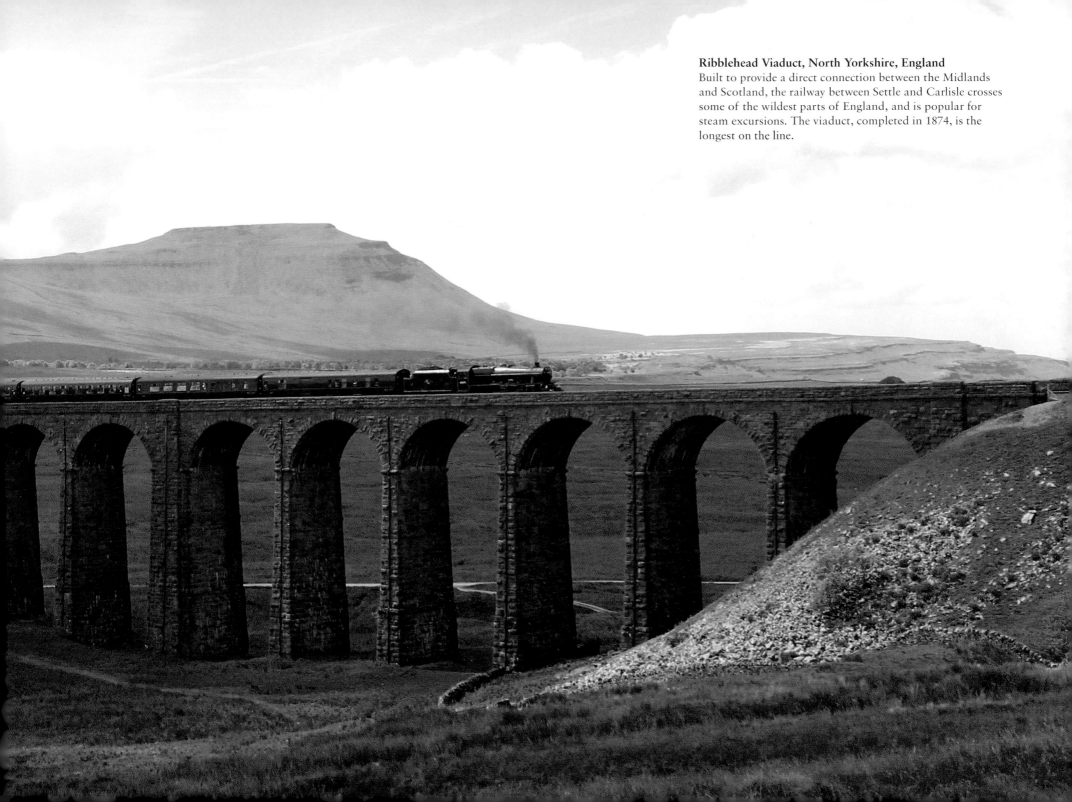

Ribblehead Viaduct, North Yorkshire, England
Built to provide a direct connection between the Midlands and Scotland, the railway between Settle and Carlisle crosses some of the wildest parts of England, and is popular for steam excursions. The viaduct, completed in 1874, is the longest on the line.

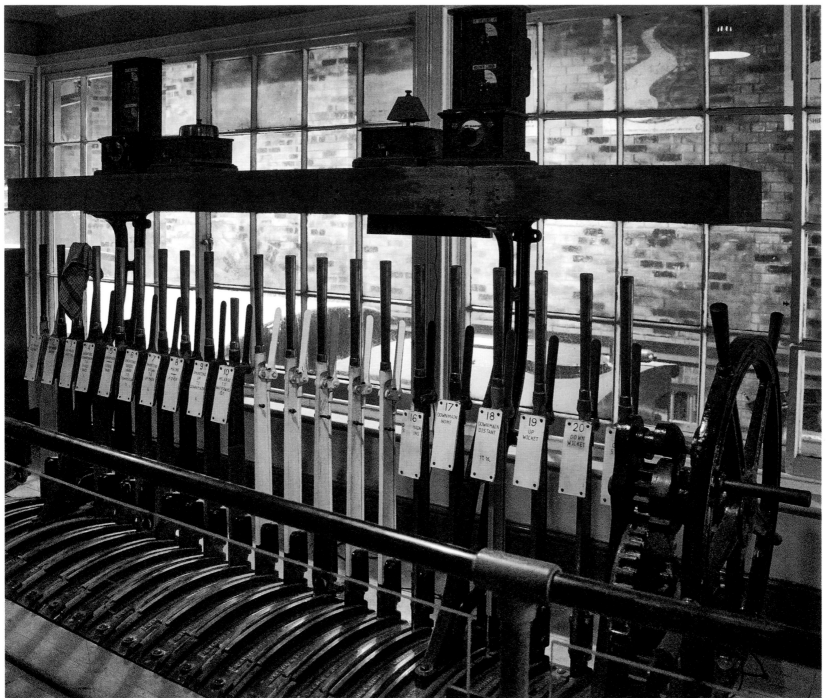

LEFT:

Kingston upon Hull, East Yorkshire, England
Railway signal cabins held racks of levers to switch rail points and operate signals. A large station cabin might have a hundred or more. This set is preserved in Hull's Street Life Museum of Transport.

OPPOSITE:

Bewdley Station, Worcestershire, England
Bewdley is on the Severn Valley Railway, a heritage line that opened in 1984 and has expanded considerably since then. The signals are the traditional semaphore type: this one's arm is of unusual design. Below it is a mechanically operated direction indicator for train drivers.

OPPOSITE FAR RIGHT:

Consall Station, Staffordshire, England
The Churnet Valley Railway runs trains on a 17.6km (11-mile) section of the former branch from a junction at North Road in Cheshire to the town of Uttoxeter in Staffordshire. The train is hauled by a former Great Western Railway 2-8-0 tank engine, built in 1920.

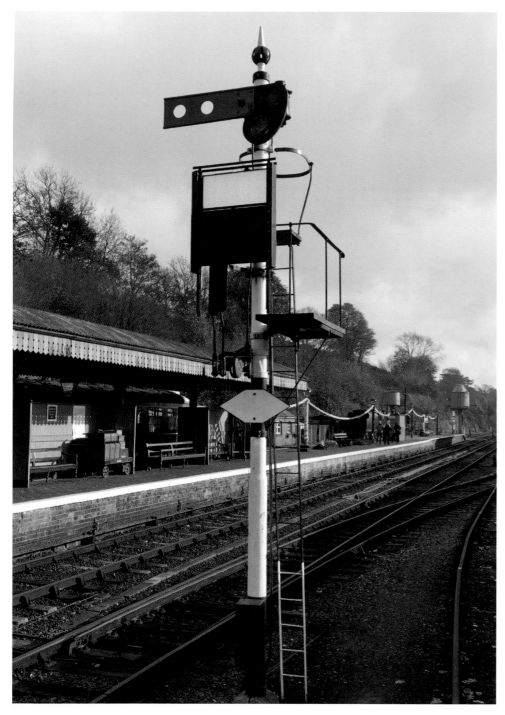

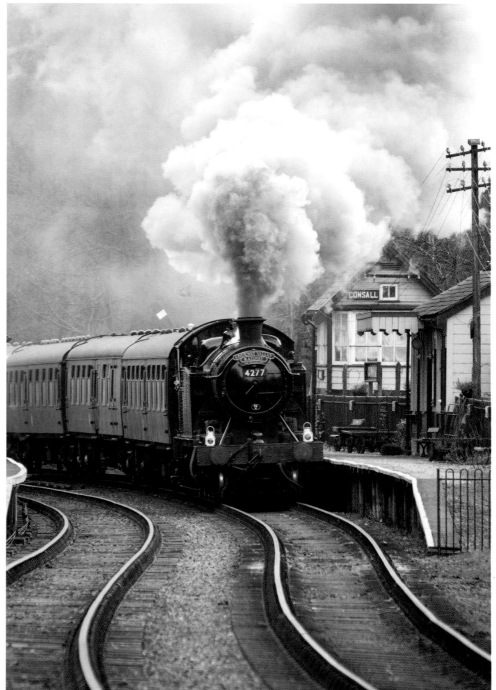

RIGHT:

Lime Street Station, Liverpool, England

Terminus of the first inter-city line, the Liverpool & Manchester, from 1836, Lime Street remains Liverpool's main terminal, though greatly changed since George Stephenson's day. Managed by Network Rail, it underwent a £140 million refurbishment in 2017–18.

OVERLEAF:

Snowdon Mountain Railway, Wales

Since 1896, trains have trundled up and down the highest mountain in England and Wales (1085m/3560ft) on this rack-and-pinion operated railway. Both steam and diesel traction are used. This view shows a train climbing upwards beyond one of the crossing loops on the line.

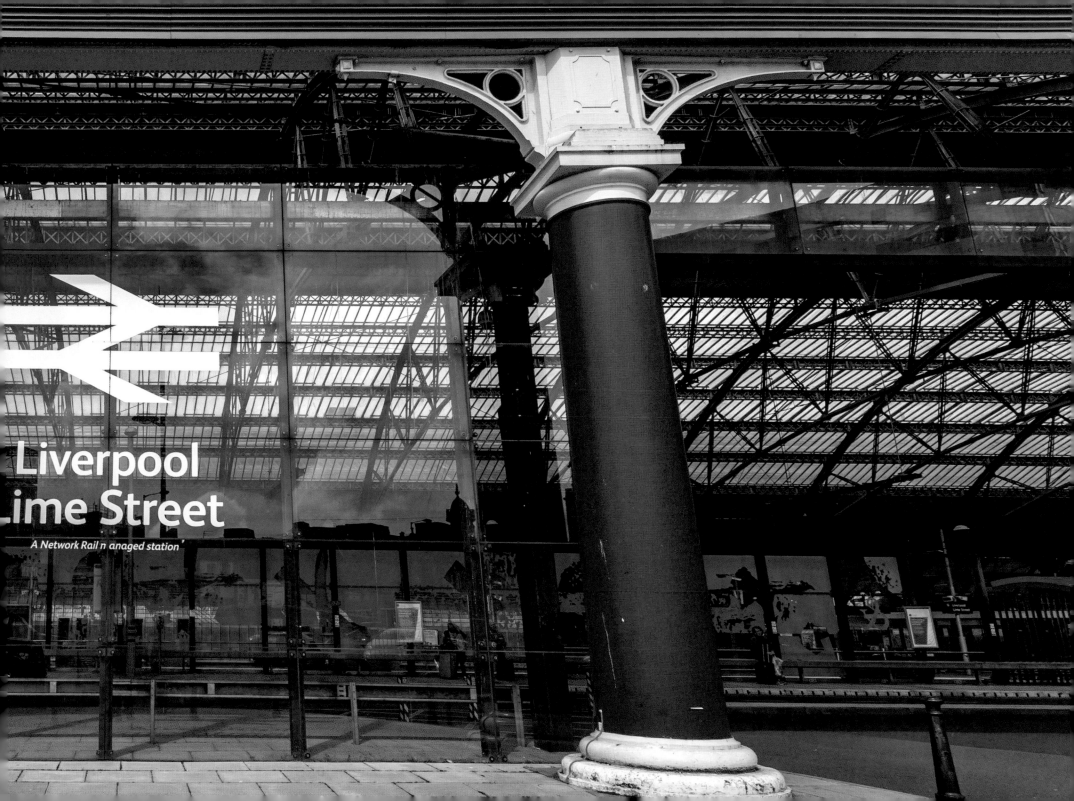

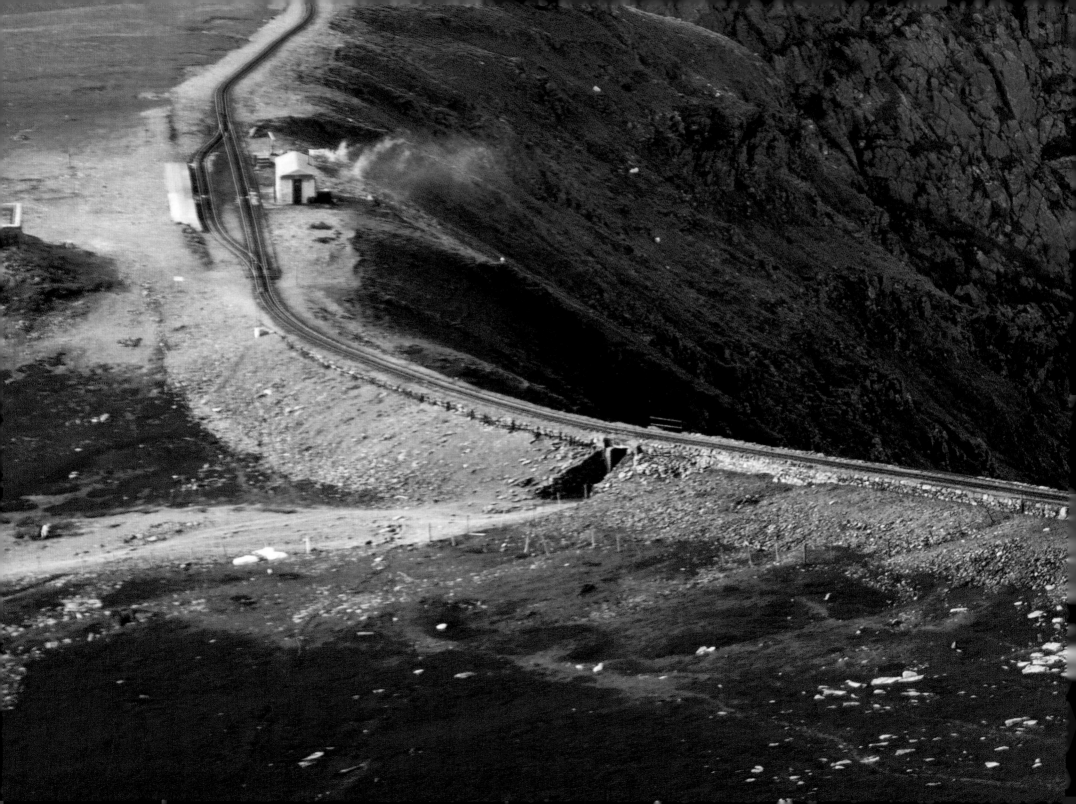

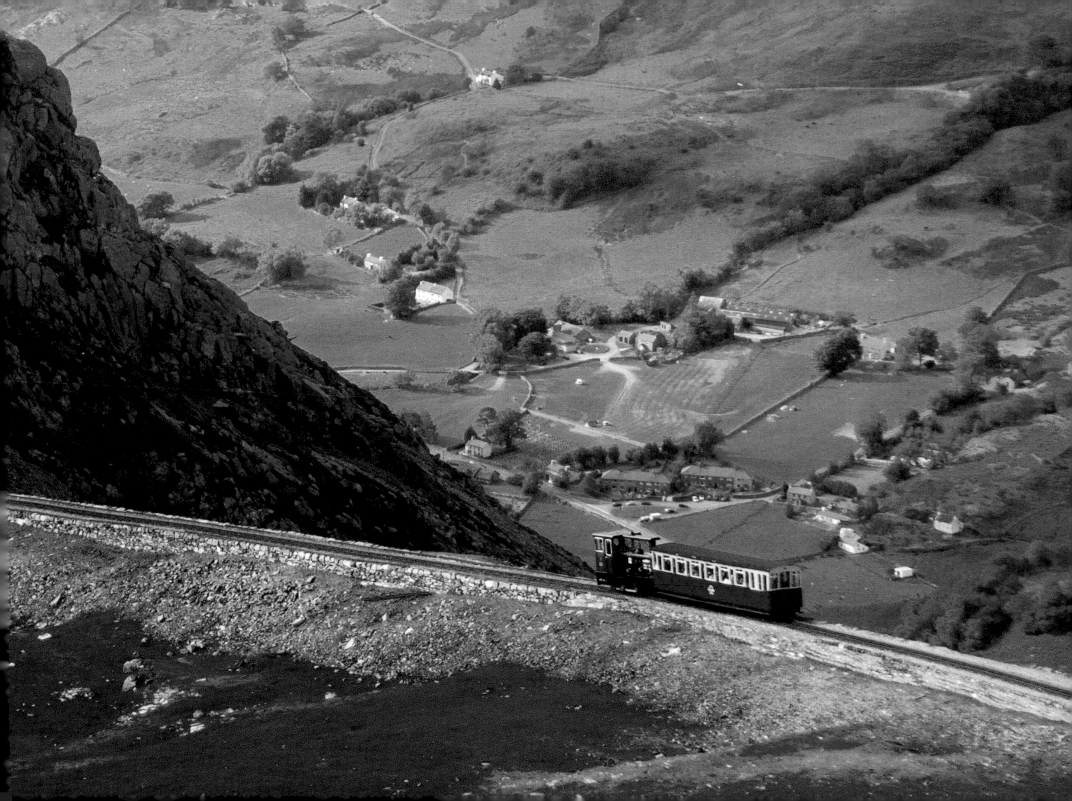

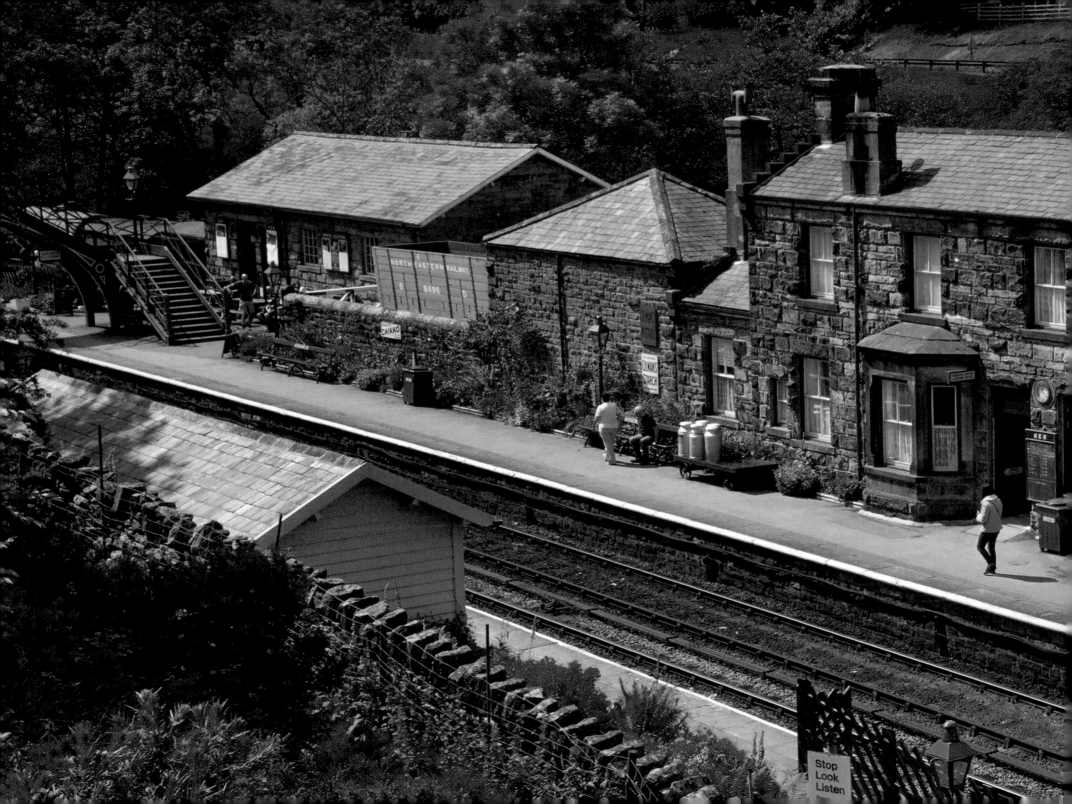

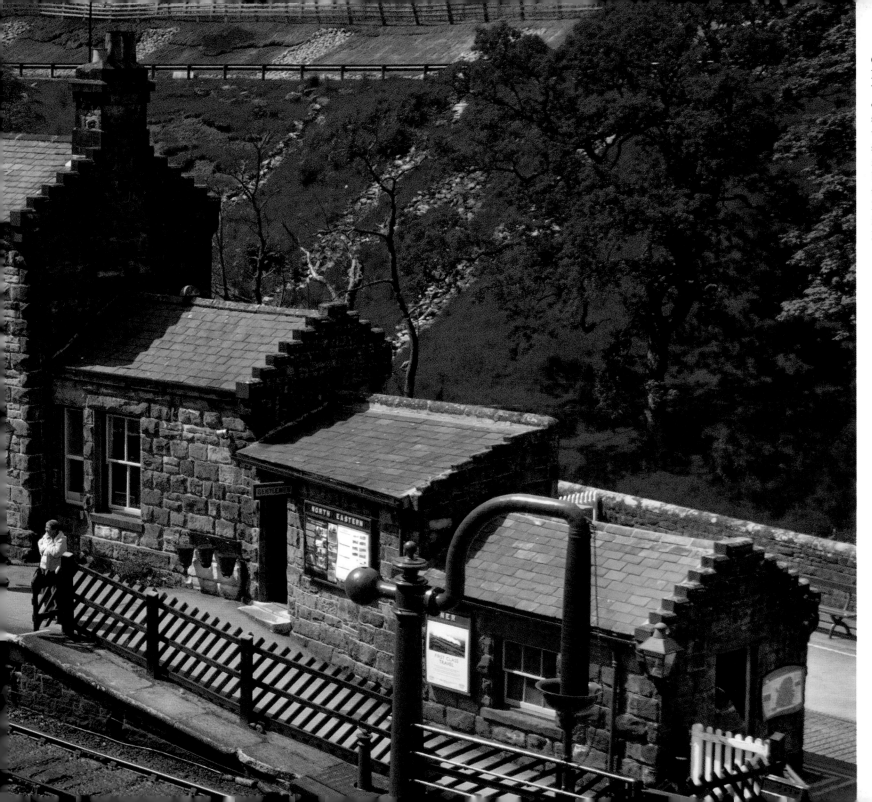

Goathland Station, North Yorkshire, England
The old English railway companies often built stations of local stone, when available, and in the style of their particular region. This station was built in 1865 and is now on the North Yorkshire Moors Railway. Fans of Harry Potter films may recognise it as Hogsmeade Station.

103

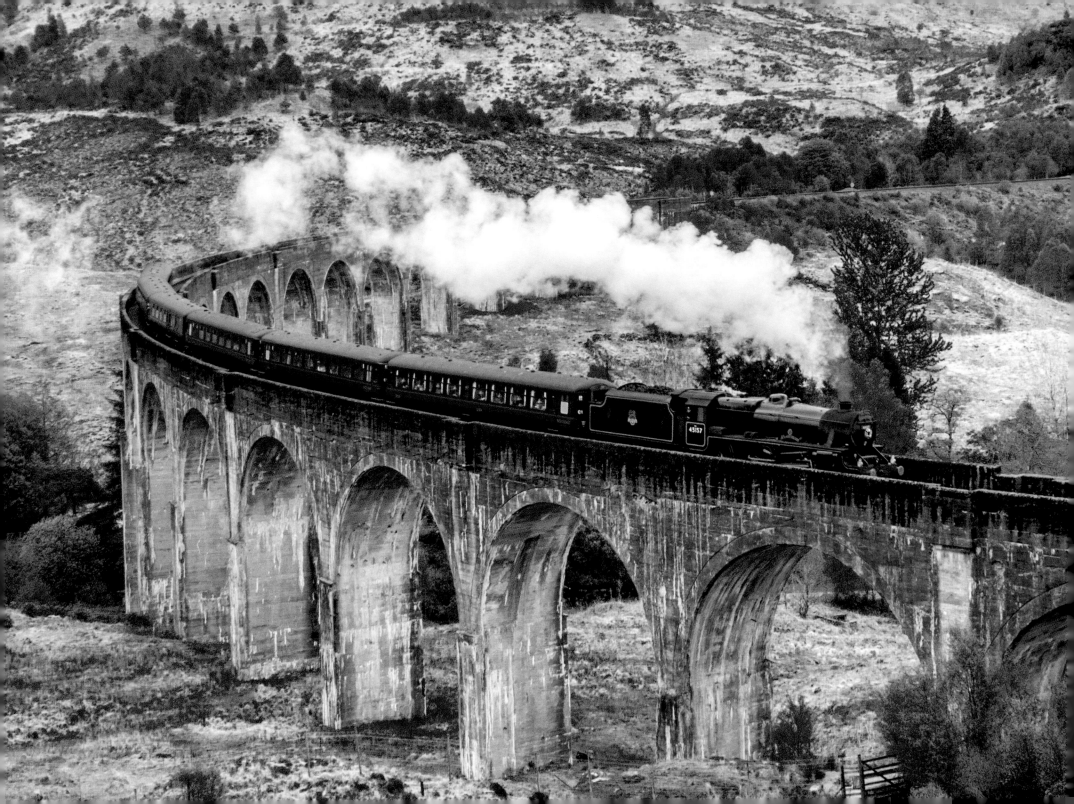

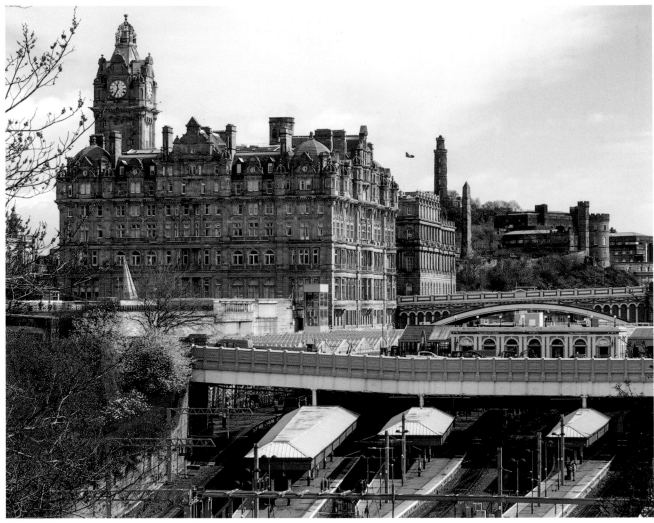

LEFT:

Glenfinnan Viaduct, West Highland Line, Scotland
Regular steam-hauled excursion trains run on the scenic
line between Fort William and Mallaig on the west coast
of Scotland. The curving viaduct, built of mass concrete, is
380m (416yds) long, with a maximum height of 30m (100ft).
The line opened in 1901.

ABOVE:

Waverley Station, Edinburgh, Scotland
Since 1847, Edinburgh's main station has been located in the
heart of the city. Originally known as the General Station, its
name commemorates Sir Walter Scott's 'Waverley Novels'.
The hotel towering above was built by the North British
Railway in 1902.

BELOW:

County Kildare, Ireland
The Railway Preservation Society of Ireland runs a variety of special services in both the Irish Republic and Northern Ireland. Here 2-6-0 engine No. 461 of the former Great Southern Railway, built in 1922, hauls a 'Santa Special' on the Dublin–Maynooth line.

RIGHT:

Dublin–Rosslare Railway, Bray Head, Co. Wicklow, Ireland
Skirting the Irish Sea, the railway track at this point has had to be relocated several times because of cliff erosion since it was laid in 1855. The line is now electrified as far as Greystones, forming part of the Dublin Area Rapid Transit (DART) network.

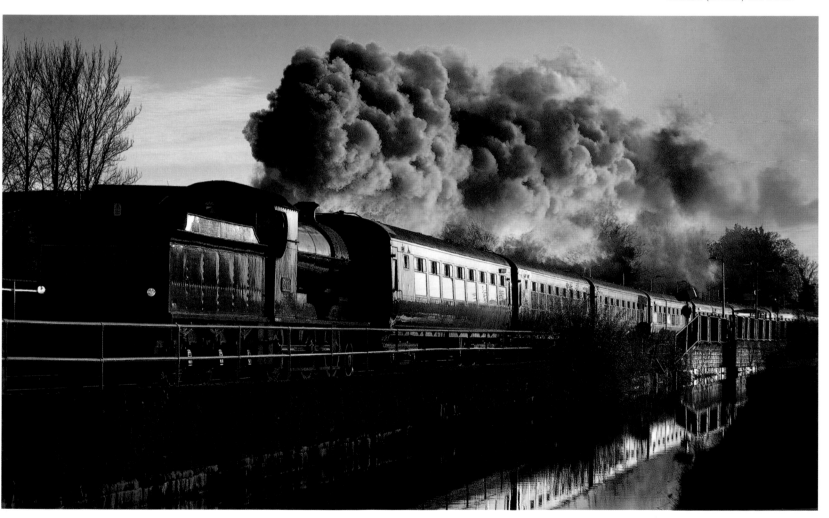

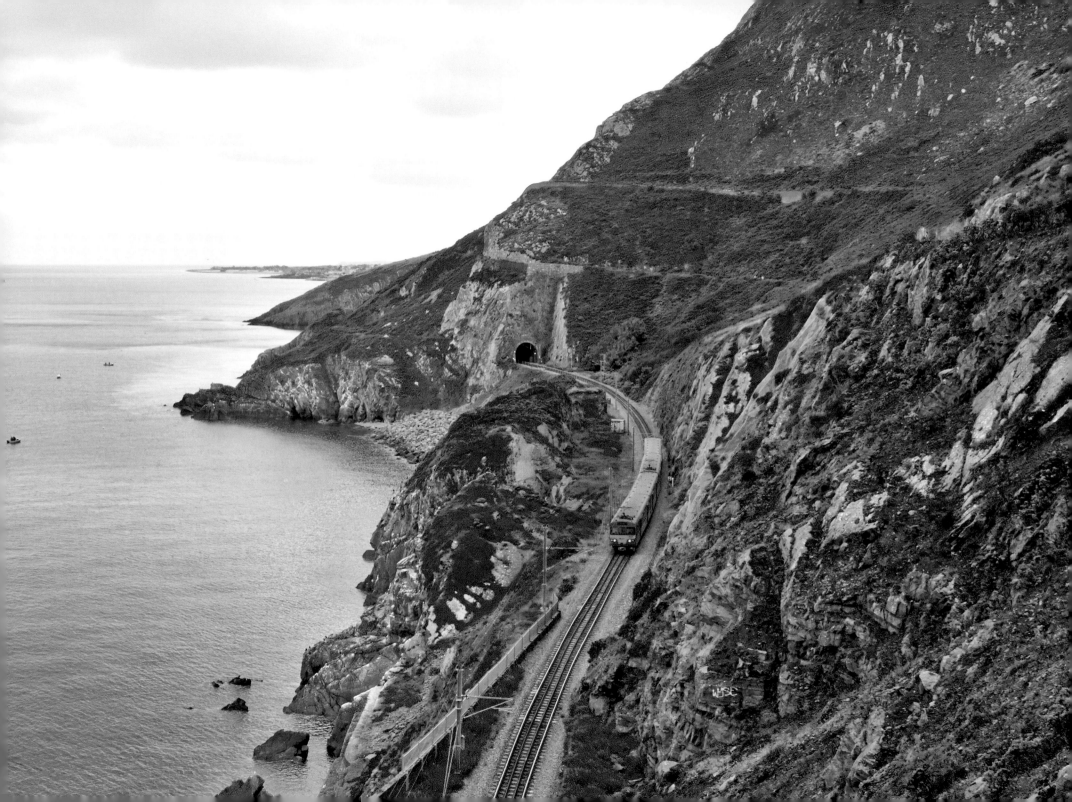

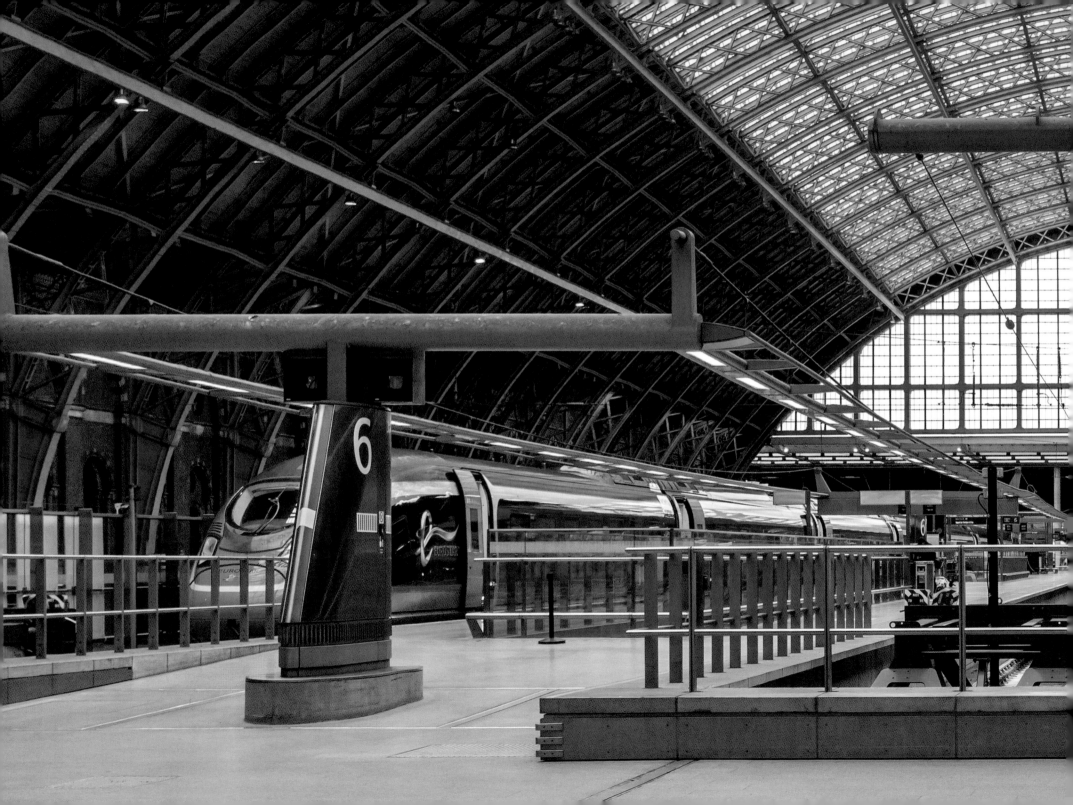

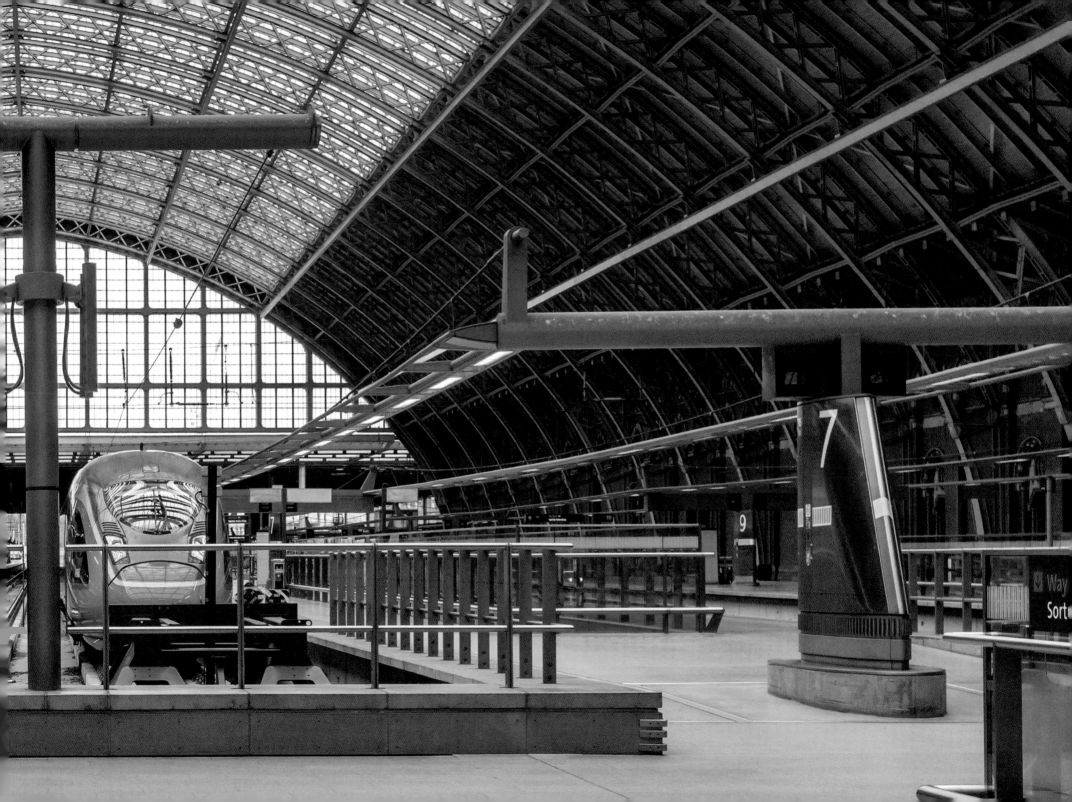

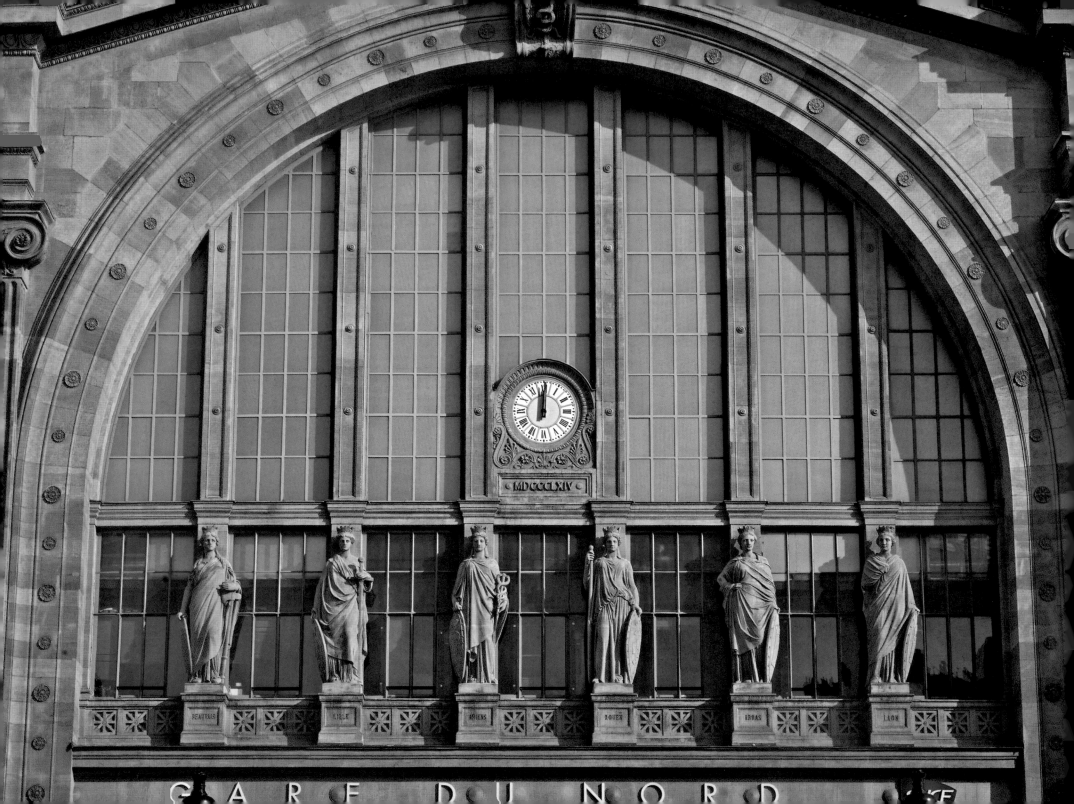

GARE DU NORD

PREVIOUS PAGES:

St Pancras Station, London, England
Eurostar travellers leaving London head briefly northwards before the high-speed line swings east and south. St Pancras was built in 1868 for trains to and from the English Midlands: at that time its great arched roof was the largest single-span building in the world.

OPPOSITE AND BELOW:

Gare du Nord, Paris, France
From 1846 this was the terminus of the the French Nord Railway, and statues representing cities of Northern France decorate its façade. Internally, its 19th century train shed is thoroughly modernised to accommodate international expresses and their passengers.

RIGHT:

Gare du Nord, Paris, France
On the departures indicator, trains to London and Brussels are shown along with internal services to French cities. But the station also has underground platforms for regional and cross-city commuter services, which make it the busiest station in the world outside Japan.

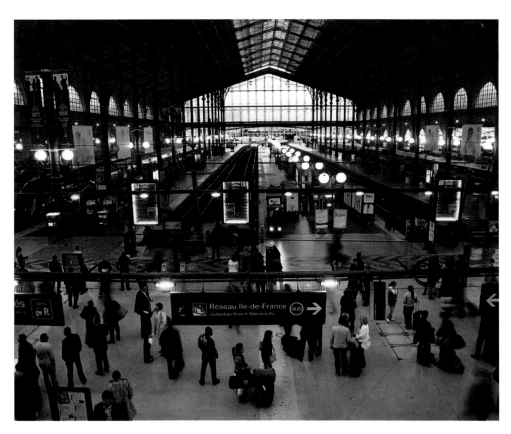

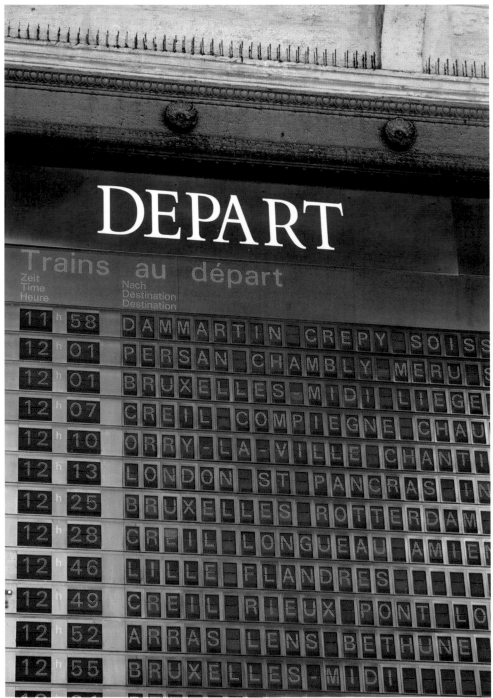

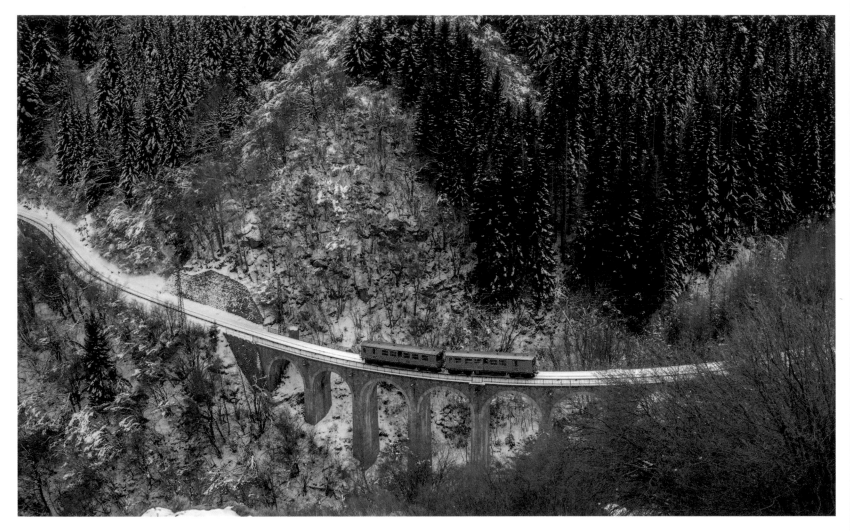

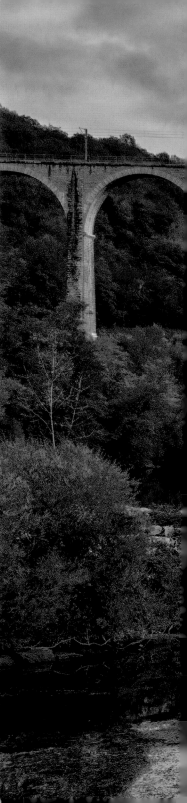

ABOVE:

Le Petit Train Jaune, Mont-Louis, Pyrénées-Orientales, France
First operated in 1909, 'the Little Yellow Train' climbs through the dramatic scenery of the eastern Pyrénées from 427m (1400ft) at its lower terminus at Villefranche-de-Conflent to a summit at Bolquère-Eyne, France's highest railway station, at an altitude of 1593m (5226ft). Running for 62.6km (39 miles) on a single metre (3ft) gauge line, the journey offers passengers views of spectacular mountain passes, historic fortifications and medieval walled towns.

RIGHT:

Cize–Bolozon Viaduct, Ain Gorges, France
The original span built in 1875 was destroyed during World War II. Part of the main line to Paris, a new viaduct (shown here) was prioritised and completed in 1950. Combining both road and rail transport, the viaduct carries traffic at different levels. Motor vehicles occupy the lower level, while a train line sits on the top level.

In 2010 after an extensive upgrade, the line was reopened to offer a fast link between Geneva and Paris using the Train à Grande Vitesse (TGV) high-speed network.

OVERLEAF (BOTH IMAGES):

Central Station, Antwerp, Belgium
A Baroque extravaganza of a station, it has been dubbed 'the railway cathedral' for its use of so many church motifs. Taking 10 years to build, completed in 1905, its marble panelling, pillars and galleries replaced a wooden structure to create a temple to the train.

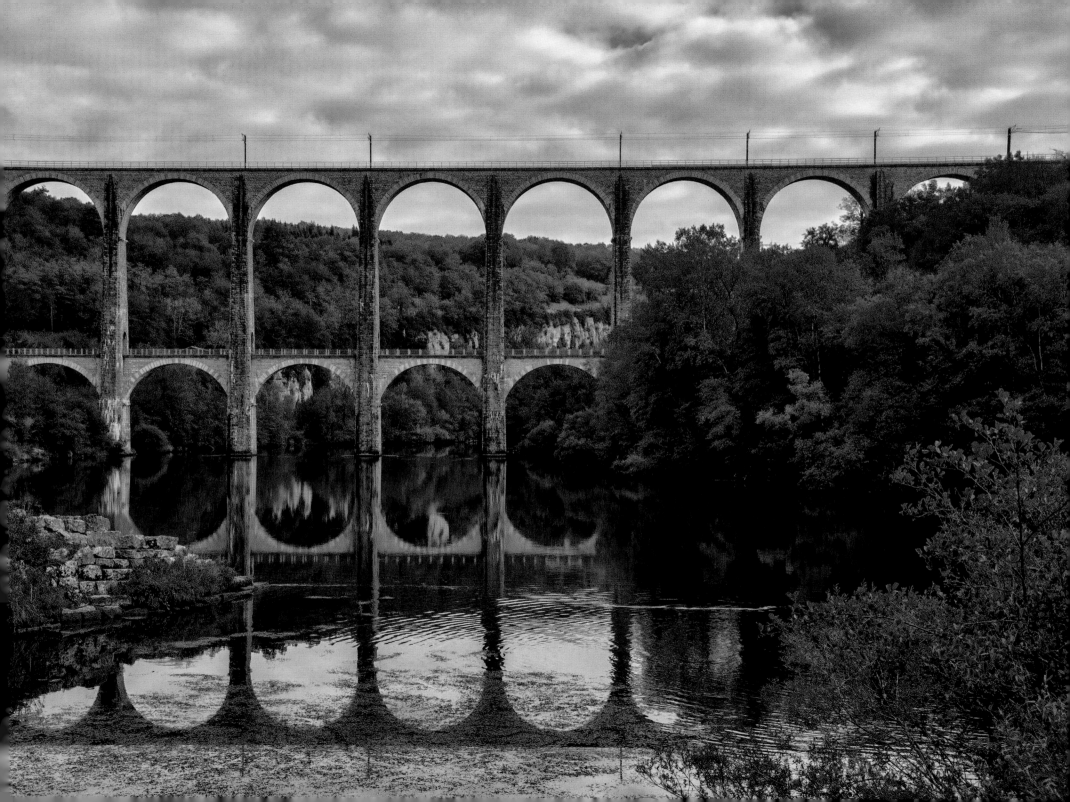

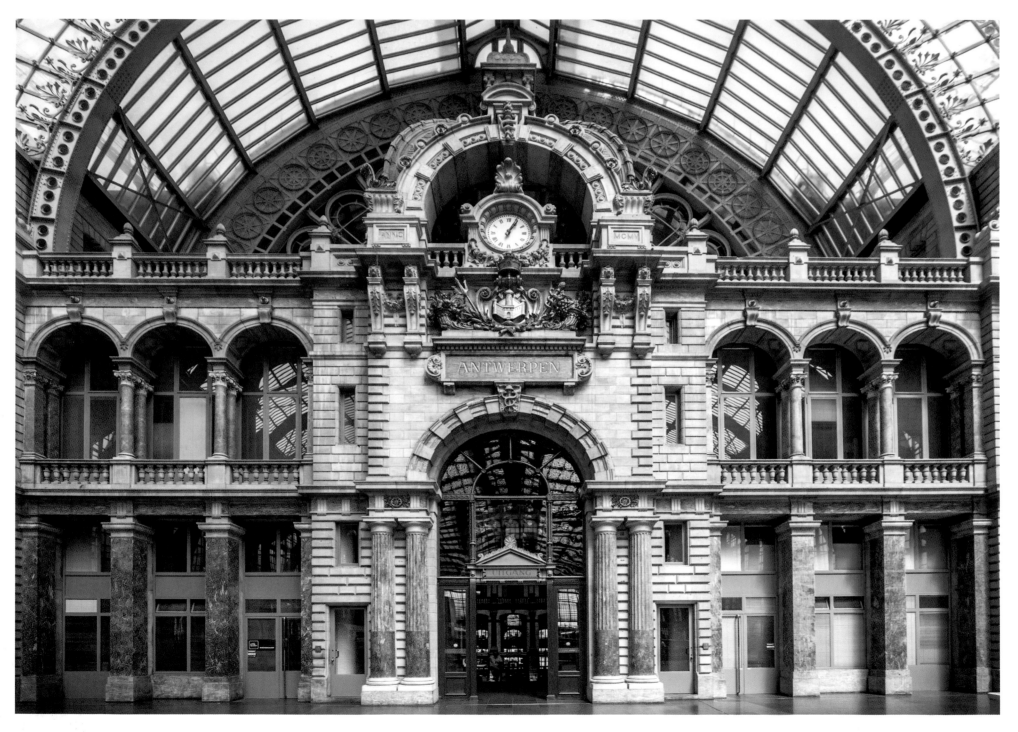

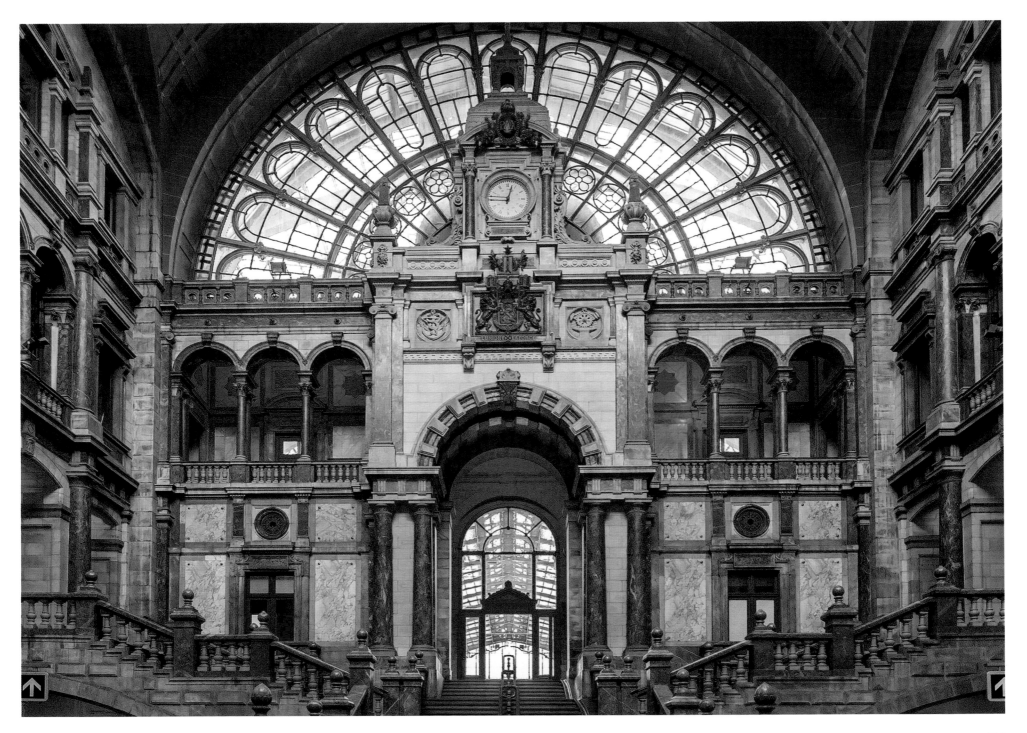

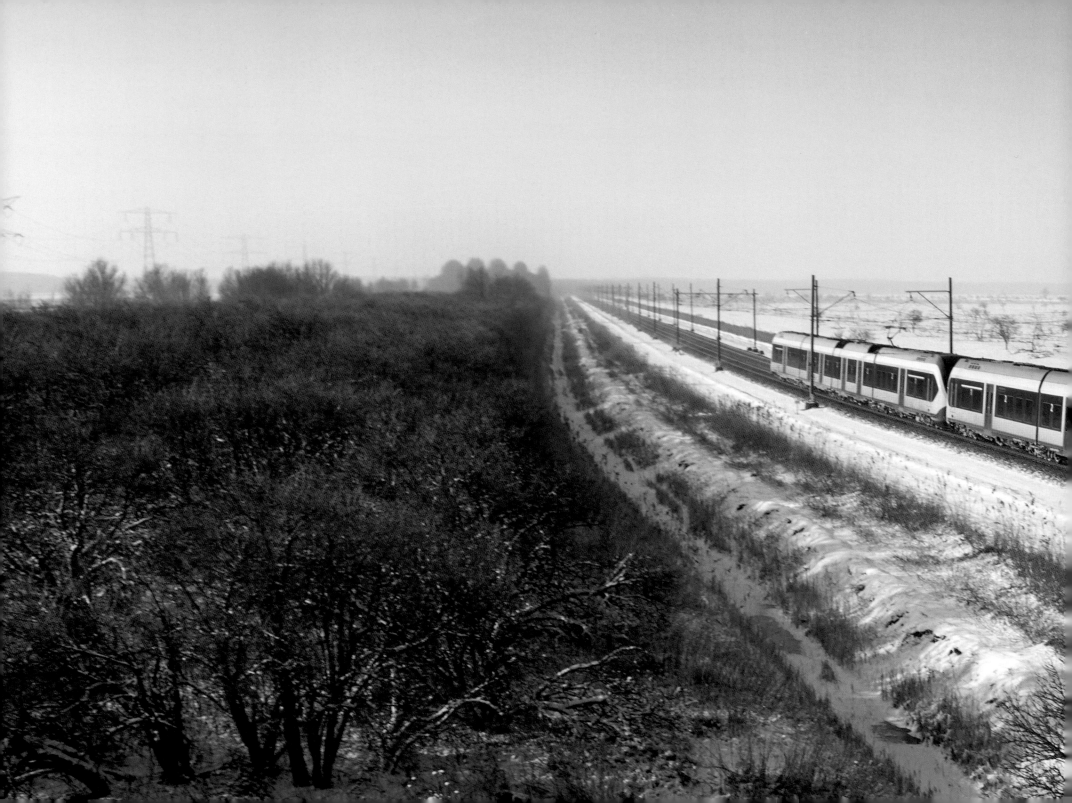

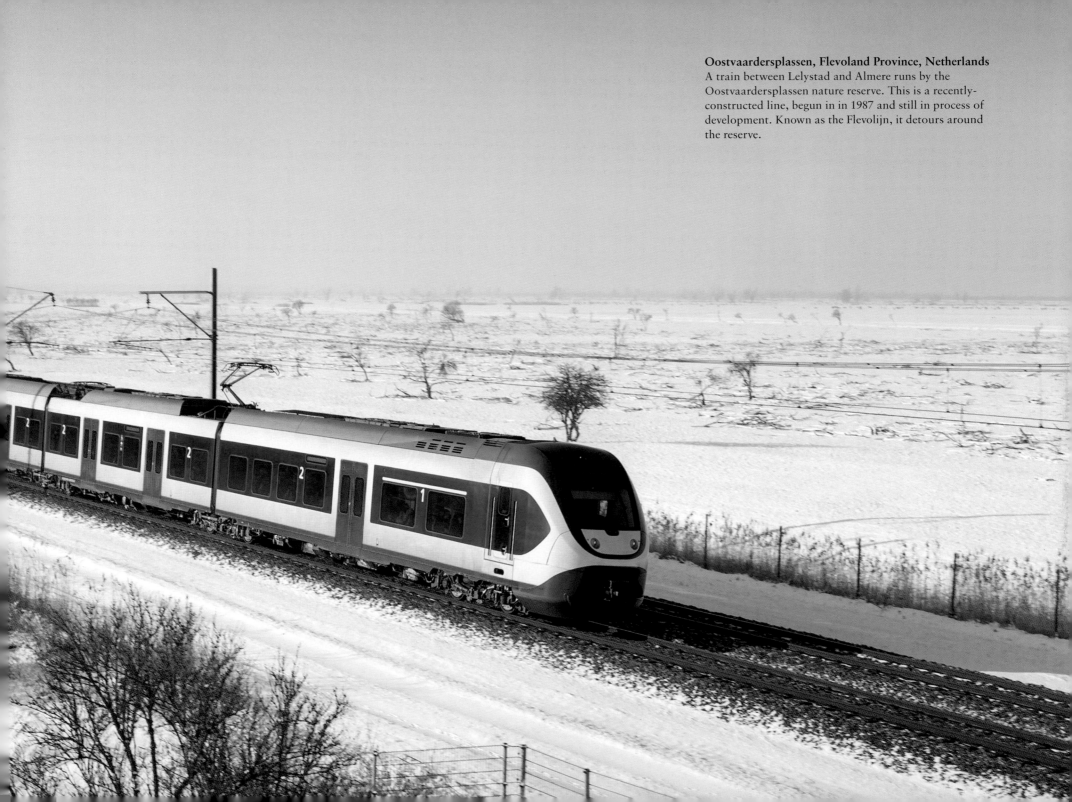

Oostvaardersplassen, Flevoland Province, Netherlands
A train between Lelystad and Almere runs by the Oostvaardersplassen nature reserve. This is a recently-constructed line, begun in in 1987 and still in process of development. Known as the Flevolijn, it detours around the reserve.

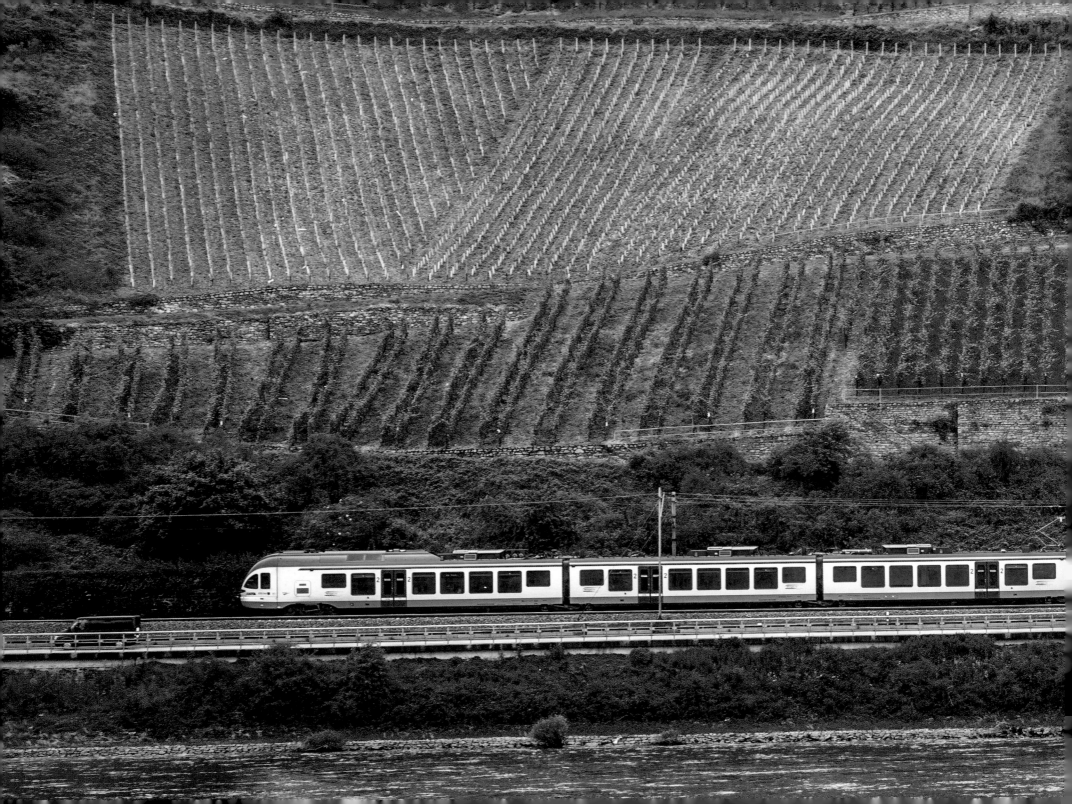

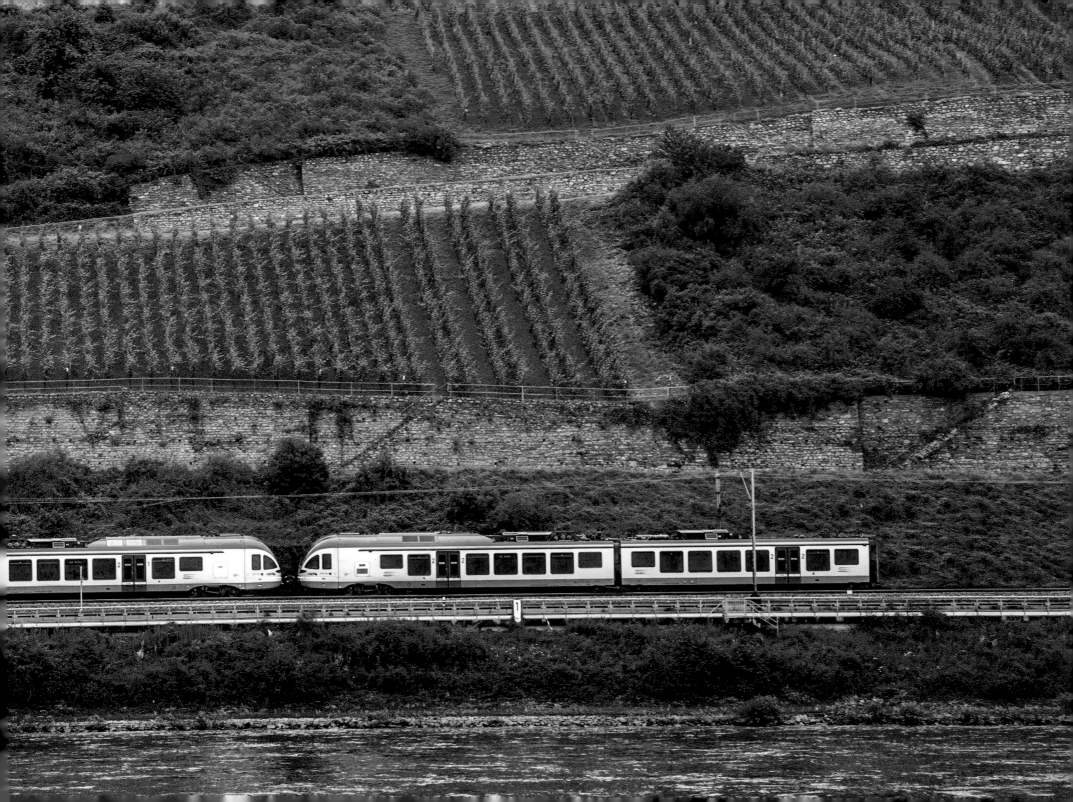

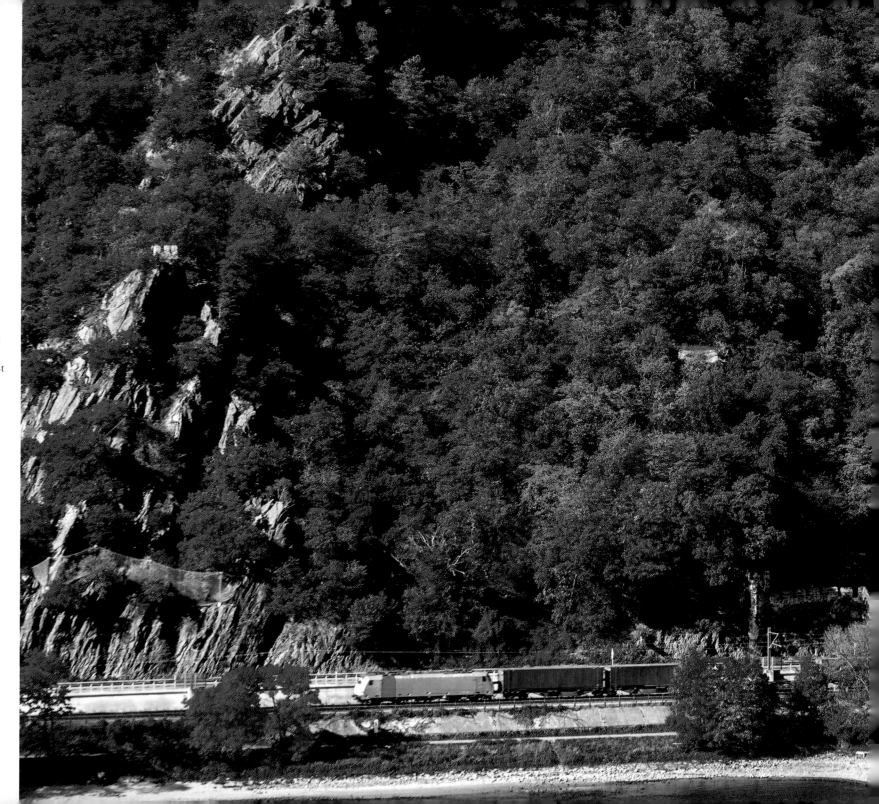

PREVIOUS PAGES:

Niederheimbach, Rheinland-Pfalz, Germany
Vineyards rise on the steep banks above a southbound regional express service following the left bank of the Rhine through one of Germany's most picturesque districts between Bingen and Koblenz.

RIGHT:

Burg Rheinstein, Rheinland-Pfalz, Germany
Castles, ruins and dramatic rock scenery dominate the Rhine Gorge, which is threaded by the West Rhine Railway linking Cologne and Mainz. Constructed in 1859, it was one of Germany's most intensively-used main lines until the construction of the Cologne–Frankfurt high-speed line.

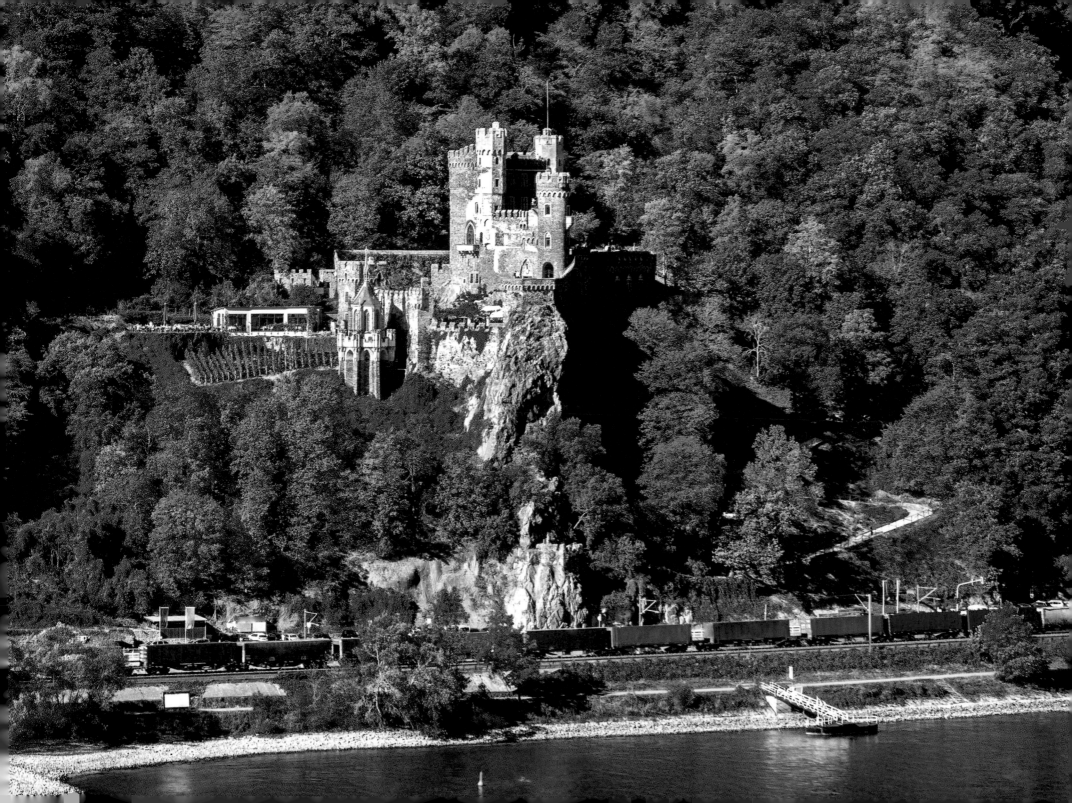

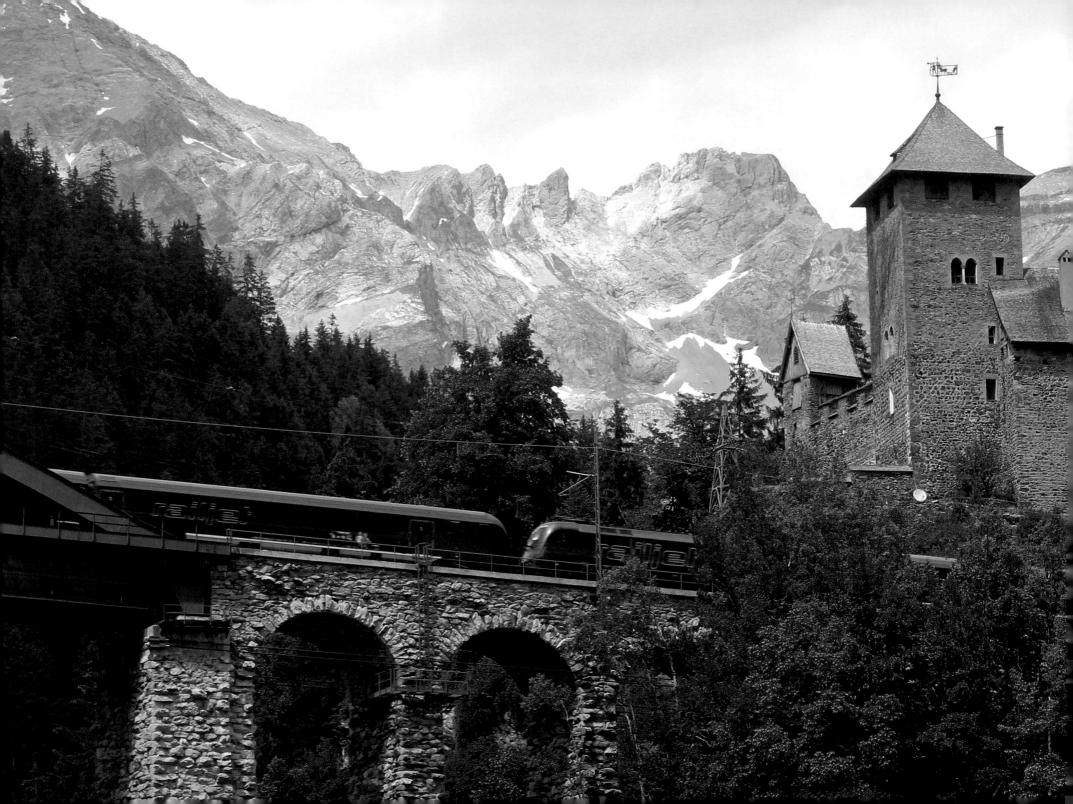

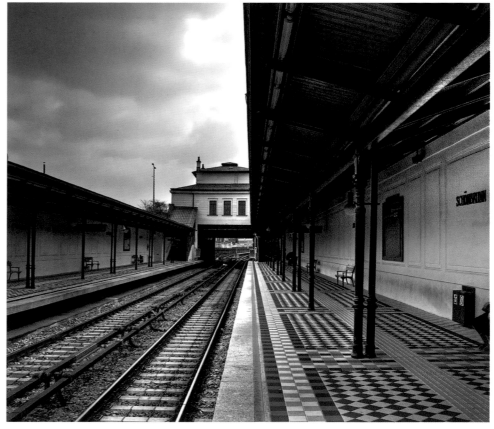

LEFT:

Trisanna Viaduct, Arlberg Railway, Tyrol, Austria
The side arches are of unmasoned stonework intended to match the adjacent Wiesberg Castle. First built in 1884, the 120m (396ft) main span, 87m (287ft) high, was replaced in 1964. The Arlberg line links Innsbruck and Bludenz.

ABOVE:

Schönbrunn Metro Station, Vienna, Austria
Vienna has one of the most highly integrated and efficient urban transport systems in the world. This is the station for Schönbrunn Palace, built as part of a suburban railway scheme in 1898, and since 1964 a stopping-point on Metro line U4.

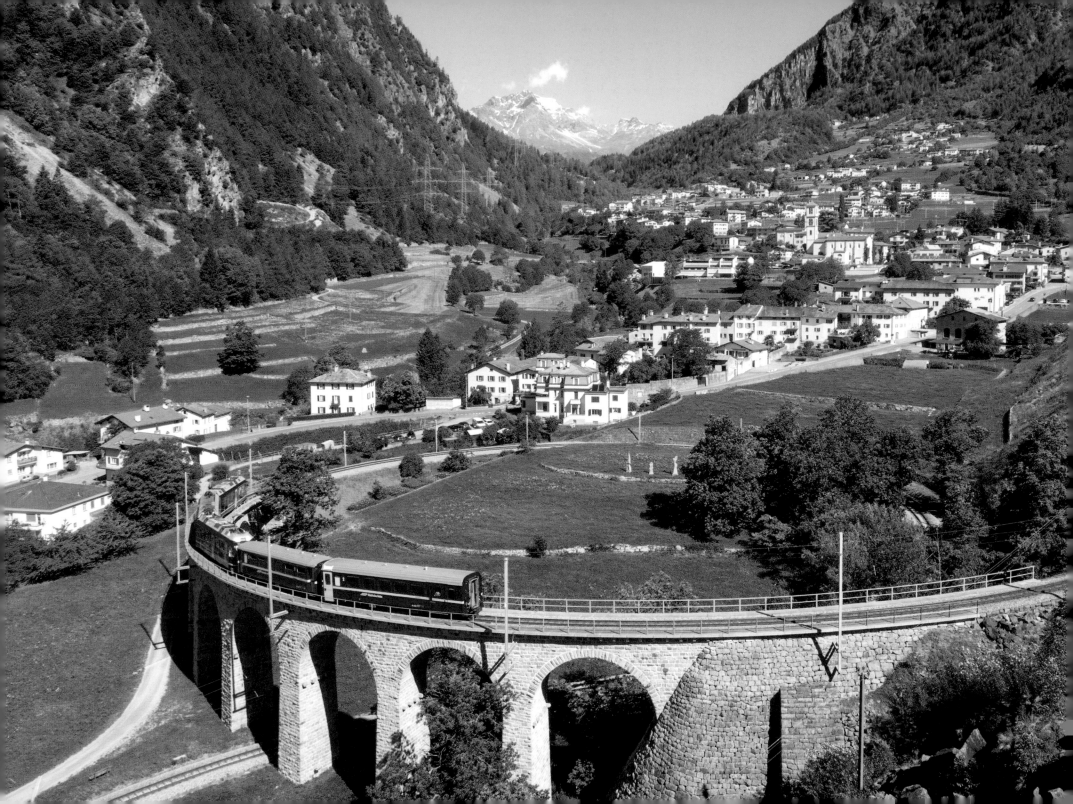

LEFT:

Rhaetian Railway, Valposchiavo, Switzerland
Winding its way down from St Moritz into Valposchiavo, the Bernina Express from Chur, Switzerland, to Tirano in Italy runs on the highest transalpine railway, reaching an altitude of 2253m (7392ft). The spectacular 122km (76-mile) ride on the metre-gauge line takes four hours.

RIGHT:

Zermatt–Gornergrat Railway, Switzerland
Breathtaking views of the Matterhorn are had from the train on the 33-minute journey between Zermatt and the Gornergrat terminus at 3089m (10,134ft). This was the world's first fully electric rack railway, using the Abt cog-wheel system, when it opened in 1898.

OVERLEAF:

Cinque Terre, Liguria, Italy
The five villages of the Cinque Terre cling to the coast and hills in what is both a national park and a UNESCO world heritage site. Inaccessible by cars, they are linked by the Genoa–Pisa trunk line that snakes along the coast. This section of the line opened in 1874 and revolutionized life in the villages.

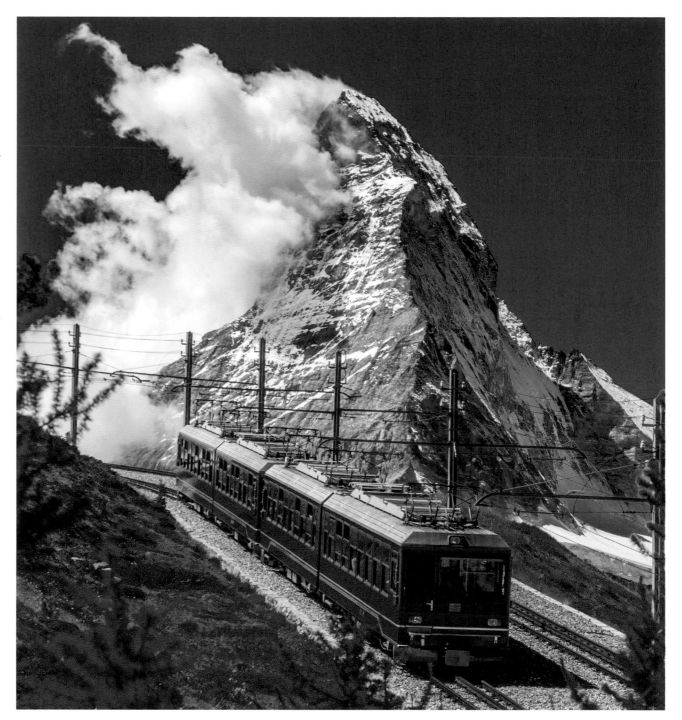

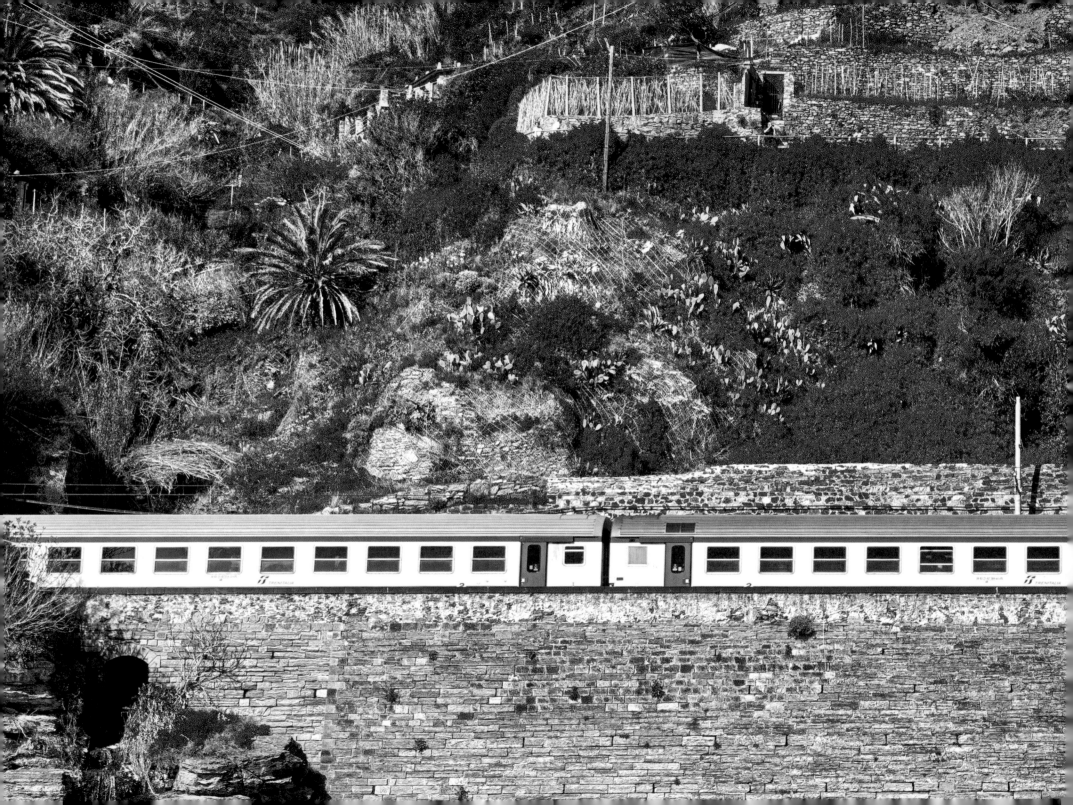

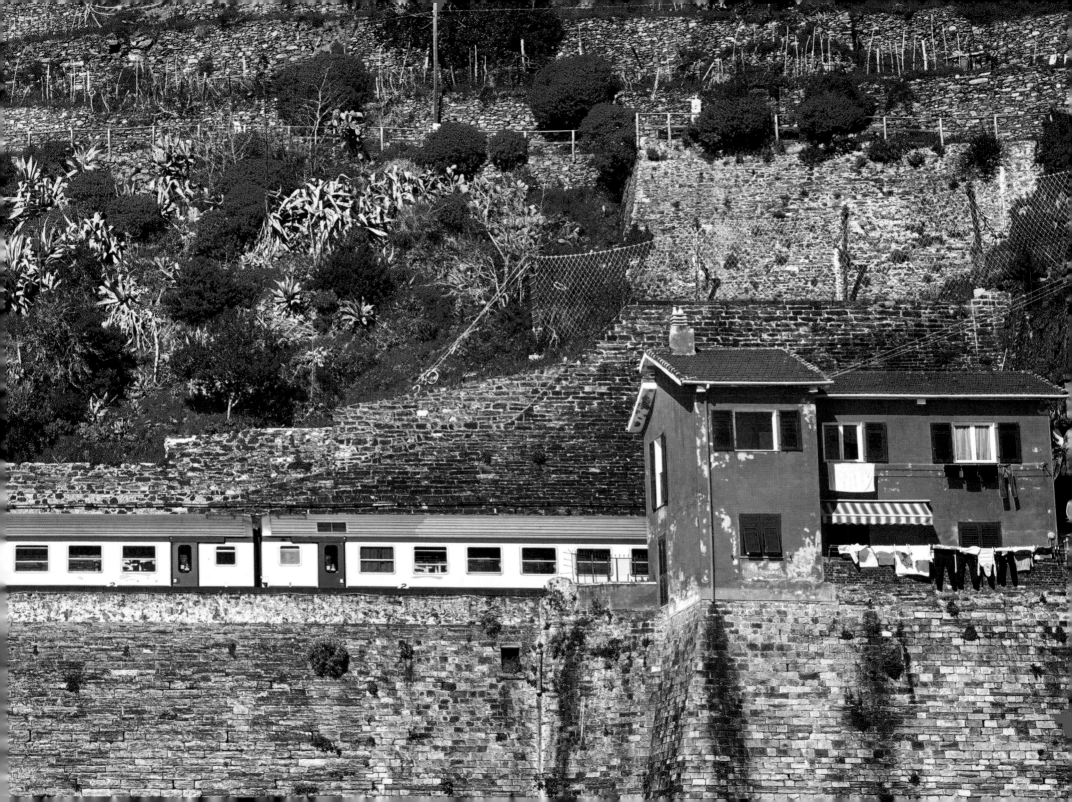

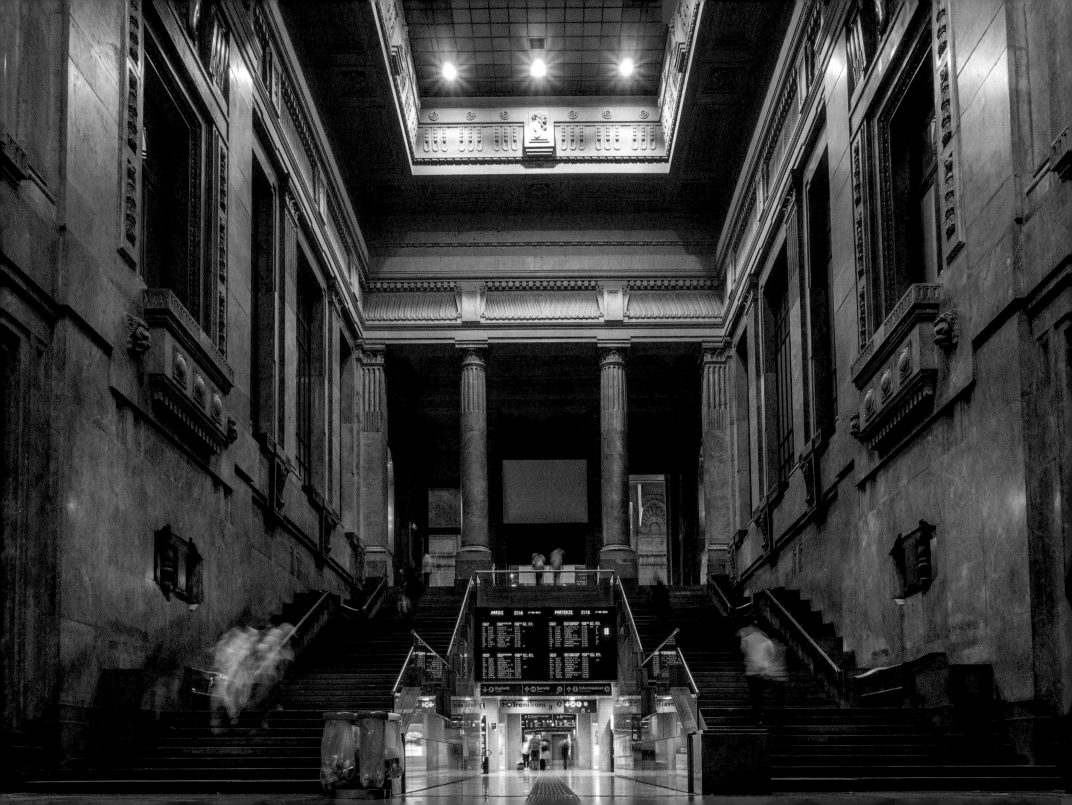

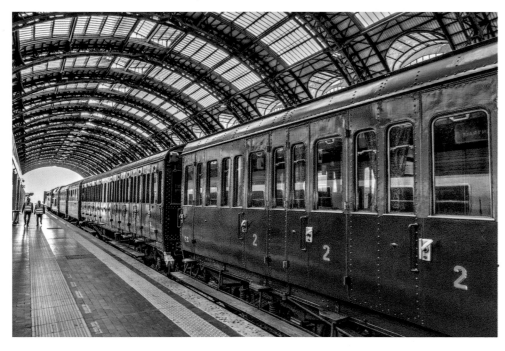

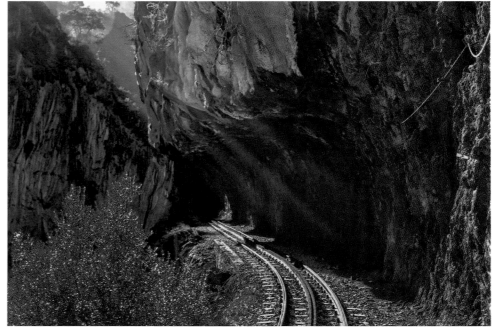

OPPOSITE:

Central Station, Milan, Italy
Modern signage and lighting in the grandiloquent great hall of Milan Central. The 24-platform station is Italy's second-biggest after Roma Termini. The foundation stone was laid in 1906 but the building was not completed until 1931.

ABOVE:

Central Station, Milan, Italy
A line of vintage carriages stands under the steel arched roof. The vast train shed comprises a central hall with two halls of diminishing sizes on each side. International and long-distance internal trains are the station's main business, and it is also connected to Milan's modern underground Metro system.

TOP RIGHT:

Diakofto–Kalavrita Odontotos Railway, Greece
'Odontotos' means toothed: a reference to the central rail of this rack and pinion railway, a 750mm (29.5in) gauge line through the Vouraikos Gorge and up to Kalavrita. Three rack sections help the train on the steepest grades. Opened in 1891 and first worked by steam, it is now operated with diesel-electric railcars.

BOTTOM RIGHT:

Diakofto–Kalavrita Rack Railway, Greece
Bits of scrap from old track fittings lie alongside the line in the Vouraikos Gorge. The 20km (12.5-mile) gorge has associations with the legendary hero Hercules.

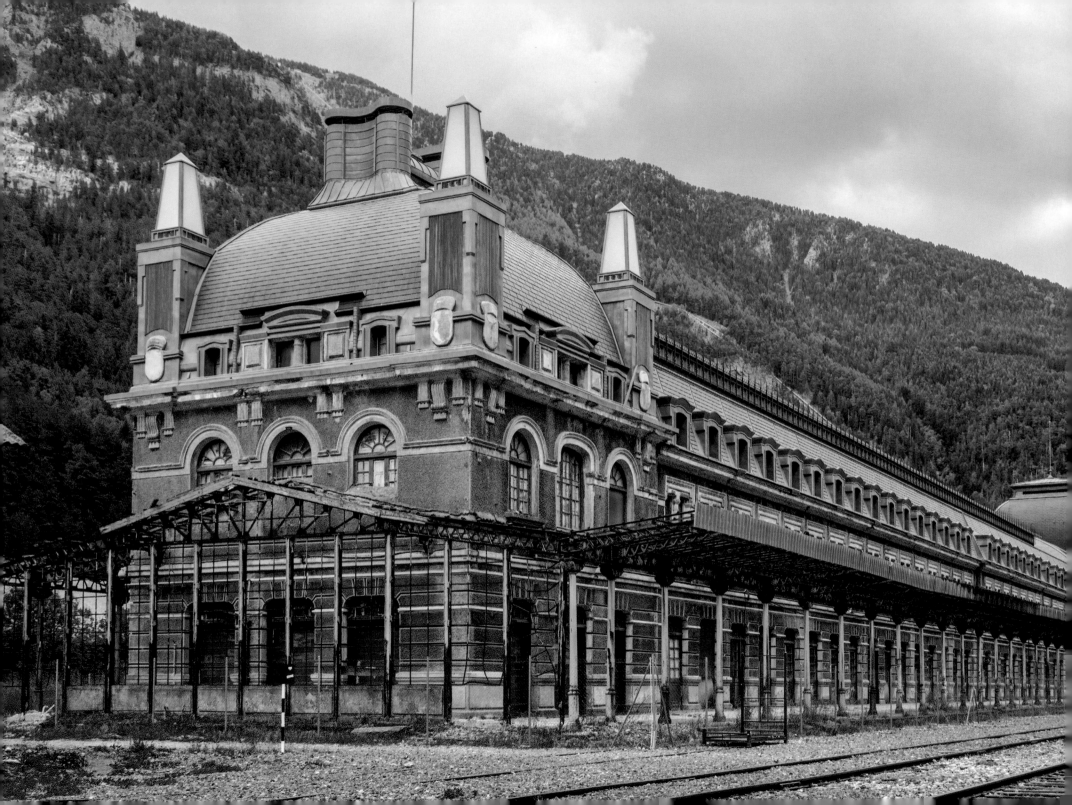

LEFT:

Canfranc Station, Huesca Province, Aragón, Spain
Once an international border station, built in imposing Empire style in 1928, with all the customs and railway offices needed, and incorporating a hotel, Canfranc station closed with closure of the Pau–Canfranc–Zaragoza line across the Pyrenees in 1970. Reopening of the route and the restoration of the station is a current project.

RIGHT:

Puerto de Atocha Station, Madrid, Spain
Virtually all major Spanish cities, as well as international destinations, are served by high-speed trains from here. Since 1992 this modern terminus has replaced the old trainshed built in 1892, which, however, has been preserved as a splendid tropical garden.

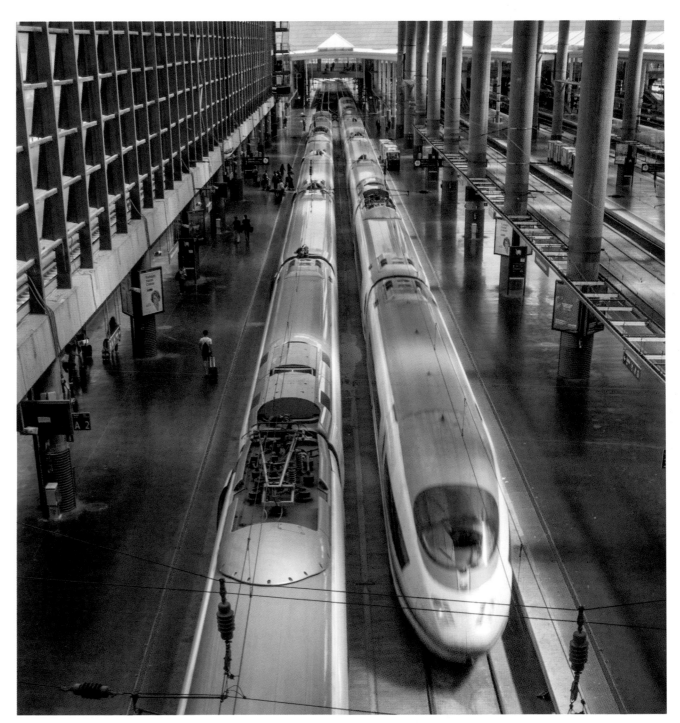

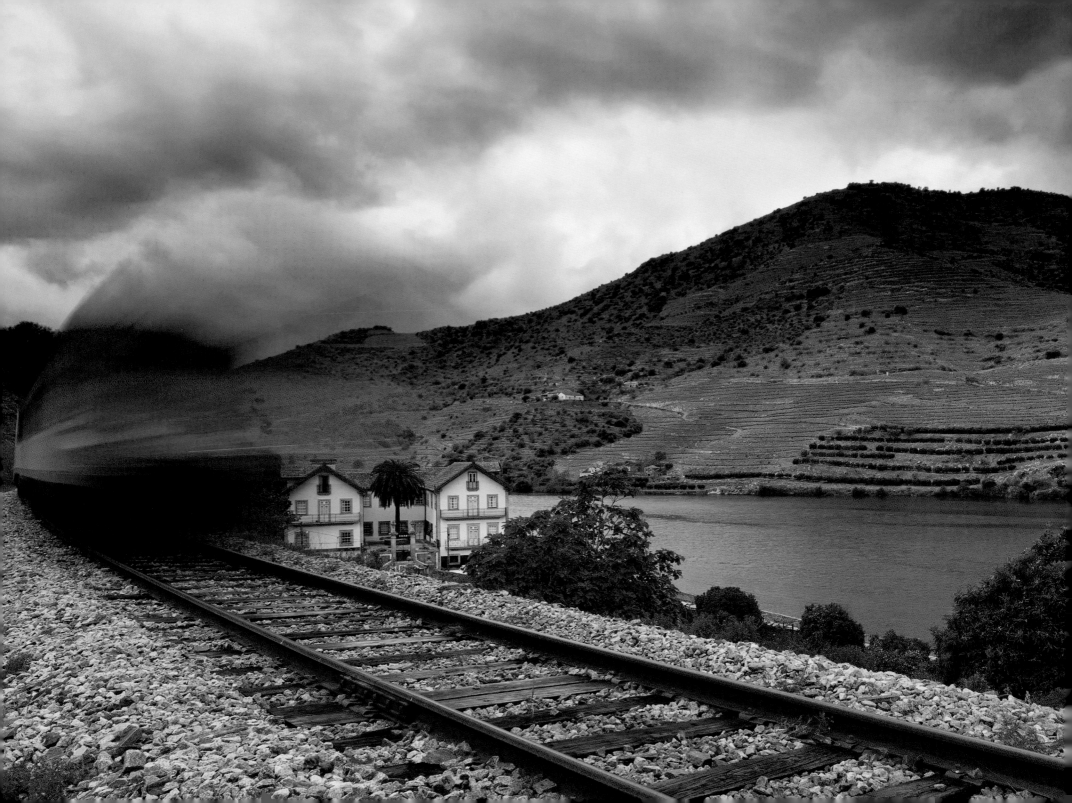

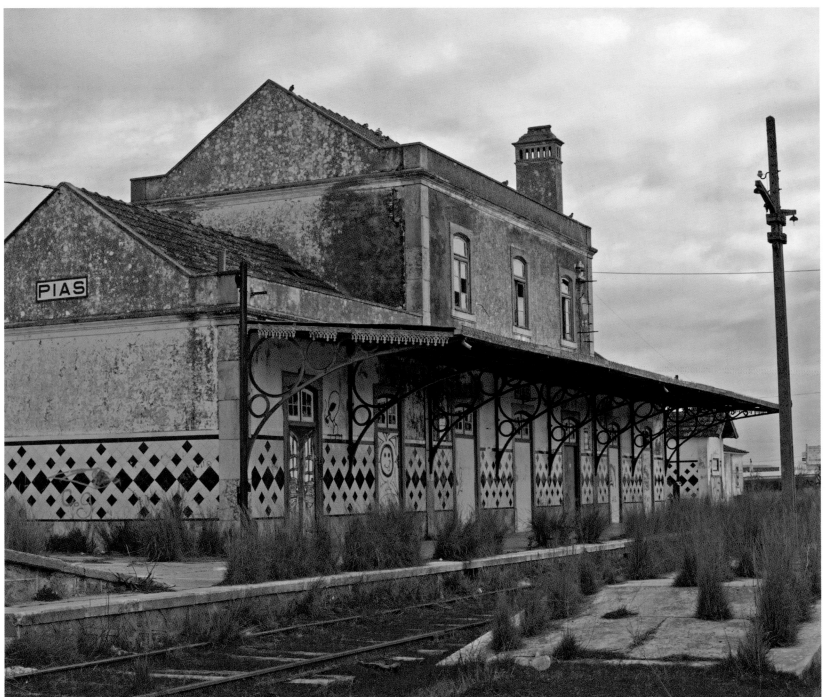

OPPOSITE:

Linha do Douro, Portugal
Substantial renovation work
in 2018–19 has restored
this scenic line to excellent
condition. Following the
River Douro, passing hills,
vineyards and picturesque
villages by way of 26 tunnels
and 30 bridges, the 203km
(127-mile) long line was first
opened in 1878.

LEFT:

**Abandoned station at Pias,
Alentejo, Portugal**
Between 1902 and 1989 a
54km (33.75-mile) railway
connected the Portuguese
towns of Beja and Moura
in the Alentejo region. The
rails and much of the fittings
remain, but in increasingly
dilapidated condition, as
this view of Pias, one of the
intermediate stations, shows.

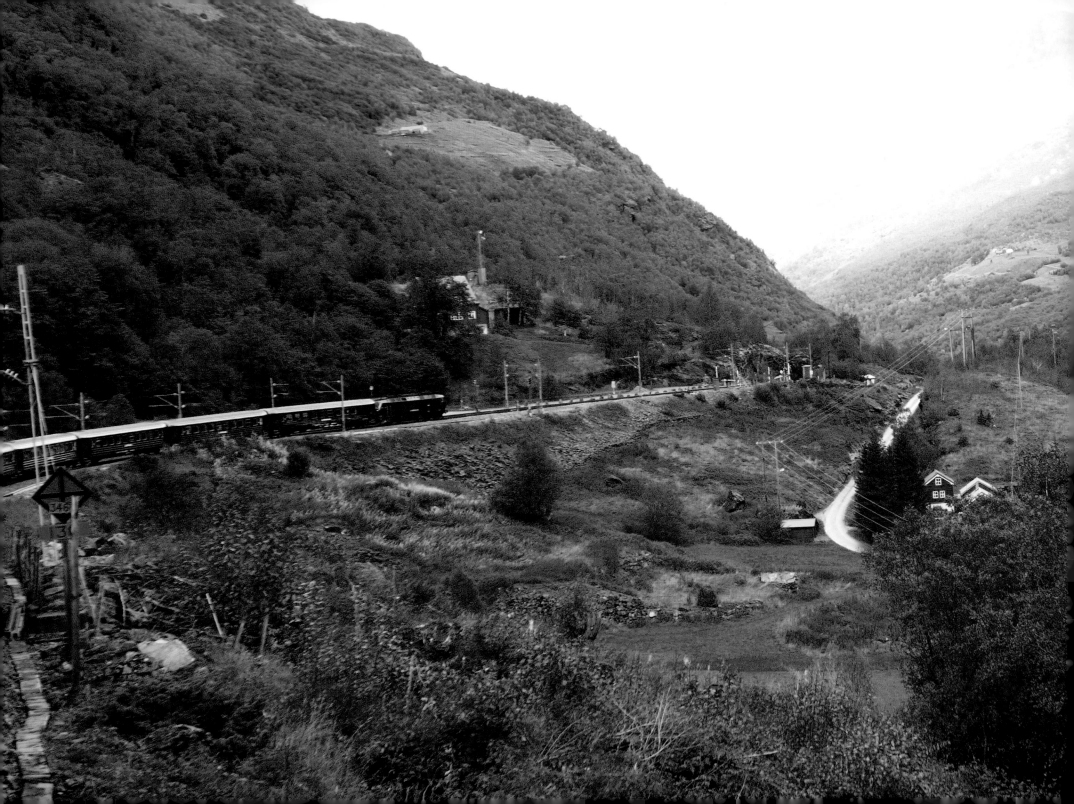

LEFT:

Flåm Railway, Norway
Considered to be Norway's most scenic railway, the Flåm line descends from a junction with the Oslo–Bergen railway to Flåm, at the inner end of Aurlandsfjord, descending 863 metres (2848ft) in just over 20km (12.5 miles), past waterfalls, gorges and dramatic mountain vistas.

RIGHT:

Central Station, Helsinki, Finland
Four 'lantern carriers', giant statues by the sculptor Erik Wikström, flank the entrance to Helsinki's main station, right in the city centre. The building itself is of granite, completed in 1919 to a modernistic design by Eliel Saarinen, and replacing the original terminus of 1862.

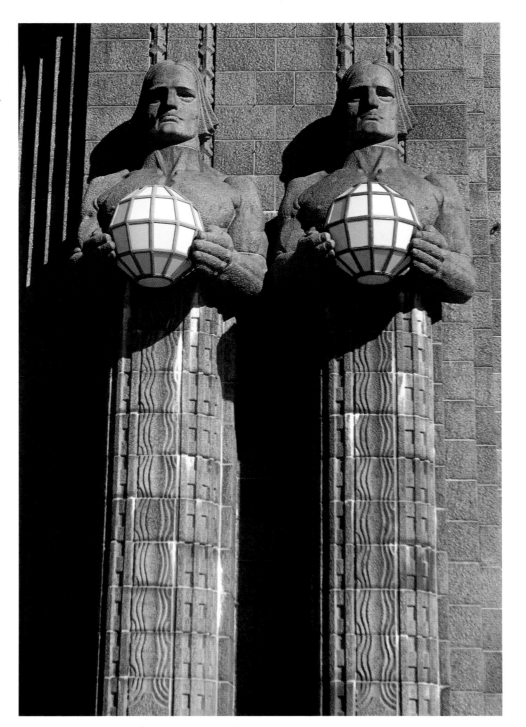

135

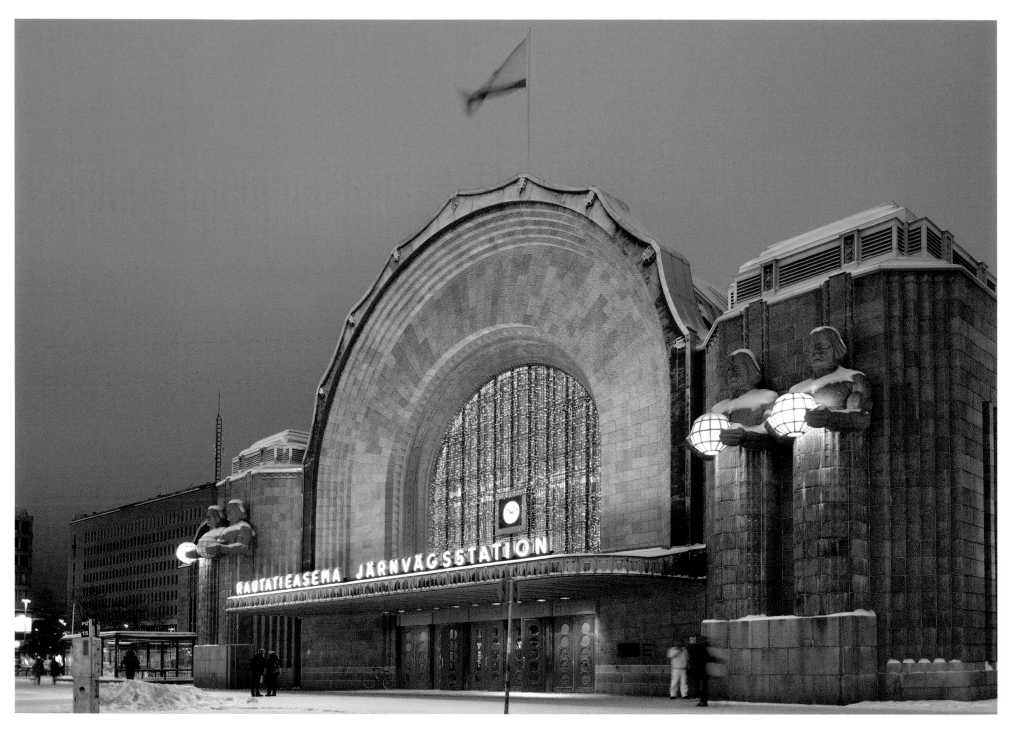

OPPOSITE:
Central Station, Helsinki, Finland
The main façade, announcing itself in Finnish and Swedish. Having won a competition for a new design in 1904, Saarinen made radical changes to the final version. Apart from internal services, international trains run between here and St Petersburg in Russia.

LEFT:
'Golden Eagle' Train, Keleti Station, Budapest, Hungary
Interior of a sleeping compartment on the luxury 'Golden Eagle' train, set up for daytime use. These cruise trains operate on several routes in Eastern Europe and Russia, and as far as China, recreating pre-war travel in the grand manner.

BOTTOM LEFT:
'Golden Eagle' Train
Steam locomotives are used on sections of the 'Golden Eagle' routes. The locomotive fireman stokes to get steam up for departure.

BOTTOM RIGHT:
'Golden Eagle' Train
A classic Austrian State Railways steam locomotive of a design dating back to 1911, 2-6-4 No. 310.263, designed by Karl Gölsdorf, pulls out with the 'Golden Eagle' Danube Express, which will run through eight countries, with Venice as the ultimate destination.

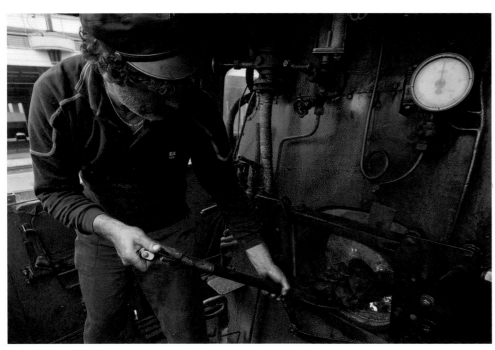

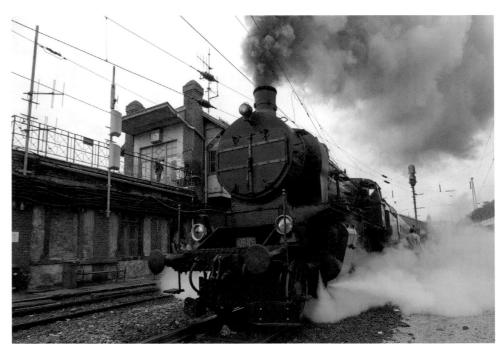

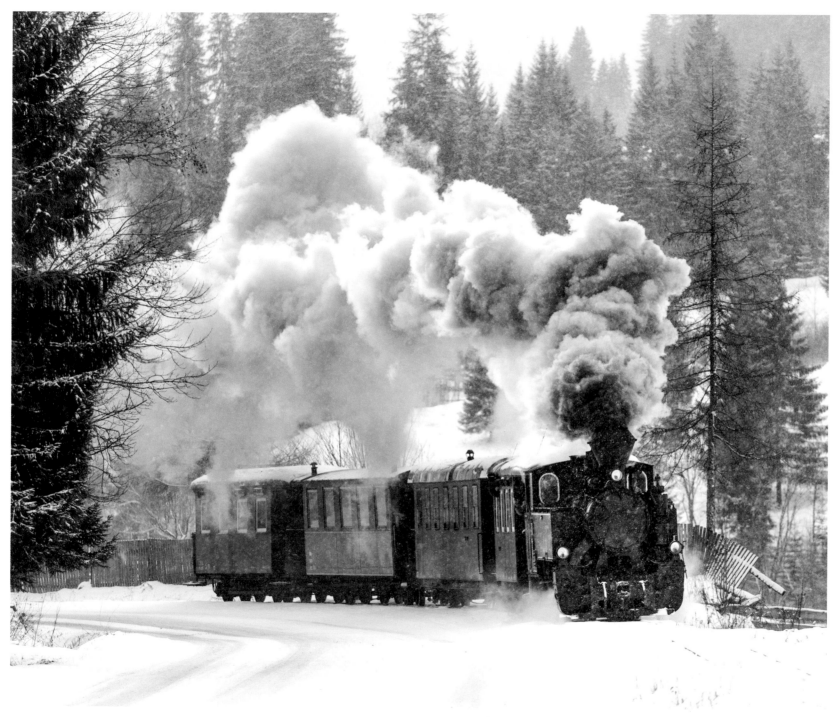

Mocanita Steam Railway, Viseu de Sus, Maramures County, Romania
'Mocanita' is a Romanian pet name for a small locomotive. Built as a timber carrying line, this narrow gauge railway still brings down wagonloads of logs as well as hauling tourist carriages, though its steam locomotives are kept for the latter. The line was built in 1933–35.

The wood-burning Mocanita makes a dramatic entrance to one of the tunnels on the line (see opposite). Its use as a public railway began only in the 21st century. Forestry trains were quite common in wooded mountain districts before the 1950s, but this is Europe's last working example.

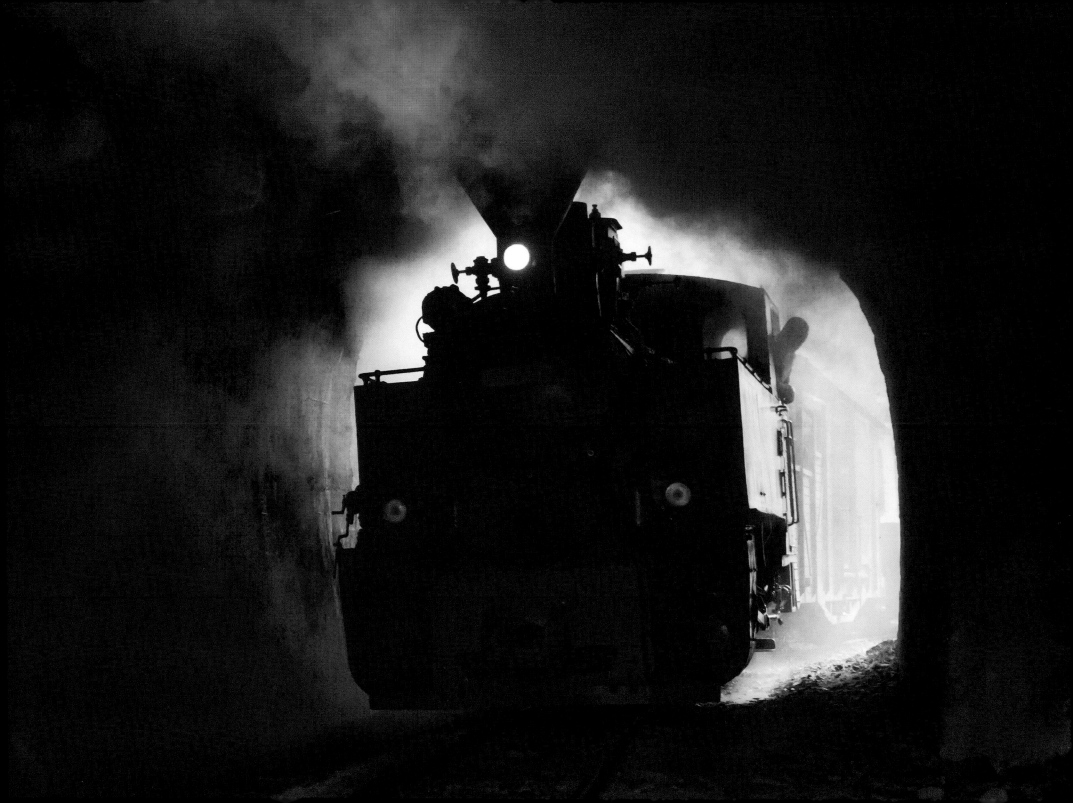

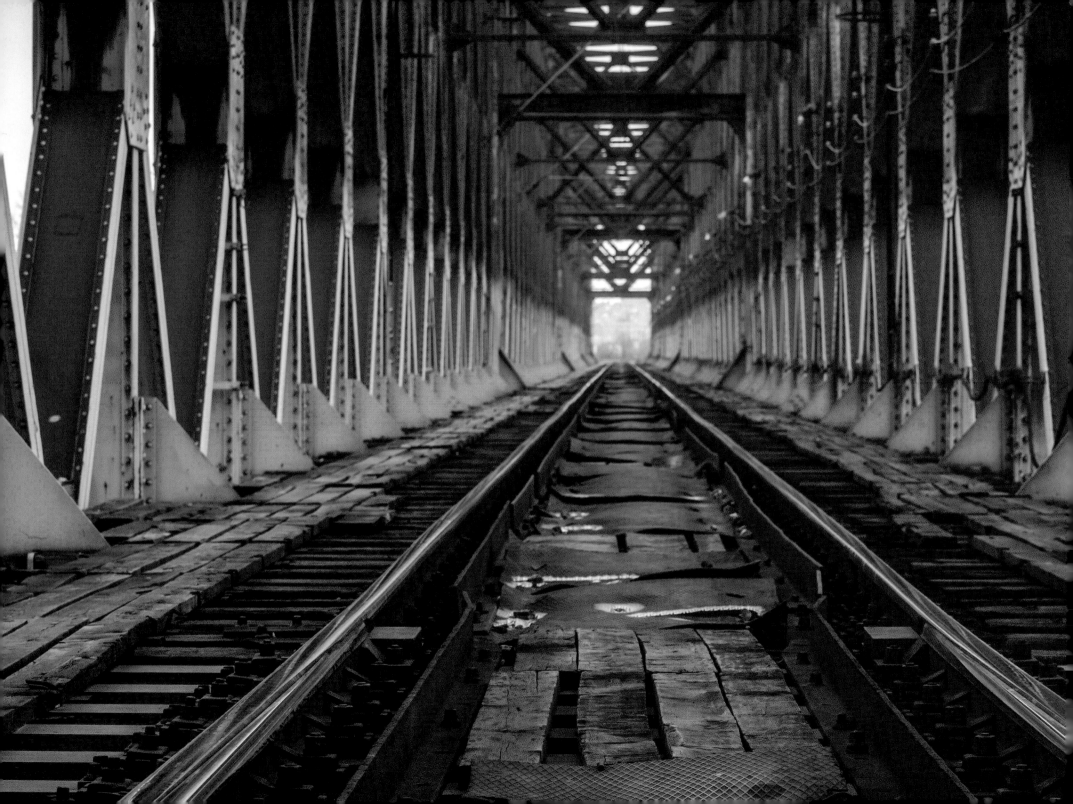

LEFT:

Sava River Bridge, Belgrade, Serbia
Though known as the 'old bridge', as the first to be built across the Sava into Belgrade in 1882–84, it was destroyed in both world wars in the 20th century and rebuilt each time. As of 2019 the authorities plan to decommission it.

RIGHT:

Station at Split, Croatia
The historic city of Split is on Croatia's coast. Its main long-distance rail connection is with the Croatian capital, Zagreb, situated inland beyond the steep coastal mountains. Split also has a modern suburban system linking it with neighbouring communities along the coast.

OVERLEAF:

Russian Railways
Well-wrapped up passengers at a Russian station in winter. Russian railway lines are classified according to the severity of their winters, and preparations are made year-round, helped by an automated system that directs snow and ice clearing equipment to where it is needed.

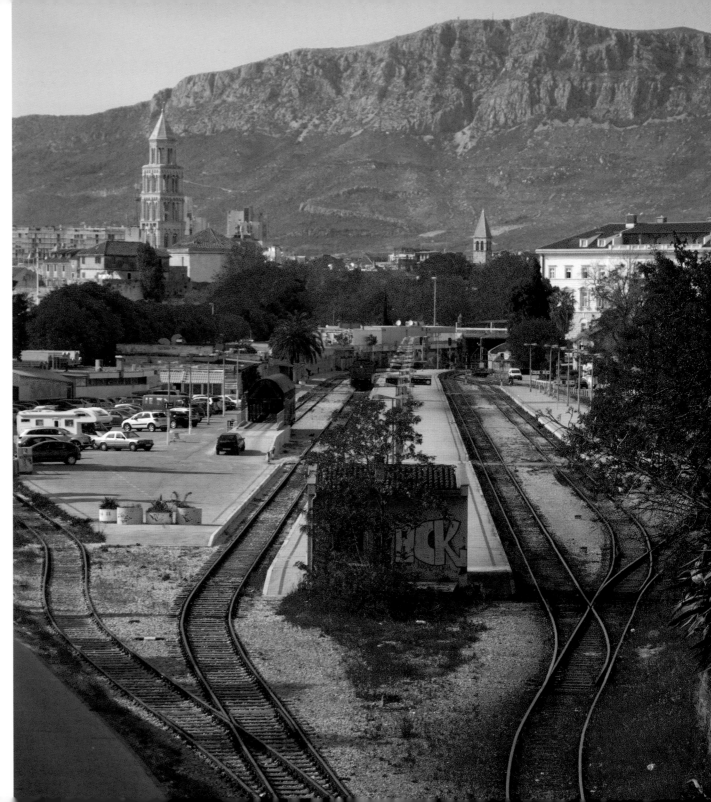

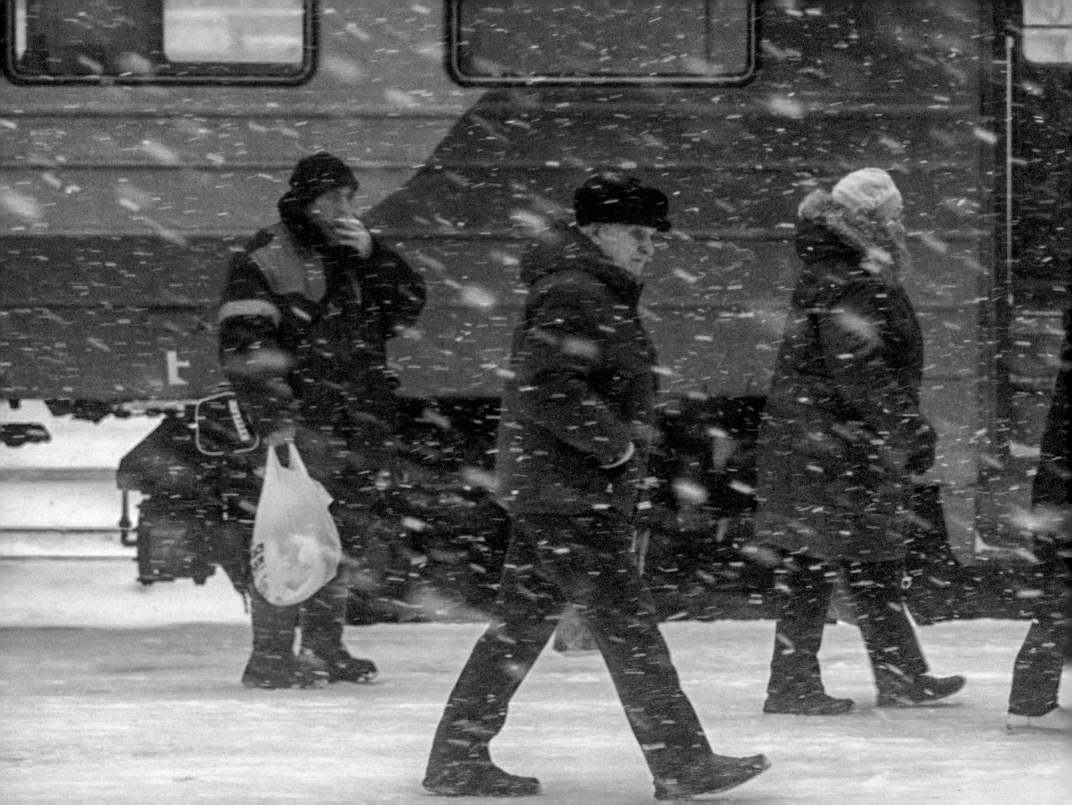

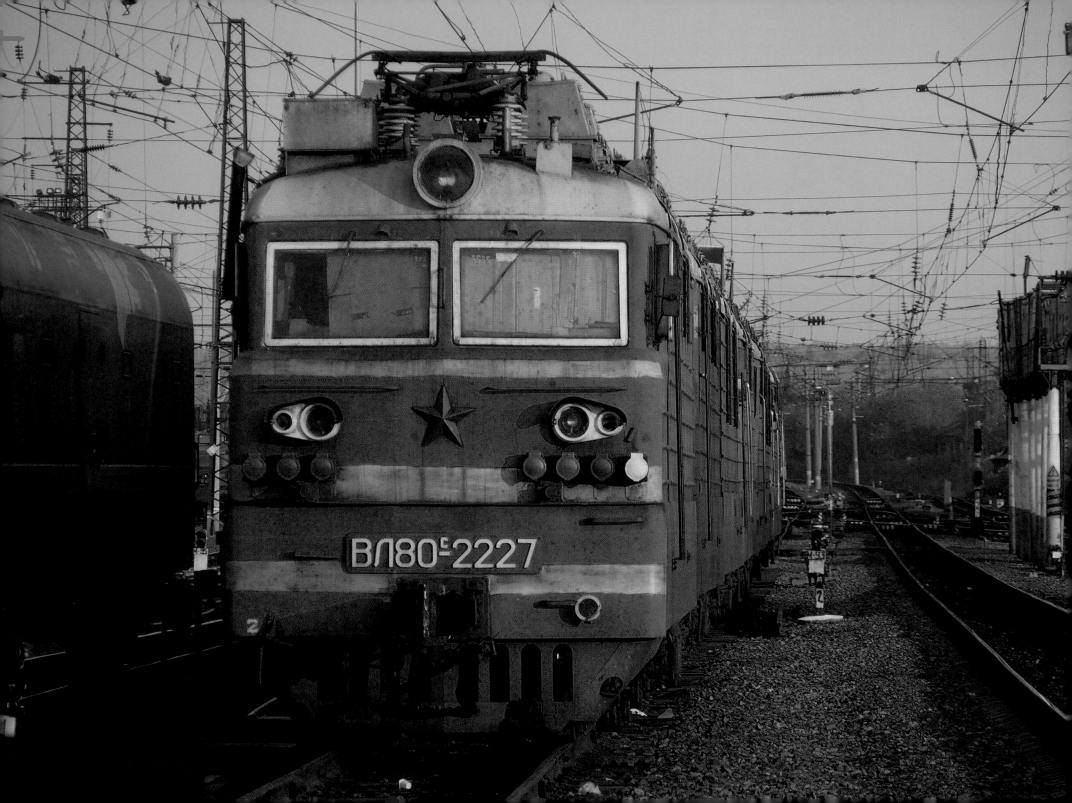

OPPOSITE:
Russian Railways
A type VL80 articulated
electric locomotive used for
long-distance freight services
across the electrified network.
Almost 5000 were built at
the Novocherkassk Works
between 1961 and 1994. VL
stands for Vladimir Lenin.
Russia's rail lines are built to
a 1520mm (5ft) gauge.

RIGHT:
**Novosibirsk-Glavny Station,
Siberia, Russia**
Novosibirsk is the largest
station on the Trans-Siberian
Railway. Opened at the
foundation of the city in
1894, the present buildings
date from 1939 and were
renovated in 1999. Eastbound
Transsib trains link the city
with Beijing, Ulan-Bataar
and Vladivostok.

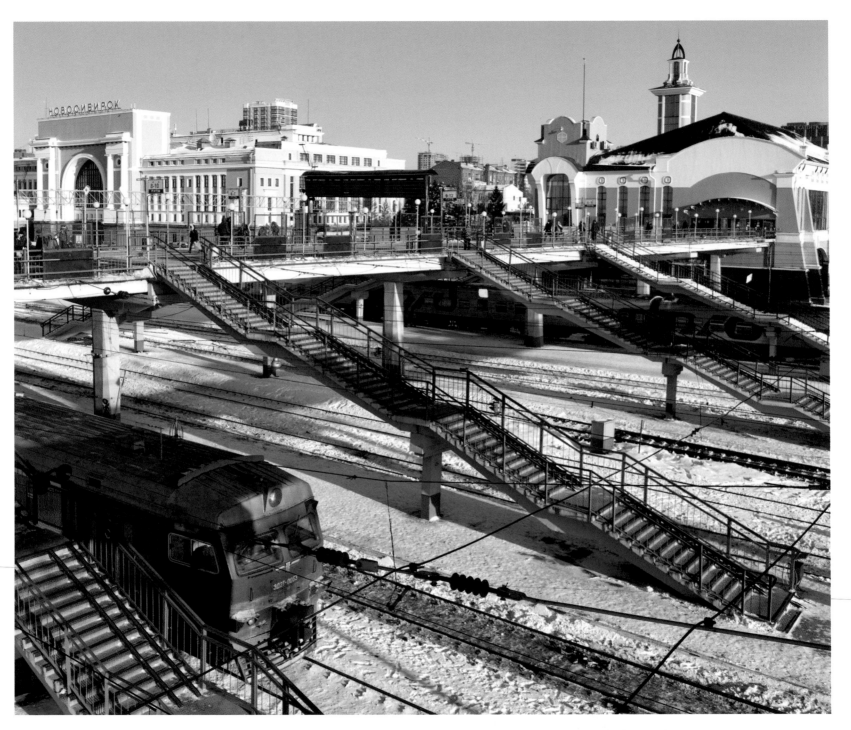

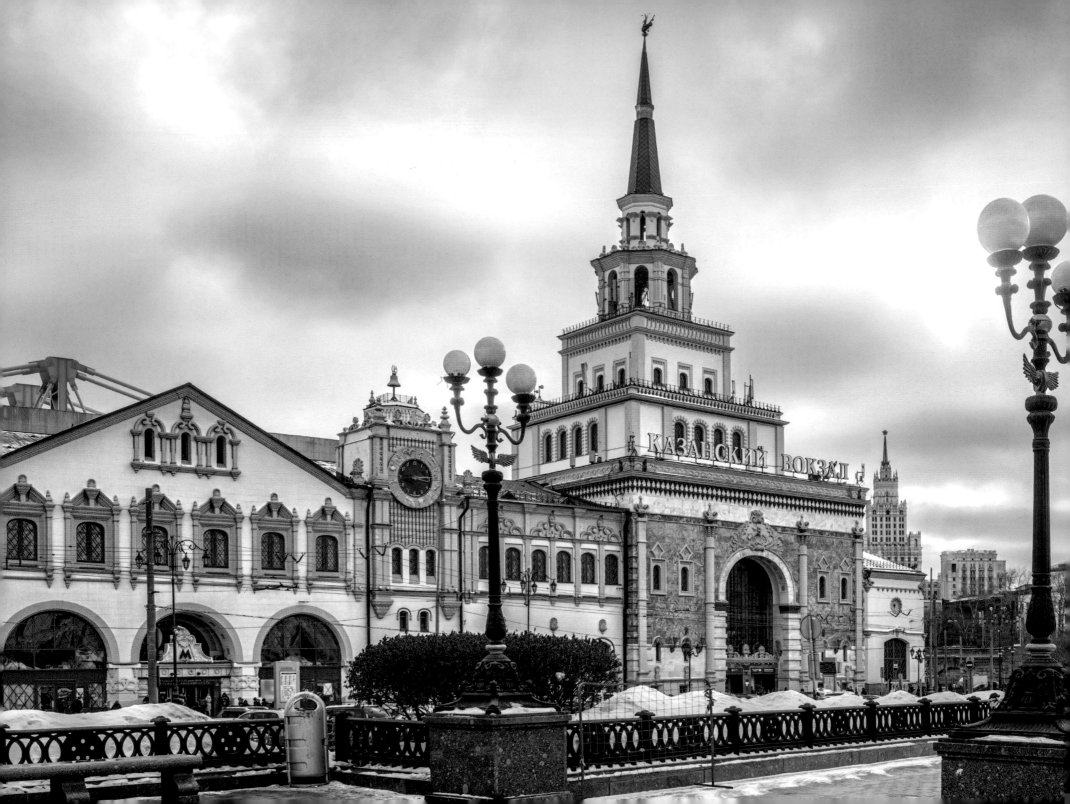

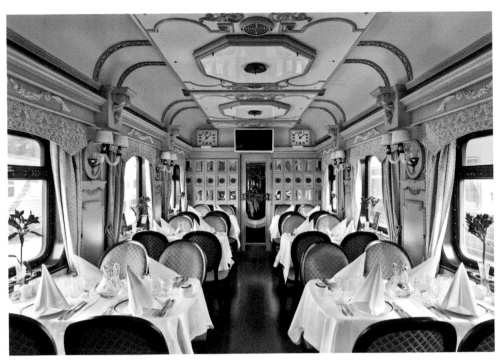

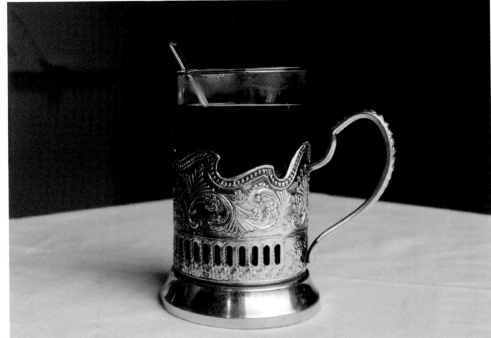

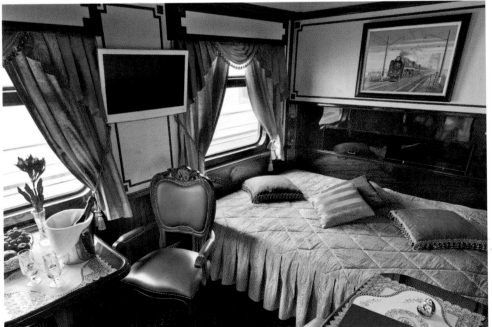

OPPOSITE:

Kazansky Station, Moscow, Russia

The wedding-cake architecture of Russia's largest train station is a prominent feature of Komsomolskaya Square. Construction began in 1913 and was completed in 1940. It serves many eastern, southern and south-eastern destinations, though the Trans-Siberian trains leave from neighbouring Yaroslavsky Station.

ABOVE:

Trans-Siberian Luxury Train

Russia's wide railway gauge allows for more spacious carriages, like this roomy dining car on the 'Golden Eagle' Trans-Siberian cruise train. Some stretches of the journey are made behind a preserved steam locomotive.

ABOVE RIGHT:

Trans-Siberian Luxury Train

Tea from a samovar is a traditional feature of the Russian long-distance train, though on most trains the hot beverage is more likely to come in an insulated cup rather than this glass in its elegant silver holder.

BOTTOM RIGHT:

Trans-Siberian Luxury Train

A bedroom set up as a dayroom on the luxury version of the Trans-Siberian. The standard Russian Railways services provide two-berth first class, four-berth second class sleeping compartments and open-plan dormitory cars. Each car has two attendants.

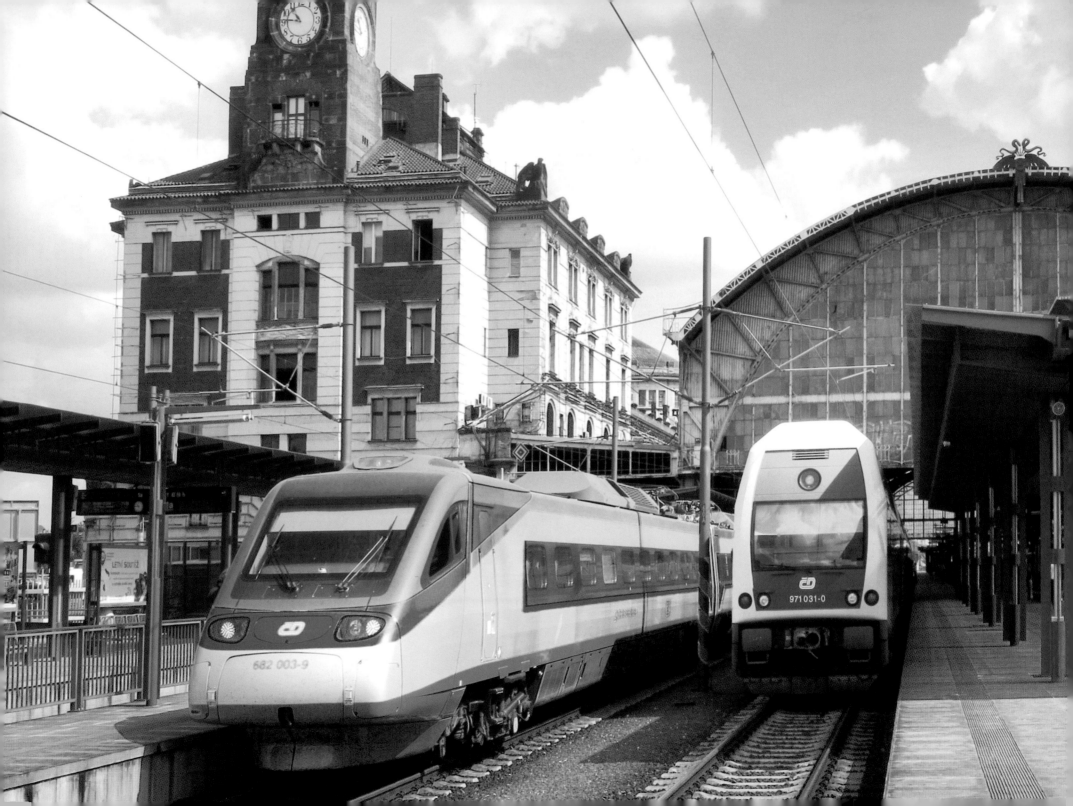

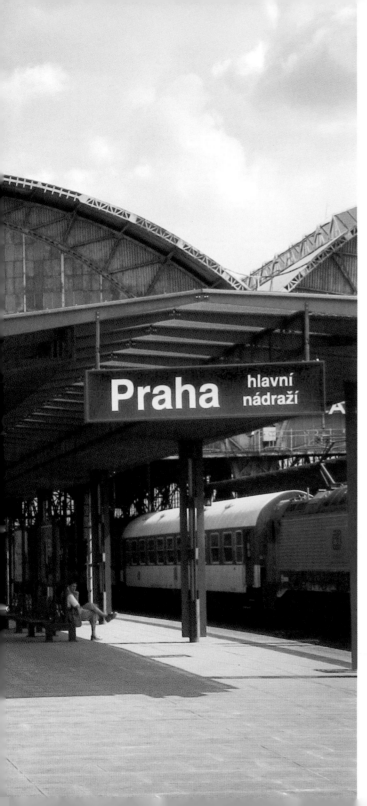

LEFT:

**Prague Main Station,
Czech Republic**

Prague's main station was
first named after the Austrian
emperor Franz Josef, and
from 1945–48 after a US
President, Woodrow Wilson.
National and international
services use the station.
On the left is a Czech
Railways Class 680
'Pendolino' tilting train.

RIGHT:

**Prague Main Station,
Czech Republic**

Originally opened in 1871,
the main station was rebuilt
between 1901 and 1909, with
Art Nouveau elements. The
building was replaced by a
modern, low-level entrance
and concourse in the 1970s,
but remains a monument to
the city's past. The roundel
includes an inscription:
'Prague, mother of cities'.

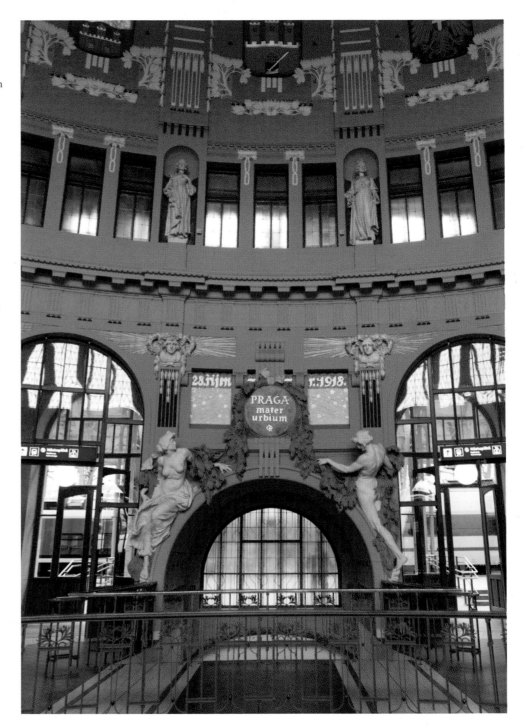

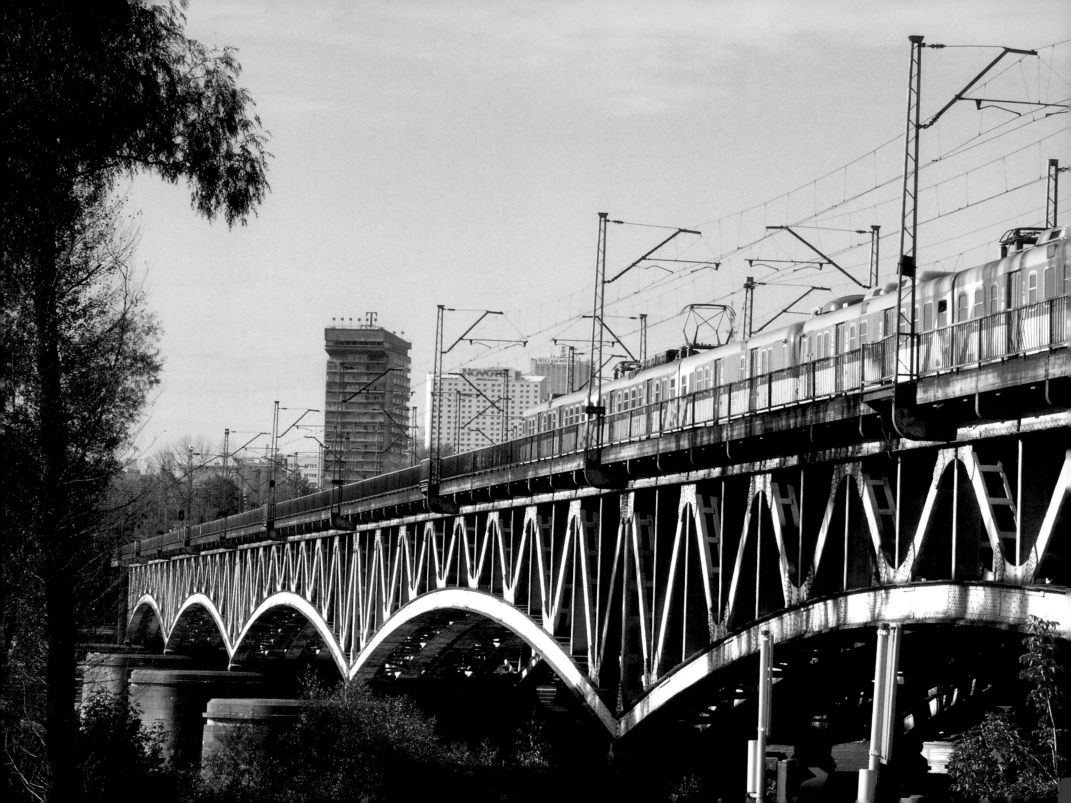

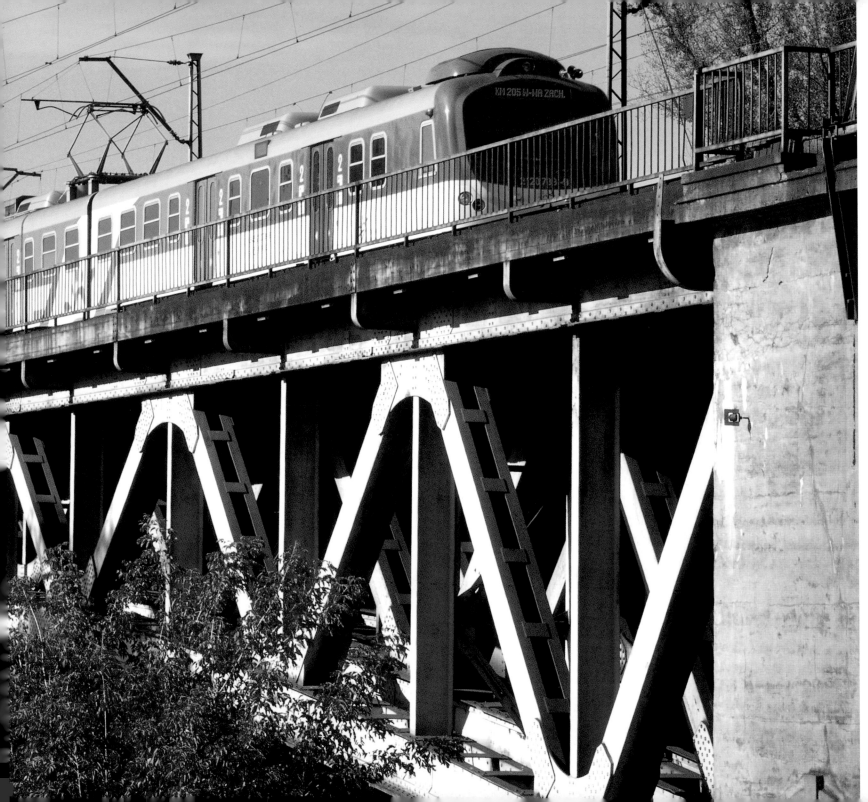

Poniatowski Bridge, Warsaw, Poland
Named after the Polish military hero Jozef Poniatowski, this 506m (556yd) bridge over the River Vistula was begun in 1904, then blown up by the Russian army in 1915 and again by the Germans in 1944. Its post-war reconstruction incorporated a tramway, now part of the city's rapid transit system.

151

Africa

Though the vision of a Cape-to-Cairo railway, a trunk line with many branches to tap the continent's mineral and agricultural wealth, was never to be realized, a multitude of separate African railway systems grew up. In the heyday of steam, some of the word's finest trains ran in Africa, like the streamlined Algiers-Oran express, or South Africa's 'Blue Train'. In the 21st century, African railways are undergoing a virtual rebirth, and whereas the old systems were started and run under colonial rule, the new power behind railway development is China, with loans, technical expertise and equipment. Africa's first high-speed line, between Casablanca and Tangier, however, owes more to the long-standing relationship between Morocco and France.

Africa has its share of scenic routes and viewpoints. The Nile Valley from Cairo to Luxor, the wildlife close by Kenya's new Standard Gauge Line, the unforgettable spectacle of the Victoria Falls viewed from the railway bridge and the eerie landscape of the Namib Desert, can all be seen in comfort by train. Somewhat less comfortable, perhaps, but to be remembered with a sense of achievement by those who have made the journey, is Madagascar's isolated line from Manakara to Fianarantsoa.

OPPOSITE:
Marrakesh Station, Morocco
Traditional Islamic motifs decorate the southernmost terminus of Moroccan Railways. Though passenger trains play a relatively minor role in Moroccan transport, the station, which opened in 2018, has become an important architectural feature of the city.

ABOVE:

Marrakesh Station, Morocco

Fast trains from Marrakesh serve the other main cities of Morocco, including an overnight service to Tangier in the north. Services are operated by the state-owned ONCF, the national train operator. Eight trains a day make the eight-hour journey between Marrakesh and Fez.

RIGHT:

Tanger Ville Station, Morocco

This was a new city terminus in 2003, and since 2018 also serves the Al-Boraq line, the first high-speed railway on the African continent. Linking Tangier and Casablanca, the trains run at 320km/h (200mph), more than halving the previous transit time to two hours, 10 minutes.

OVERLEAF:

Tanger Ville Station, Morocco

Platform scene, with a double-deck Al Boraq set of eight carriages ready to depart. There are 12 trains, built by Alstom in France, each with capacity to hold 533 passengers. 'Al Boraq' is Arabic for lightning, and, by extension, 'winged steed'.

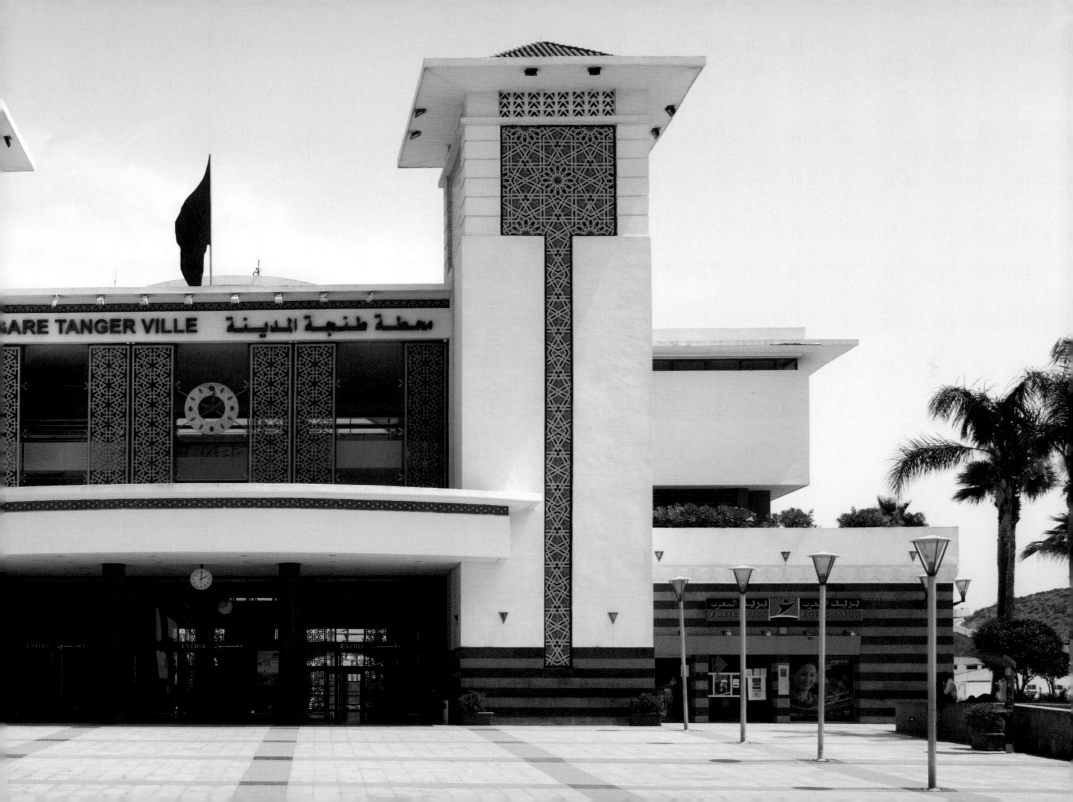

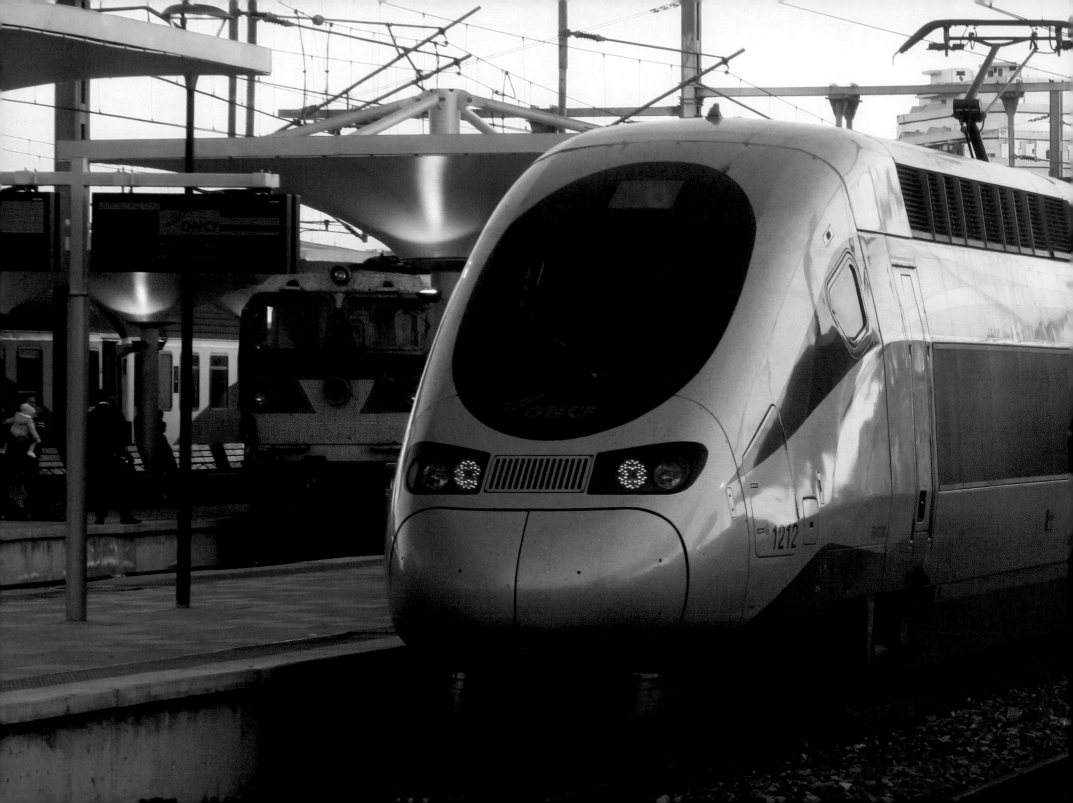

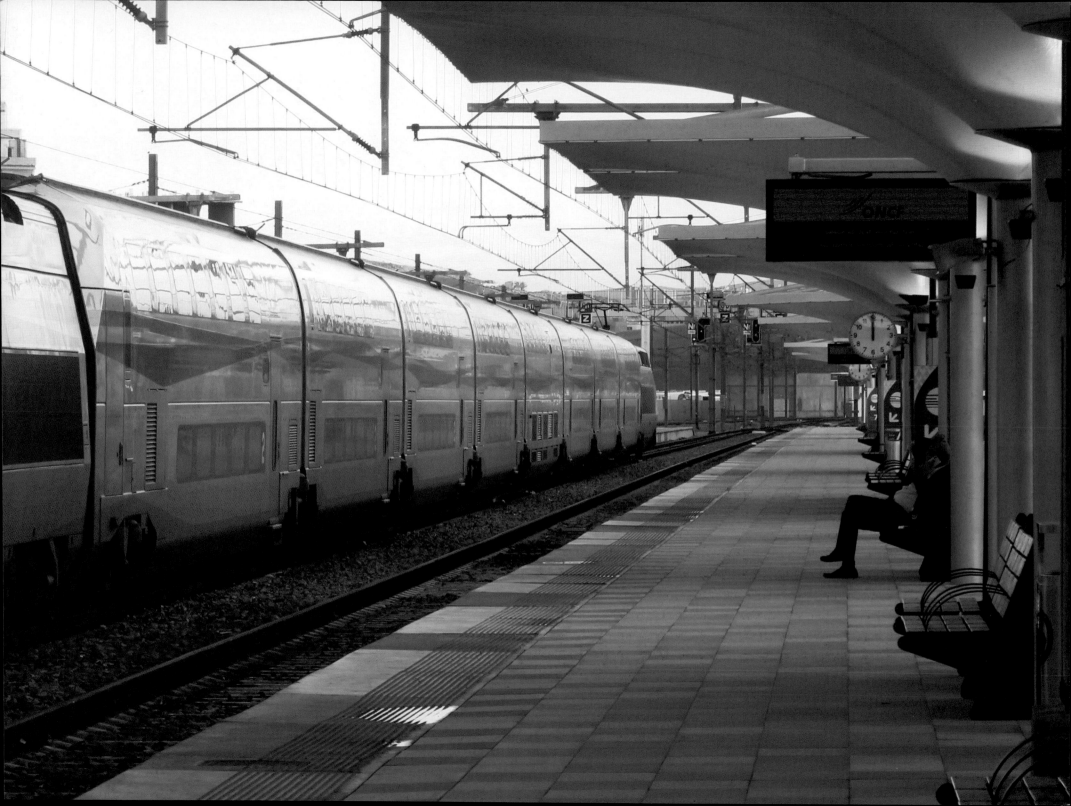

LEFT:

Cairo–Luxor Railway, Egypt
Luxor was first reached by railway from Cairo in 1898, when the line also served to bring equipment and materials for the first Aswan Dam. Day and night (the luxury option) trains depart from Ramses Station in Cairo. The railway follows the Nile's left bank, with the day train taking ten hours and the night express just nine hours.

RIGHT:

Kenyan Railways
An old-style arrival board at an up-country station announces the arrival of the overnight train from Mombasa, now superseded. Zero is an unusual number for a station platform.

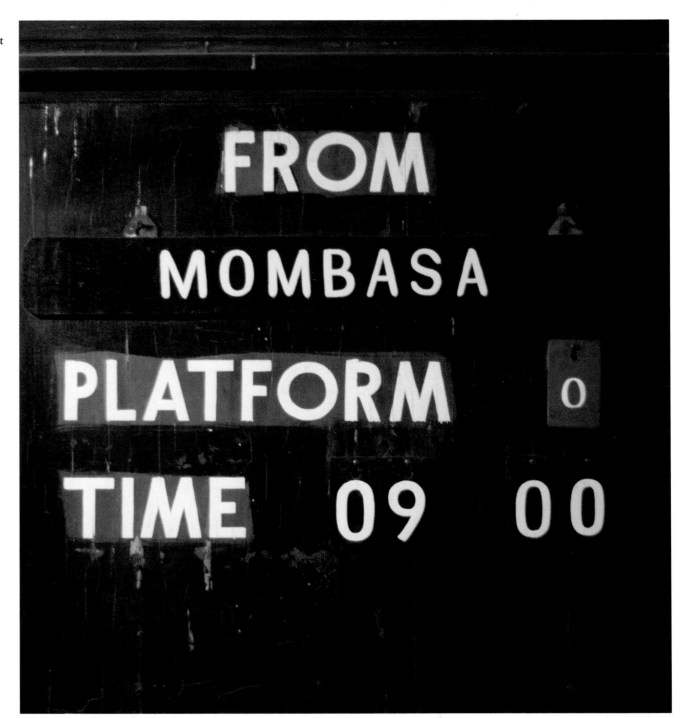

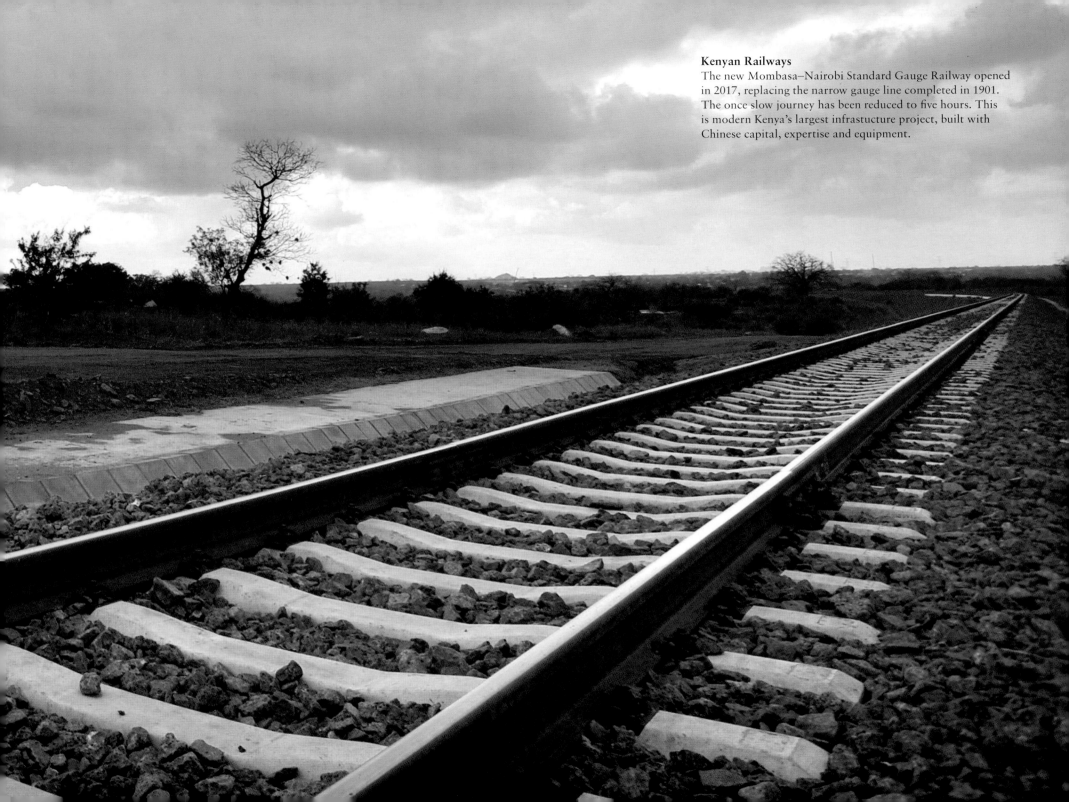

Kenyan Railways
The new Mombasa–Nairobi Standard Gauge Railway opened in 2017, replacing the narrow gauge line completed in 1901. The once slow journey has been reduced to five hours. This is modern Kenya's largest infrastucture project, built with Chinese capital, expertise and equipment.

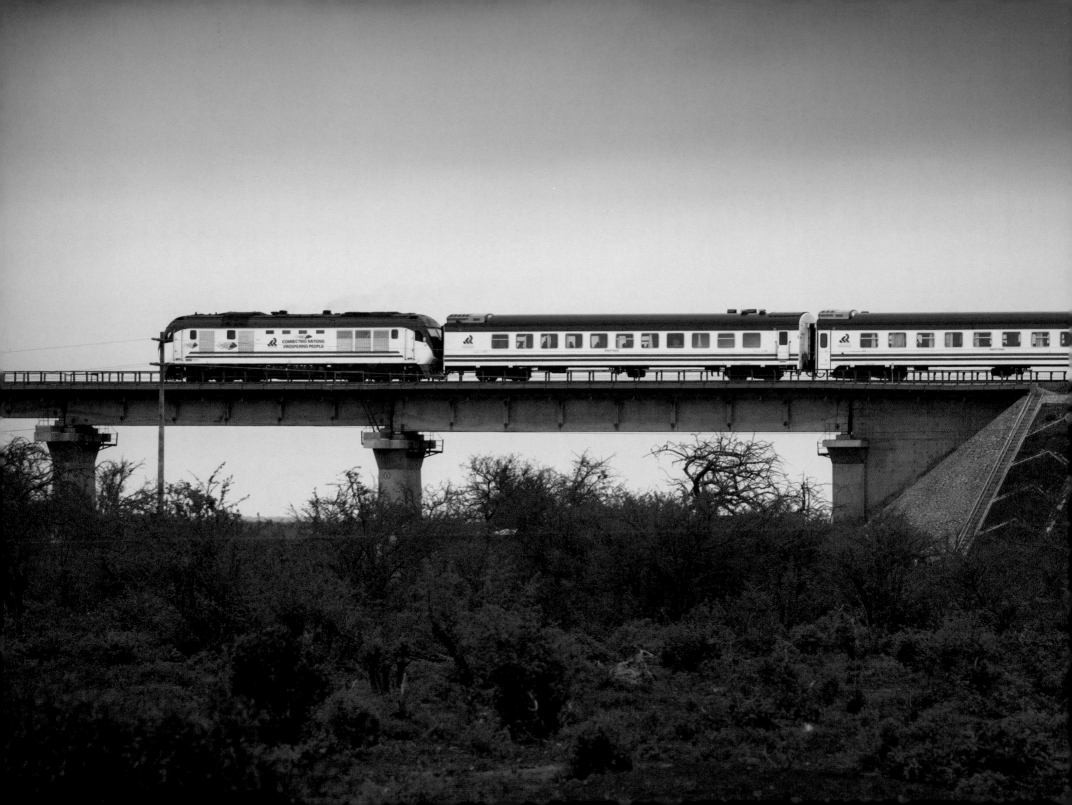

OPPOSITE:

Kenyan Railways
Much of the Standard Gauge Line line runs on elevated track both in the interest of maintaining speed across undulating country, and to allow the passage of wildlife. Views of elephants and other animals are usual as it crosses Tsavo National Park.

BELOW LEFT:

Kenyan Railways
Hospitality staff attend to the needs of passengers on the 472km (293-mile) journey. Standard-class carriages are comfortable, with good leg-room.

RIGHT:

Kenyan Railways
A pair of Chinese DF8B diesel-electric locomotives at the head of the first train, on 27 May 2017. Altogether 48 road locomotives and eight switchers work the line. The total cost of the new railway was US$3.2 billion.

BELOW RIGHT:

Mombasa Terminal, Kenya
The terminal is designed to reflect Mombasa's coastal position: its structure of concentric circles with a central tower representing 'a ripple in the ocean'. Two trains run each way daily, the non-stop Madaraka Express and the 'Inter-County' service, which stops at the seven intermediate stations.

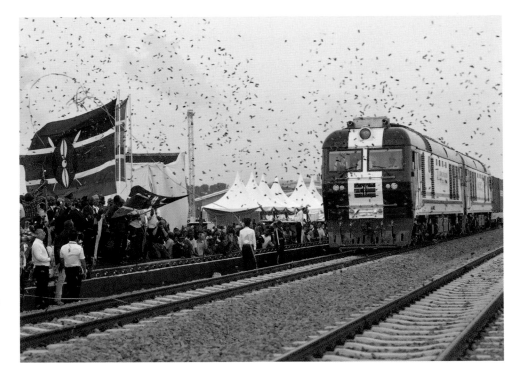

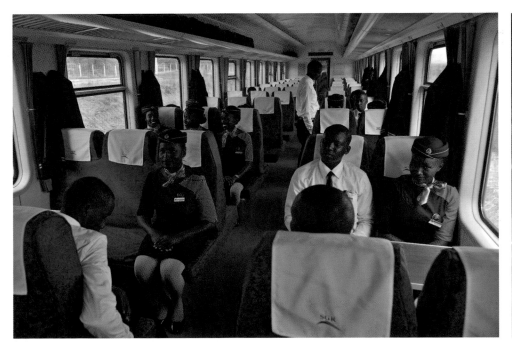

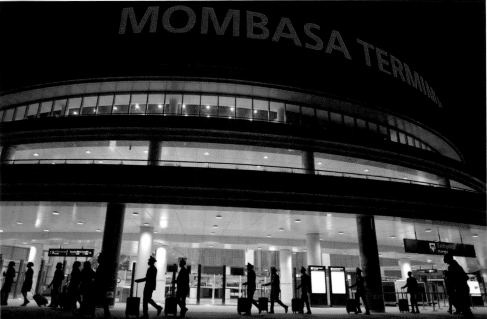

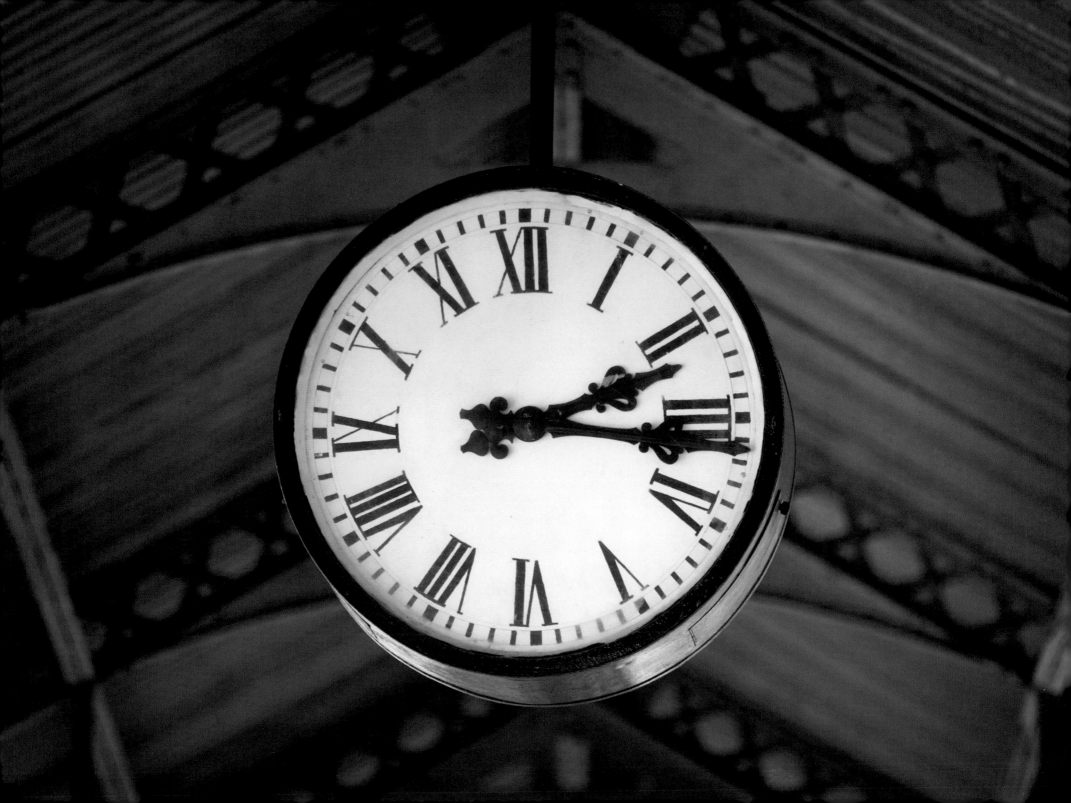

OPPOSITE:

Station Clock, Central Station, Maputo, Mozambique

The Central Station in Mozambique's capital is among the world's finest. Begun in the colonial era in 1906, it was finally completed in Neo-classical Beaux-Arts style in 2016. It serves not only as an international rail centre but as a railway museum and centre for artistic events.

RIGHT:

Fianarantsoa–Côte Est Railway, Madagascar

Madagascar has only two surviving passenger railways – one is this 163km (102-mile) line running inland from the coast at Manakara. The metre-gauge track twists and turns through jungle terrain, stopping many times in a journey that may take five or 15 hours, but for intrepid travellers this is one of the great rail trips.

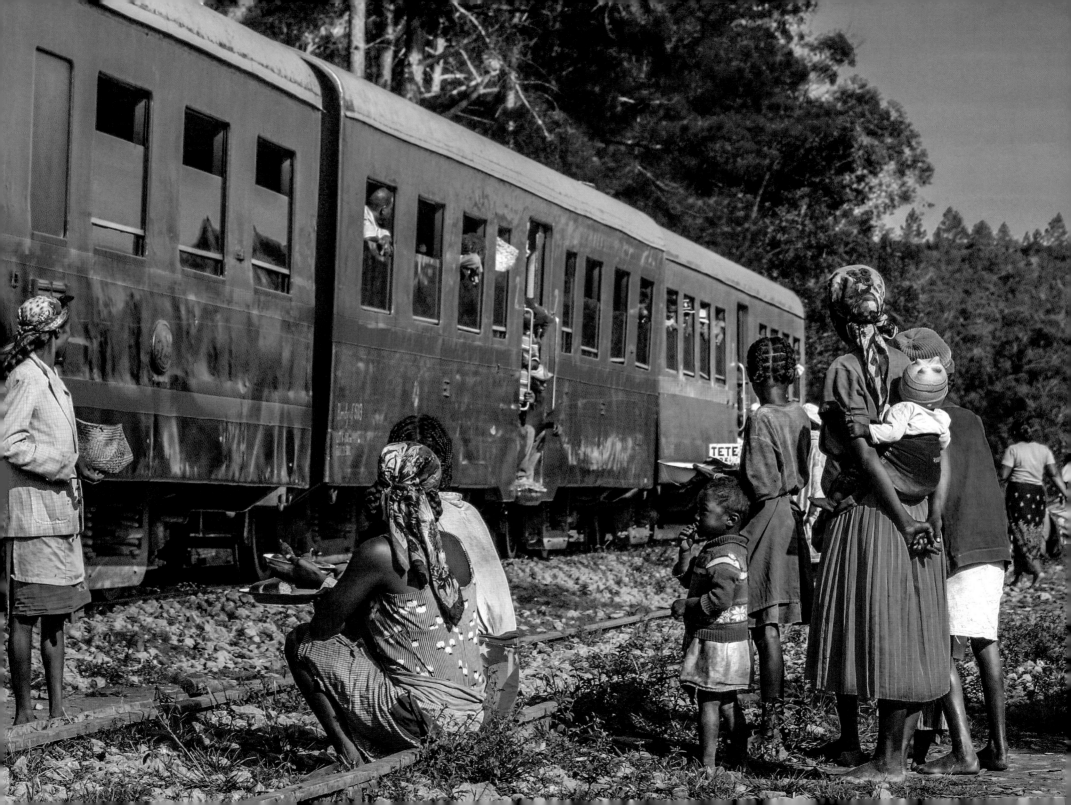

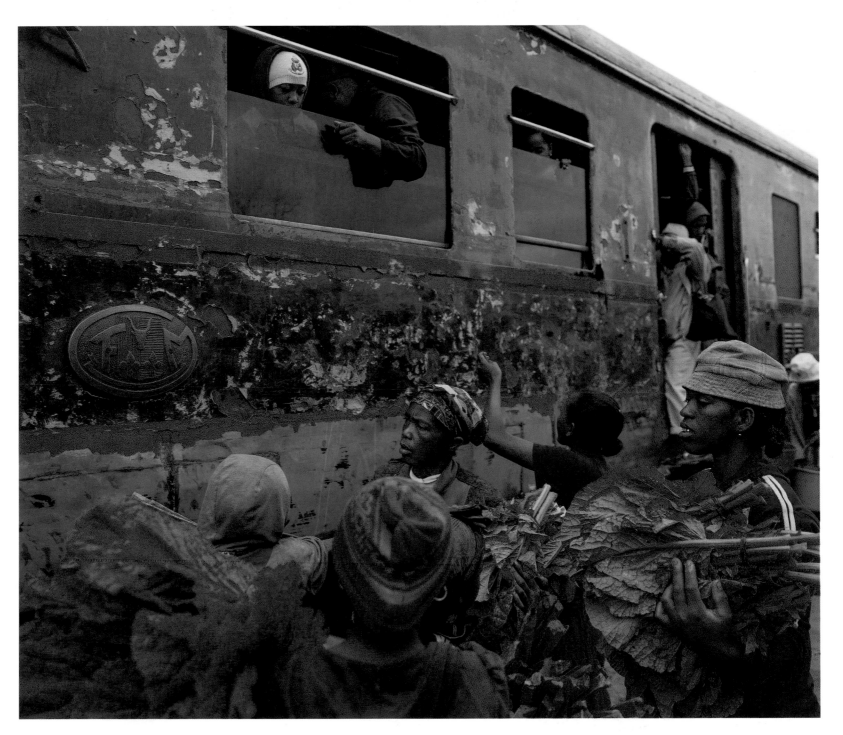

OPPOSITE:

Fianarantsoa–Côte Est Railway, Madagascar
One of the many halting places on the line to Fianarantsoa. The arrival of the single daily train each way is an important moment in the many villages that line the route.

RIGHT:

Fianarantsoa–Côte Est Railway, Madagascar
Though a first-class carriage is normally provided, this is not a tourist train, which adds to its charm for the adventurous visitor. Villagers jostle to sell local produce and vegetables to passengers.

Victoria Falls Bridge, Zambia/Zimbabwe
Spanning the Zambesi River just below the Victoria Falls, this bridge has been a spectacular viewpoint since 1905. Built in England and shipped to Africa in parts, it was intended to be a vital link in the railway linking Cape Town to Cairo. A vintage train headed by ex-Zimbabwe Railways Garratt locomotive No. 512 stands on the bridge.

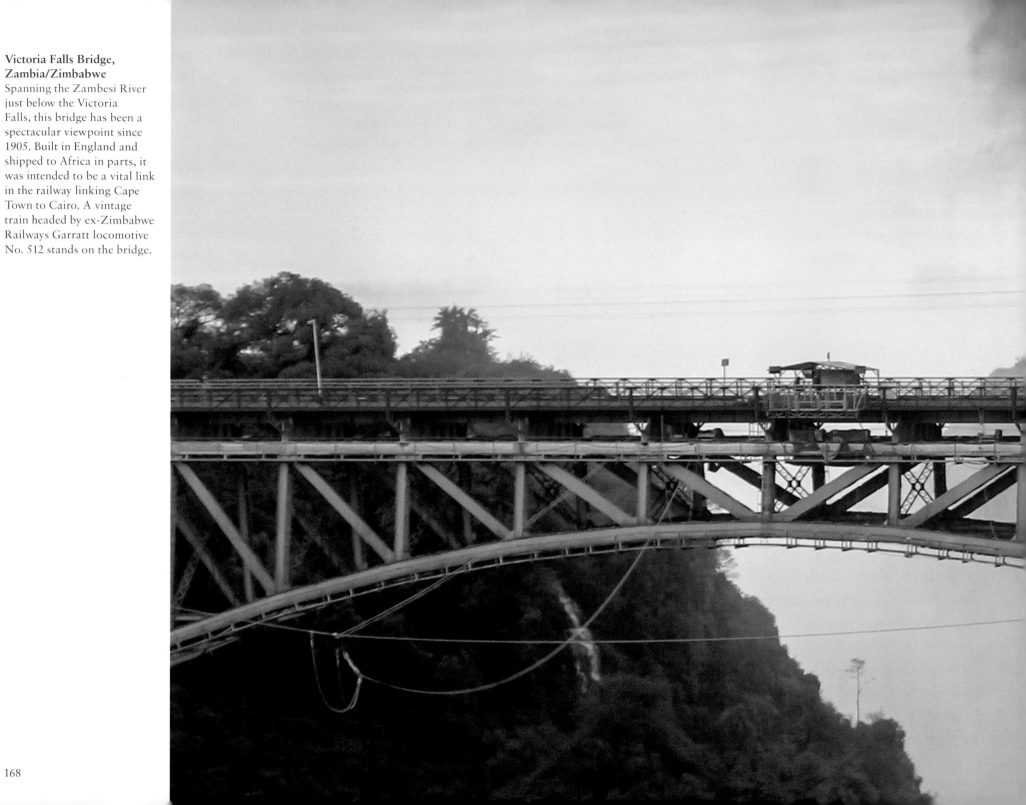

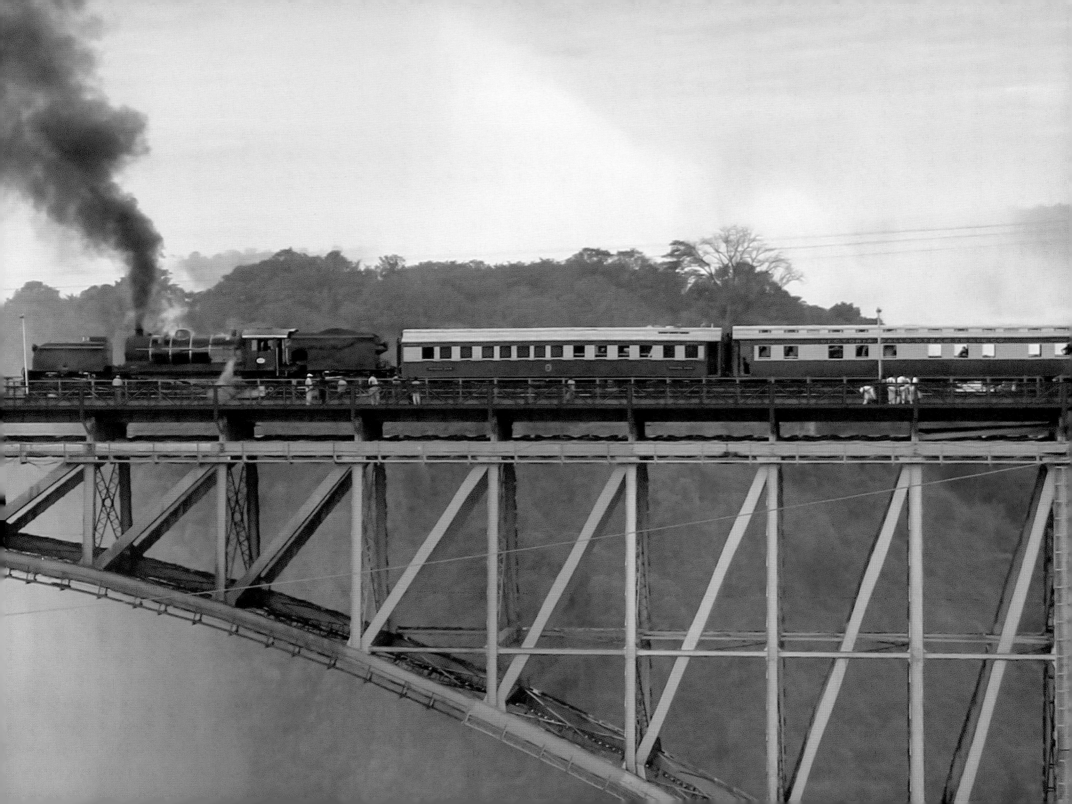

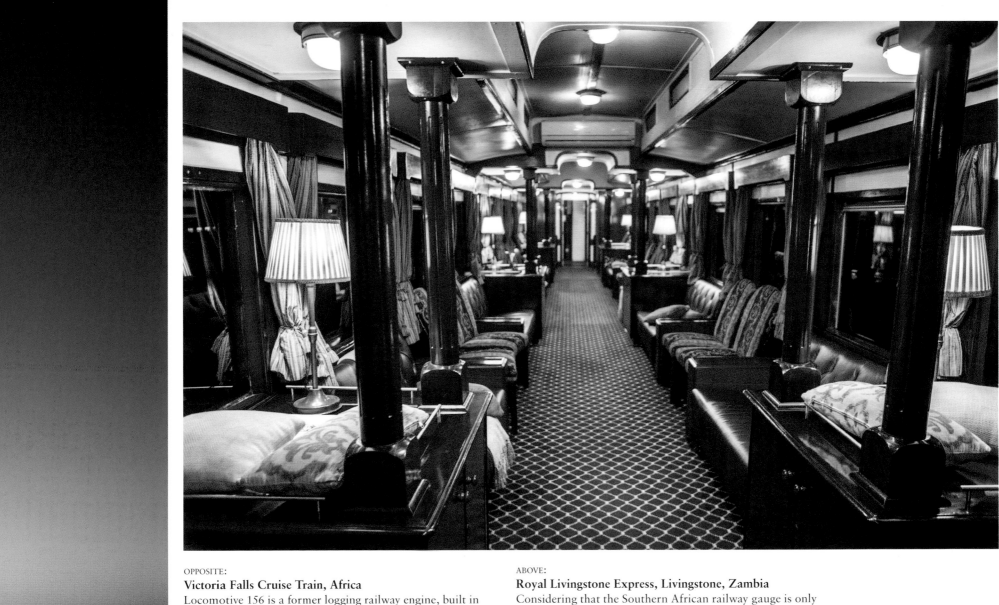

OPPOSITE:

Victoria Falls Cruise Train, Africa

Locomotive 156 is a former logging railway engine, built in 1922. Once owned by wildlife artist David Shepherd, it has been restored to full working order and hauls cruise trains run by Bushtracks Africa, including the Royal Livingstone Express.

ABOVE:

Royal Livingstone Express, Livingstone, Zambia

Considering that the Southern African railway gauge is only 1067mm (3ft 6in), this restored parlour car looks surprisingly roomy. African timber and African motifs feature prominently in the design and furnishings. The clerestory-type roof was important for ventilation in pre-air conditioning times.

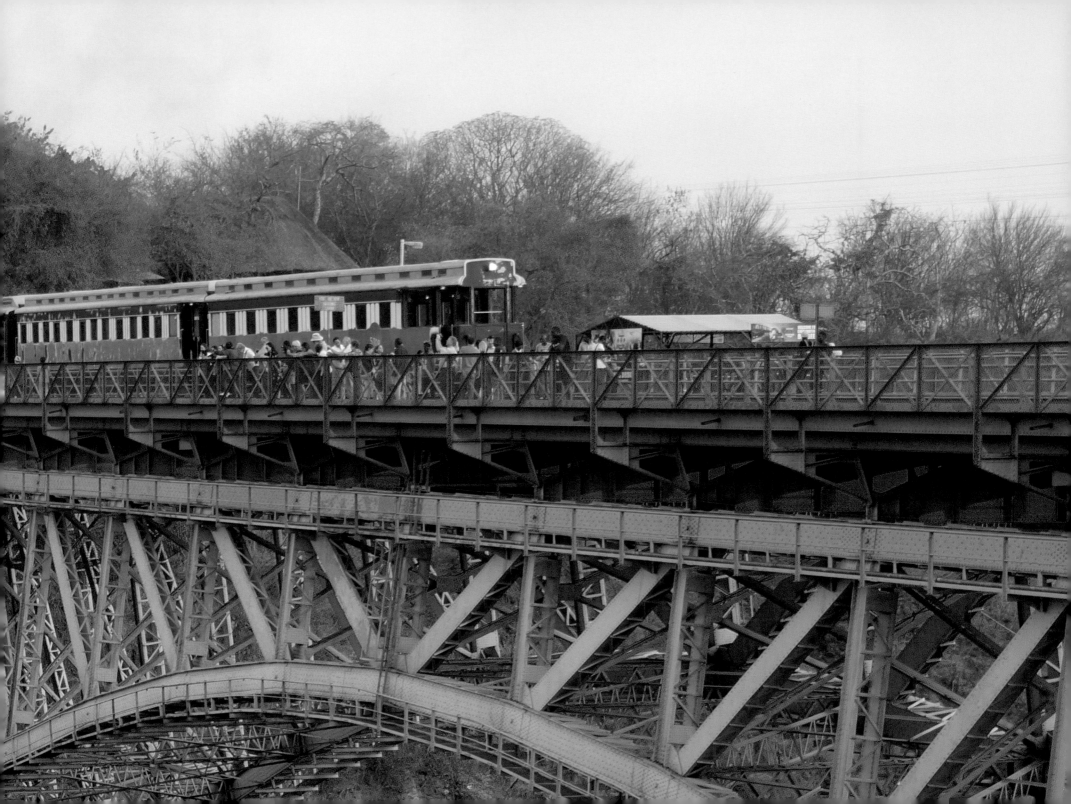

OPPOSITE:

Victoria Falls Bridge, Zambia/Zimbabwe

A cruise train stops on the bridge to give passengers a good view of the falls. The image also gives a good view of the steelwork which, more than a cenury old, though strengthened in 2008, is showing its age. Speed and weight restrictions are currently applied.

RIGHT:

Bulawayo Station, Zimbabwe

Trains run from here to Harare, Victoria Falls, Beitbridge and other destinations within Zimbabwe, and also to Francistown (Botswana) and Maputo (Mozambique). A railway museum, with historic locomotives and rolling stock, is beside the station.

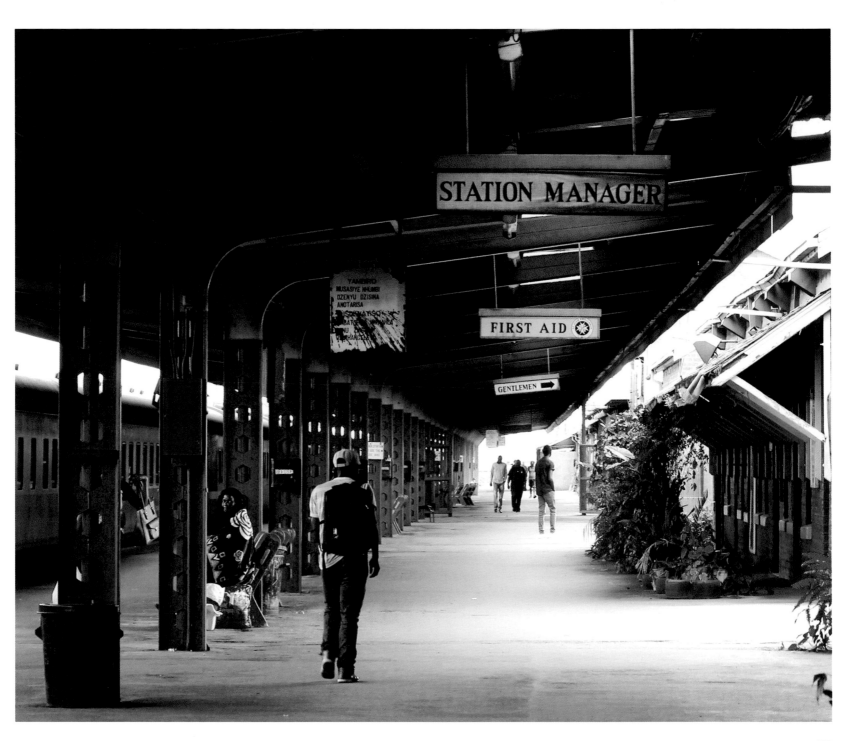

LEFT:

Victoria Falls Hotel, Zimbabwe

Erected by the railway company in 1904 in order to accommodate railway engineers, the Victoria Falls Hotel speedily outgrew that aim because of its situation overlooking the falls, and has developed into a luxury hotel. This is its 'Bulawayo Room' lounge.

BOTTOM LEFT:

Victoria Falls Cruise Train, Africa

A red glow comes through the open firedoors as the locomotive fireman shovels in coal. A large Garratt locomotive consumes around a ton of coal for every 20 miles travelled: tough work, especially in a hot country.

BOTTOM RIGHT:

Zimbabwean Steam

Garratt 2-6-2+2-6-2 No. 512 is one of 18 Class 14A locomotives built in Manchester by Beyer Peacock in 1953 for the then Rhodesian Railways (National Railways of Zimbabwe from 1980). This locomotive type was favoured in Southern Africa for its high water-tank capacity and tractive power.

OPPOSITE:

Victoria Falls Cruise Train, Africa

A typical service for No. 512 is hauling the Victoria Falls tourist cruise trains that operate both from Livingstone in Zambia and from cities in South Africa. The trains travel at relatively low speeds both to avoid undue strain on the 70-year-plus engines and to give passengers a full opportunity to enjoy the passing landscape.

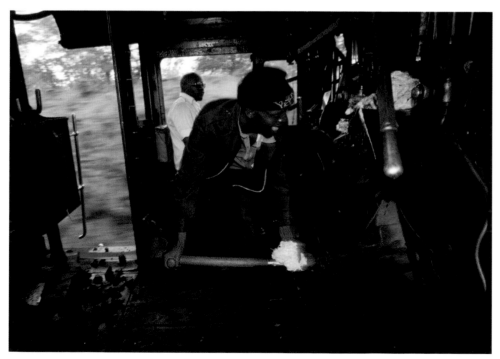

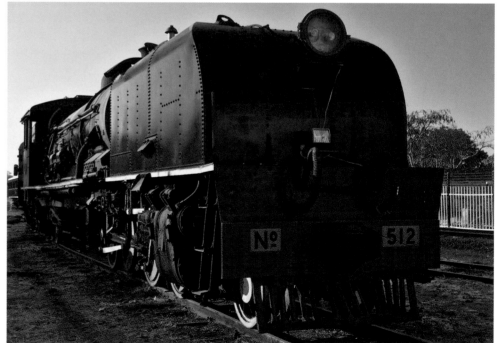

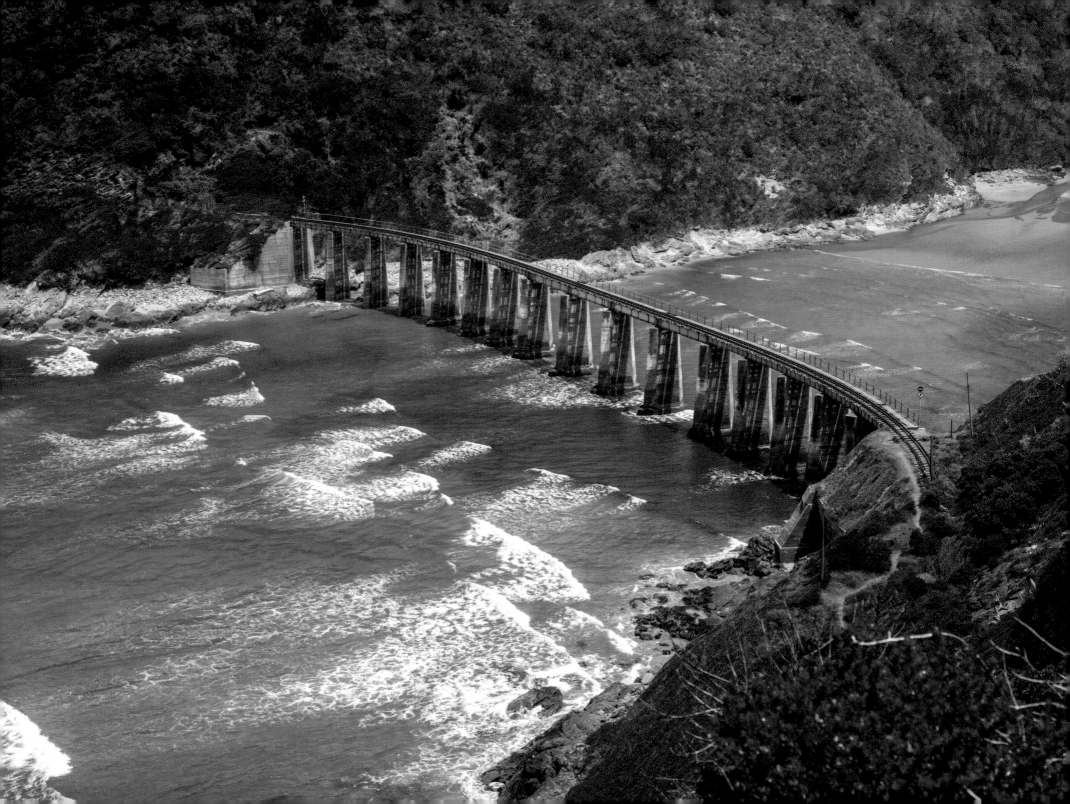

OPPOSITE:

Kaaimans River Bridge, Wilderness, Western Cape, South Africa

Built in 1928 to carry the George–Knysna railway across the estuary, the bridge is 210m (689ft) long and 36m (118ft) high. It has been out of commission following flood damage in 2006, but there are active plans to resuscitate the 'Outeniqua Choo Tjoe' steam services over the line.

RIGHT:

Beaufort West Station, Western Cape, South Africa

The Blue Train originated with the Union Express of 1923, between Cape Town and Johannesburg. It is now a luxury cruise train, running between Cape Town and Pretoria, and occasionally on other routes. The rear carriage is a lounge car with a large observation window for passengers to look backwards.

177

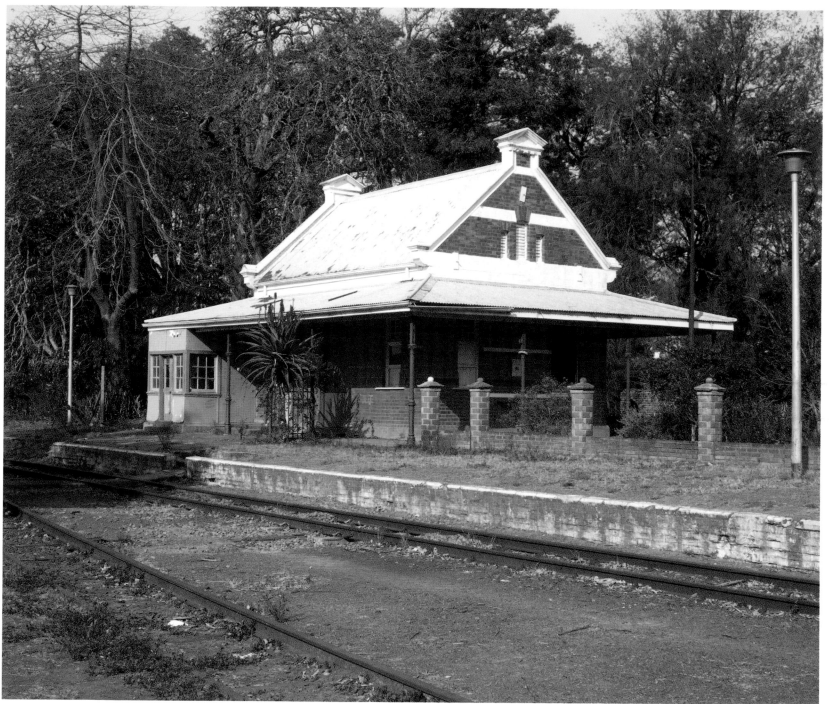

LEFT:

Botha's Hill Station, Kwa-Zulu Natal, South Africa
The station is closed and the old main line from Durban to Pietermaritzburg (apart from the Kloof-Inchanga section) is not in use, though plans have been mooted for a new passenger service between the two cities.

OPPOSITE:

Botha's Hill Station, Kwa-Zulu Natal, South Africa
At 53km (33 miles) from sea level at Durban, the line attains 739m (2424ft) here. A crossing loop allowed trains to cross each other on the single track railway. The levers, coded red for signals, the others for the pointwork, carry instructions in English and Afrikaans.

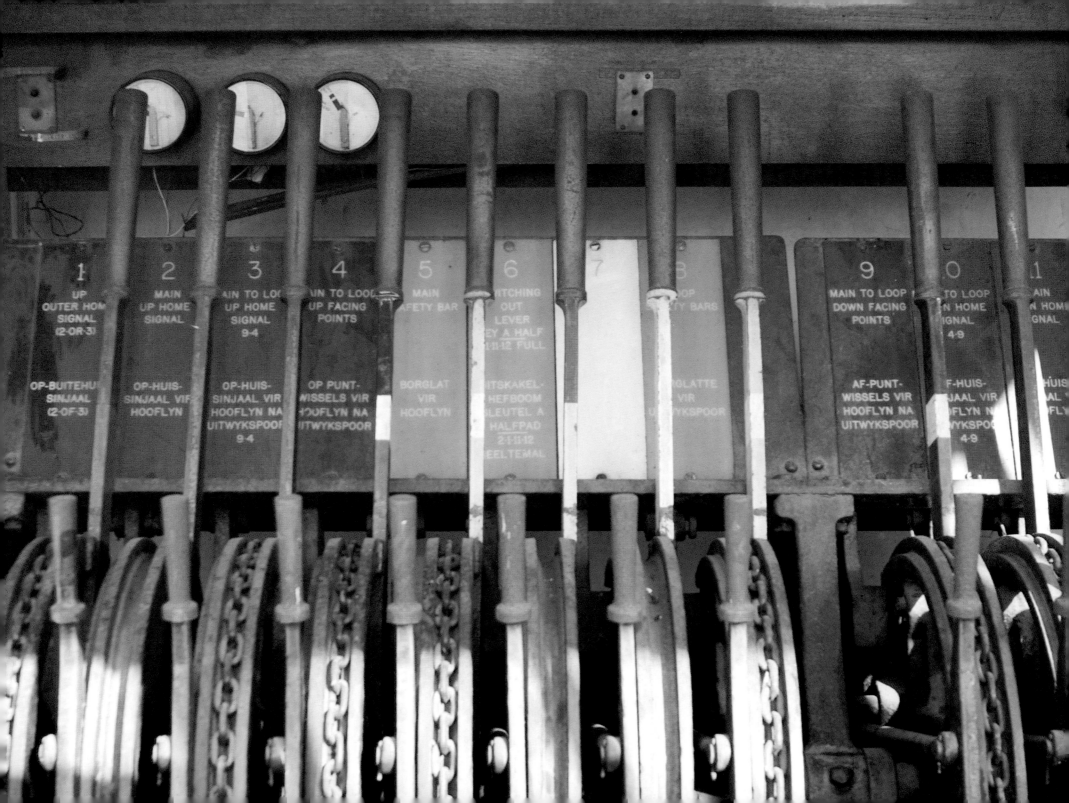

BELOW:

Matjiesfontein Station, Western Cape, South Africa
The village of Matjiesfontein is a national heritage site, with the station, whose buildings date from 1890, a prime element. Its present tranquillity contrasts with an eventful period during the Second Boer War (1899–1902). It has no scheduled services but is a regular venue for tourist trains.

RIGHT:

The Garden Route, Western Cape, South Africa
Below the Outeniqua mountain range and fringing the Indian Ocean, the railway from Cape Town to Port Elizabeth is highly scenic but vulnerable to storm and flood damage. Its famous Outeniqua steam service, seen here in a typical setting, is currently suspended.

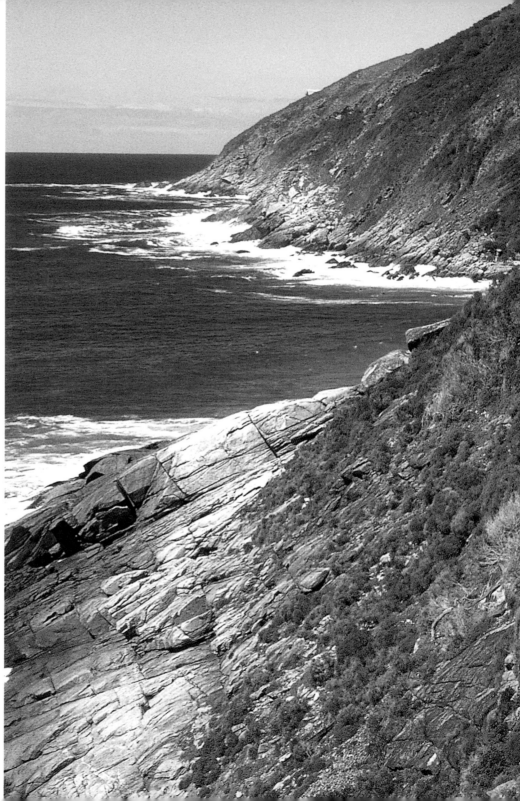

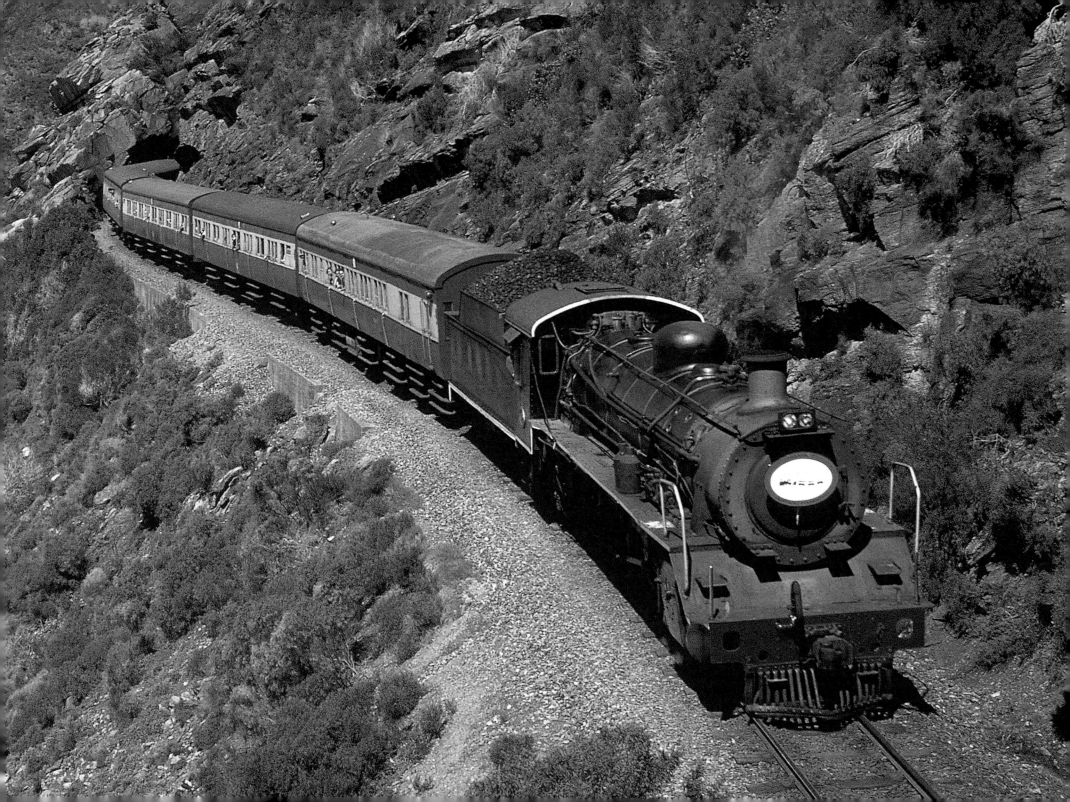

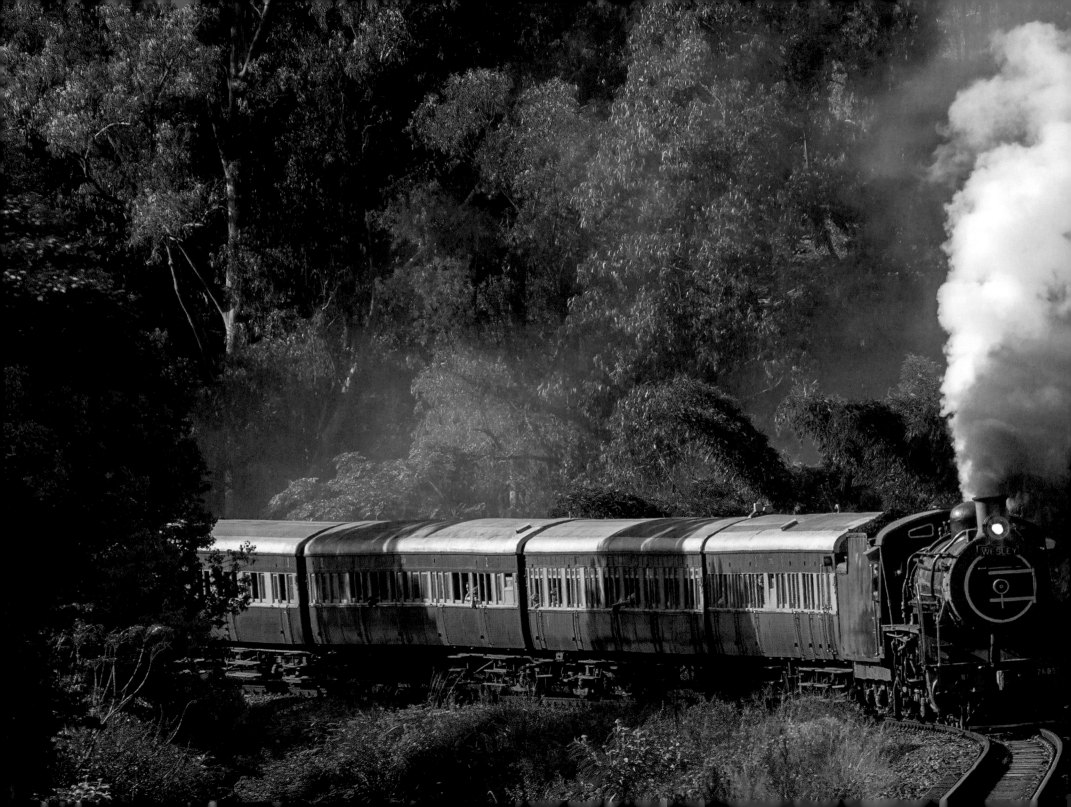

Umgeni Steam Railway, Kwa-Zulu Natal, South Africa
Between Kloof and Inchanga, this volunteer-manned heritage line uses the steeply-graded track of the old Natal main line. Former South African Railways Class 19D 4-8-2 No. 2685 *Wesley*, built in Germany in 1938, heads the train.

'African Explorer' Train, Namibia

Described as a 'rolling hotel', this train operates a 14-day cruise service between Cape Town and Windhoek, capital of Namibia. The journey includes full-day stops at game parks as well as visits to historic settlements, and traverses a variety of landscapes, from jungle and savannah to the Namib Desert.

RIGHT:

Ikeja-along, Lagos, Nigeria

A train moves slowly past a busy market place on the outskirts of Nigeria's largest city. The line linking Lagos and Ibadan was opened in 1901. Nigeria has plans for enhancement and improvement of rail transport, including both new long distance and urban rapid-transit lines.

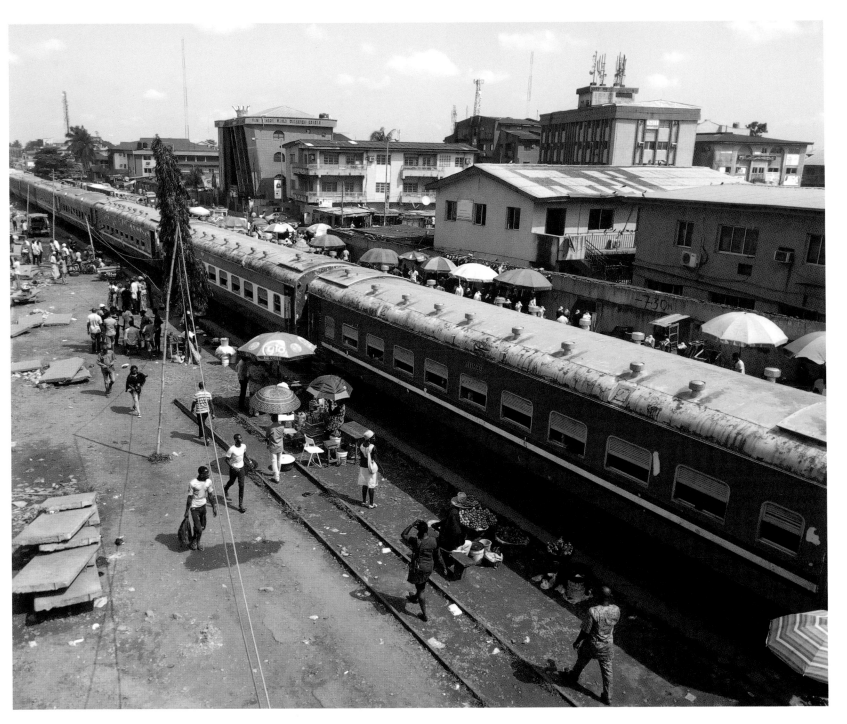

LEFT:
Terminus of the Dakar-Niger Railway, Dakar, Senegal
The arrivals gate of the terminal building. The station is currently closed for reconstruction, though the façade will be preserved. A new line to link the city with the airport is being built from here.

ABOVE:
Dakar Station, Senegal
The railway between Dakar and St Louis was the first in French West Africa, opened in 1885. Operated by modern trains with diesel-electric locomotives, it was still working in 1991 when this photograph was taken at the Dakar terminus, but operations are currently suspended.

OPPOSITE:
Railway Station, Bamako, Mali
The Malian capital was terminus of the Dakar-Niger trains, which ceased to run in 2009. A limited service operates between here and the Malian town of Kayes. An official project is in hand to refurbish the track between Dakar and the Malian border, restoring the international service.

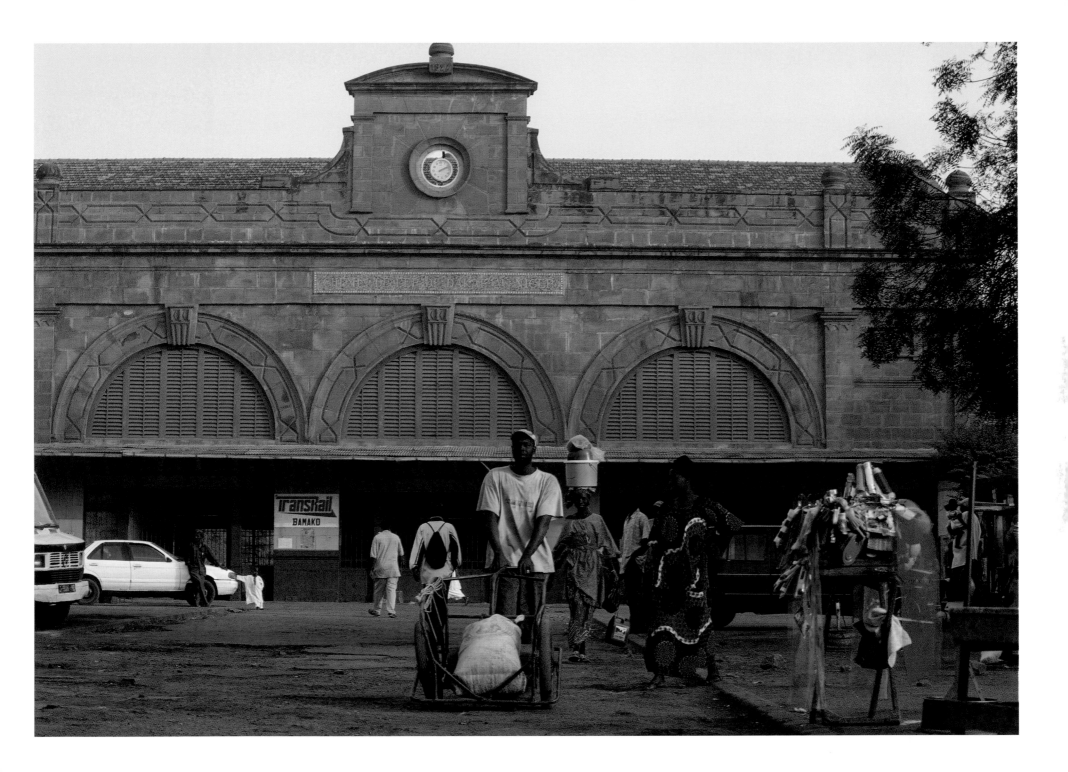

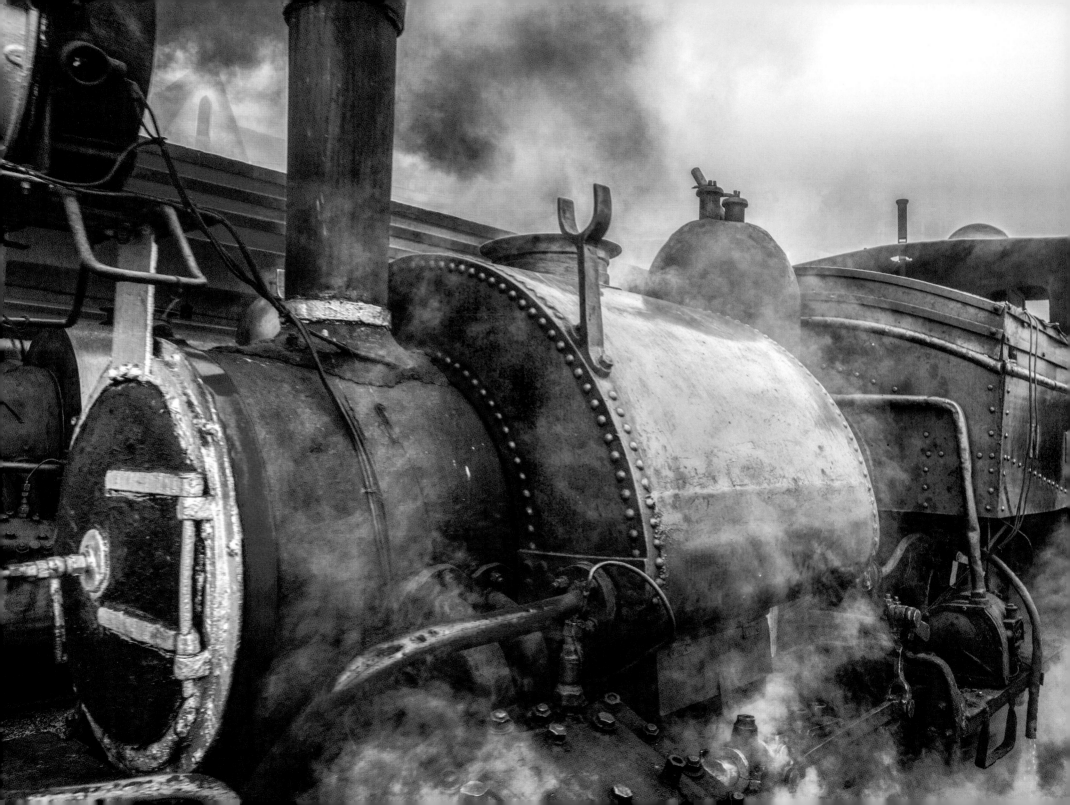

Asia

Some of the most important aspects of railway development in the past 50 years or so have been pioneered in Asia. The high-speed train, running at over 300km/h (200+mph) was introduced in Japan in 1964. China has formed its high-speed network with astonishing rapidity. By 2019 it had over 29,000 kilometres (18,000 miles) – over two-thirds of the world's entire high-speed mileage, with ambitious plans to extend its lines into neighbouring countries. China and Japan are also major exporters of railway materials and equipment. And along with sophisticated technology goes a confidence in design, seen to best advantage perhaps in stations that are created to combine daring architecture with functional efficiency.

Early railways were usually keen not to seem futuristic, in case passengers were scared off, preferring to build termini that resembled traditional palaces or even cathedrals, but stations like Japan's Kanazawa are at the forefront of modern architecture (though, intriguingly, the most admired feature of Kanazawa Station is its wooden temple-entrance style 'Drum Gate'). Still, on railways it is the journey that matters, and at least for those not in a hurry, speed is not a prime requirement. More important for them is the human, mechanical and scenic interest of lines like the Darjeeling & Himalayan Railway or Taiwan's forest lines.

There are many memorable journeys to be made, both short- and long-distance, in Asia and Australia. In Australia, rather than compete with air, long-distance railways have adapted to make their service attractive. The transcontinental journey was once something of an ordeal, but the 'Indian-Pacific' train makes it a pleasant four-day holiday experience.

OPPOSITE:
Darjeeling Himalayan Railway, West Bengal, India
One of the railway's diminutive Class B saddle tank engines.
These were first introduced in 1889. The 610mm (2ft) gauge
line, incorporating spiral loops, zig-zags and steep gradients,
partly follows the line of a cart road from New Jalpaiguri as it
climbs around 2100m (6890ft) to Darjeeling.

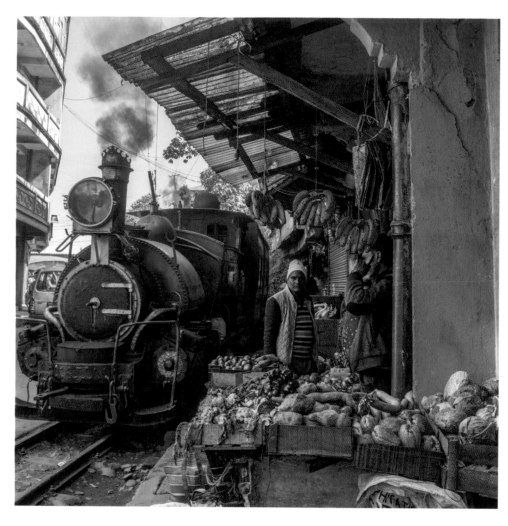

ABOVE:

Darjeeling Himalayan Railway, West Bengal, India
Train passing Ghoom, at 2225m (7300ft). The entire 88km (55-mile) railway, completed in 1881, is a UNESCO World Heritage Site. Most services are run by diesel locomotives, with the surviving tank engines, all built in Glasgow, used for special excursions.

RIGHT:

Darjeeling Himalayan Railway, West Bengal, India
Ready for the downhill return to New Jalpaiguri, a class NDM6 four-wheel diesel stands at Darjeeling, upper terminus of the line, with the locomotive shed in the background and the town buildings rising beyond.

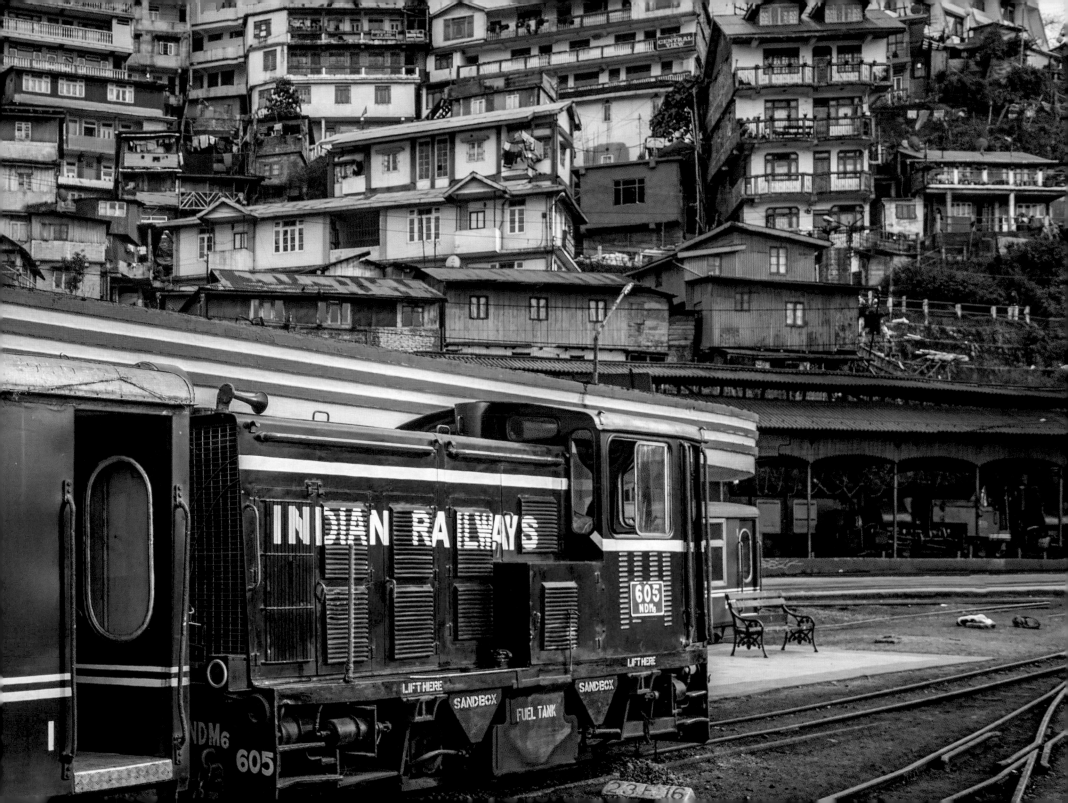

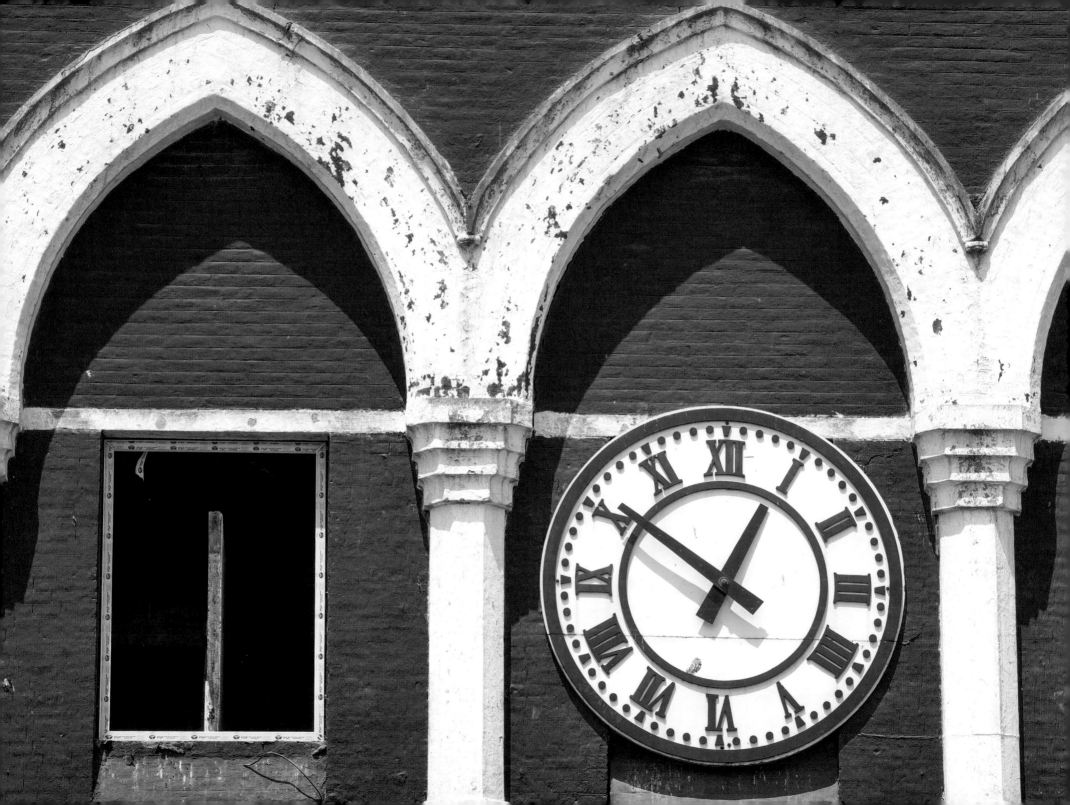

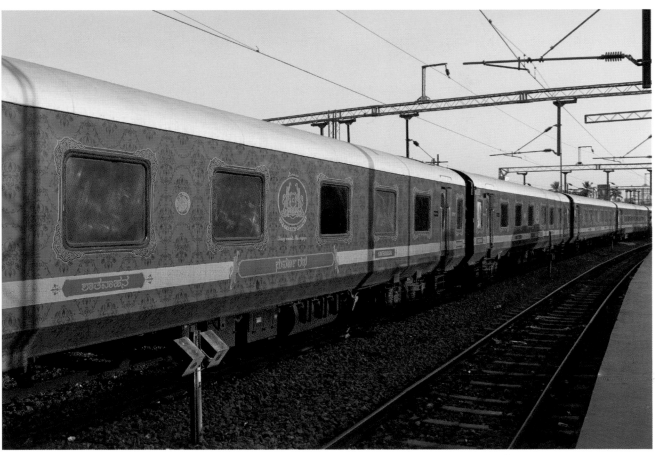

LEFT:

Delhi Junction Station, India
The clock in the centre of the façade of Delhi's oldest station. It dates back to 1864 but the present buildings were erected in 1903, their style intended to match the nearby Red Fort. Express trains leave here for Kolkata, Allahabad, Chandigarh and many other cities.

ABOVE:

Maharajas Express, India
India's 'palace on wheels' is a luxury train that offers multi-day cruise trips to such places as Jaipur, Agra, the 'Golden Triangle' and Fatehpur Sikri. The terminal stations are at Delhi and Mumbai. This is the rolling stock of the 'Golden Chariot' train, established in 2008, whose 11 newly-refurbished coaches run on two routes in Karnataka Province.

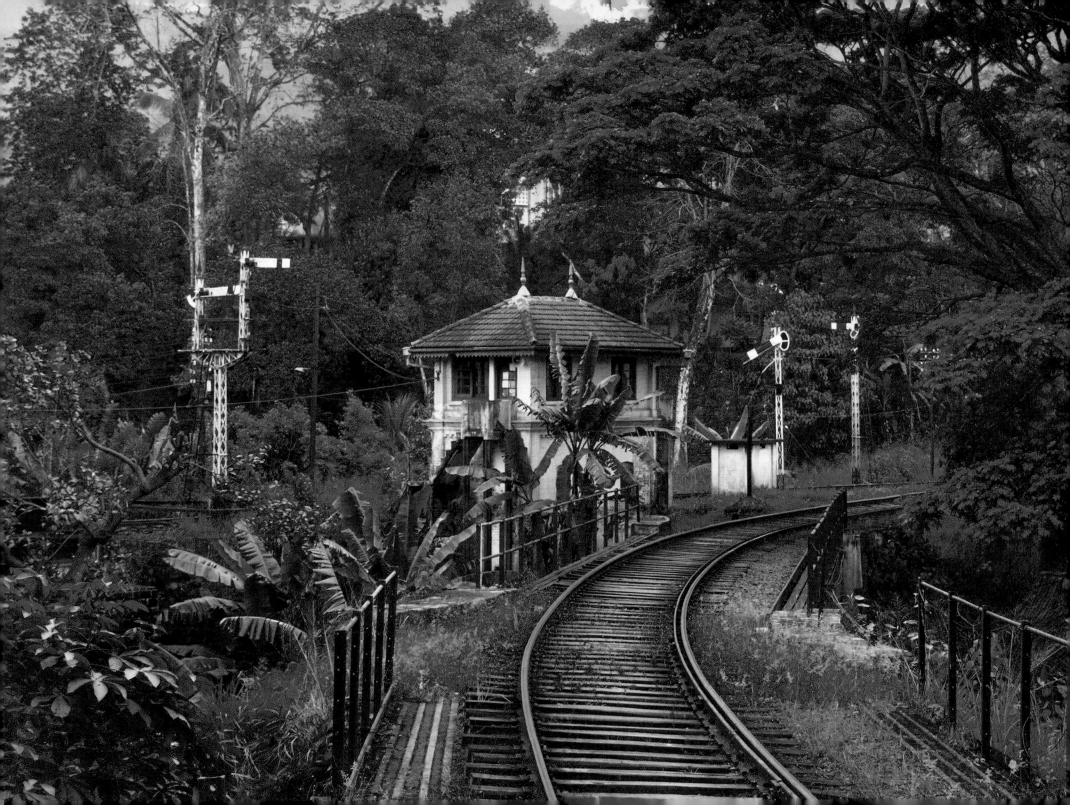

LEFT:

Kandy–Badulla Line, Sri Lanka

Classic British-type signal posts and signal cabin at a junction on the line. Passing through lush rainforest country, the Kandy–Nuwara Eliya–Badulla route is one of many which claim to be the 'world's most scenic railway'.

RIGHT:

Colombo Fort Station, Sri Lanka

A departure board at Colombo's main station, opened in 1908. Sri Lankan Railways are engaged in a long-term programme to modernize stations, track, information systems and rolling stock.

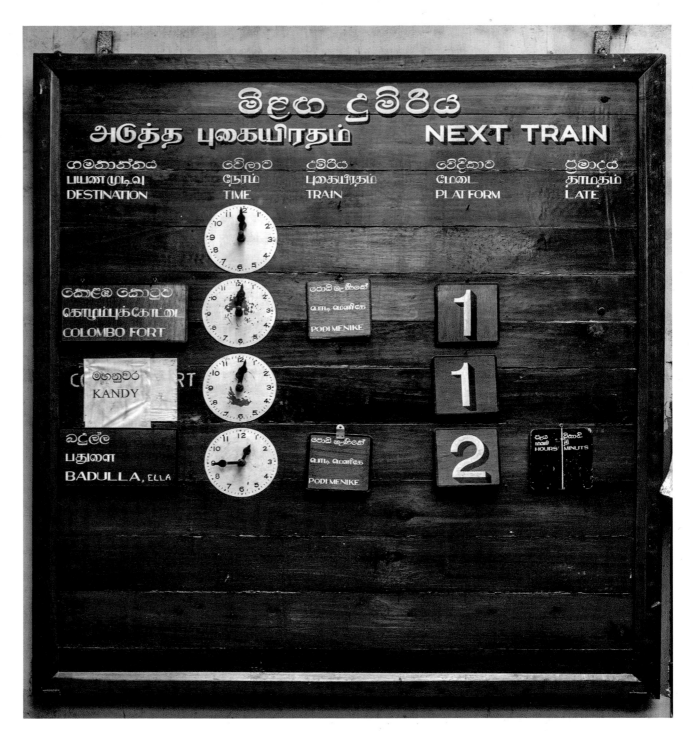

195

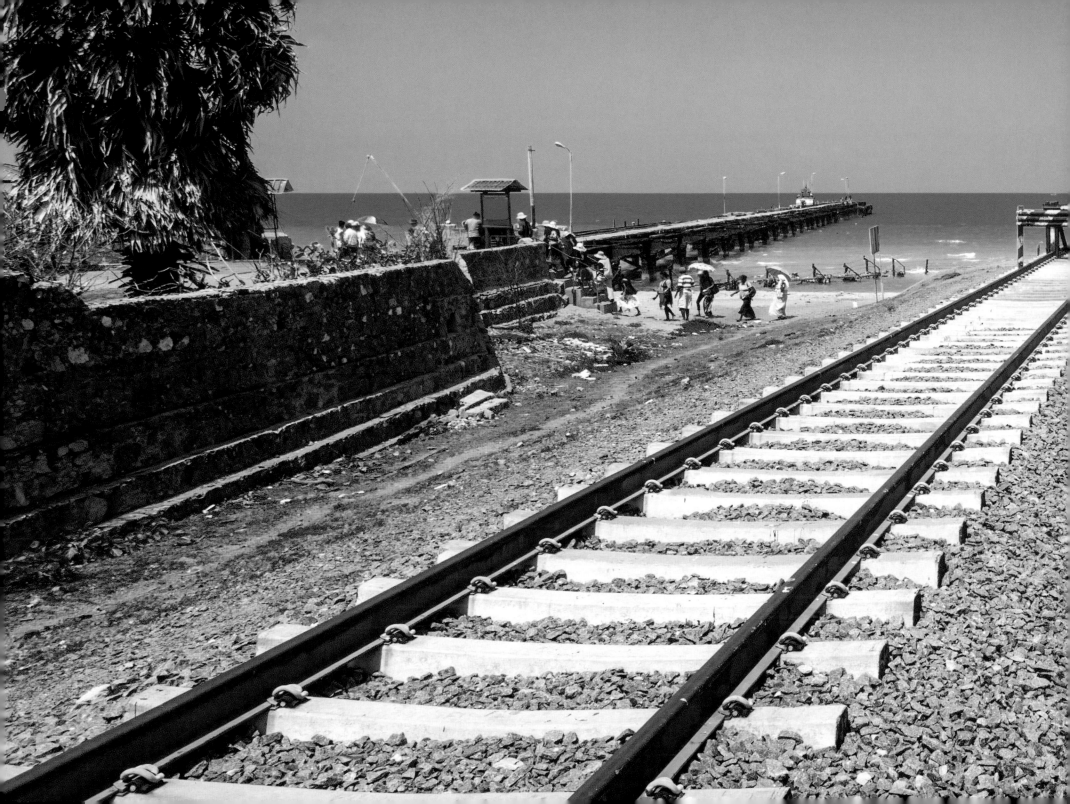

Talaimannar Pier, Sri Lanka
The northern extremity of Sri Lankan Railways. Situated at the nearest point to India, the Mannar line opened in 1914 but was abandoned in 1990, reopening in 2015 after the cessation of hostilities in the region. Day and night express services run from here to Colombo.

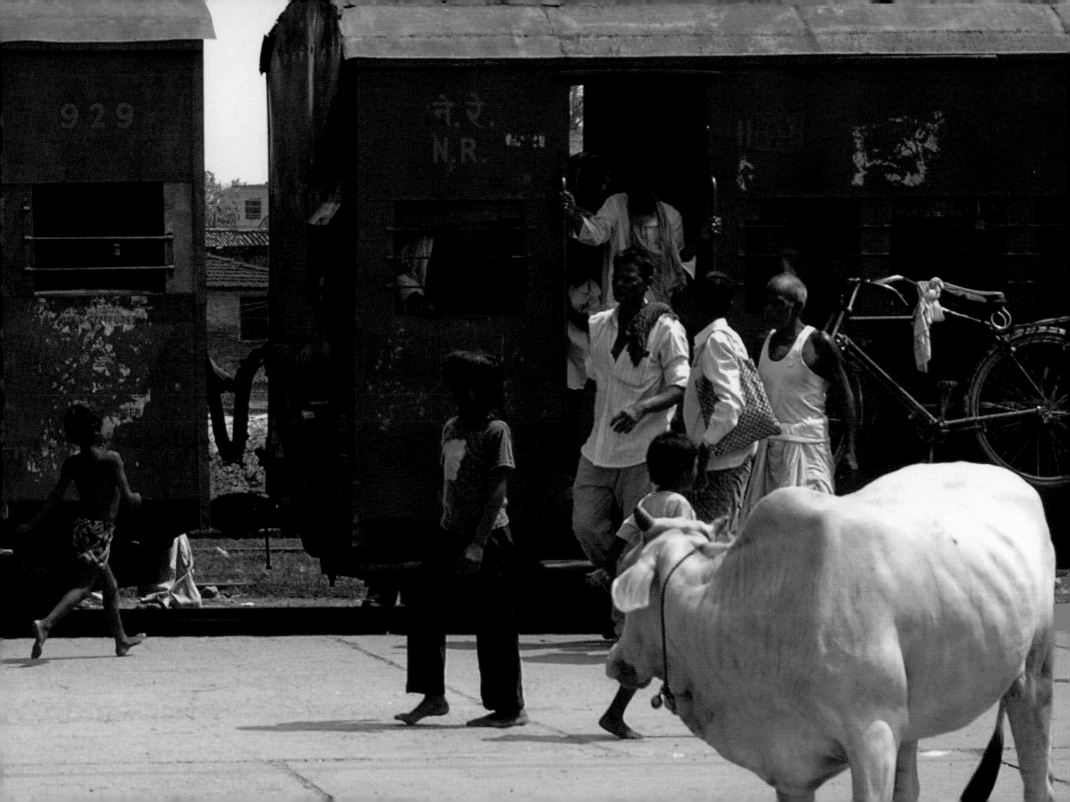

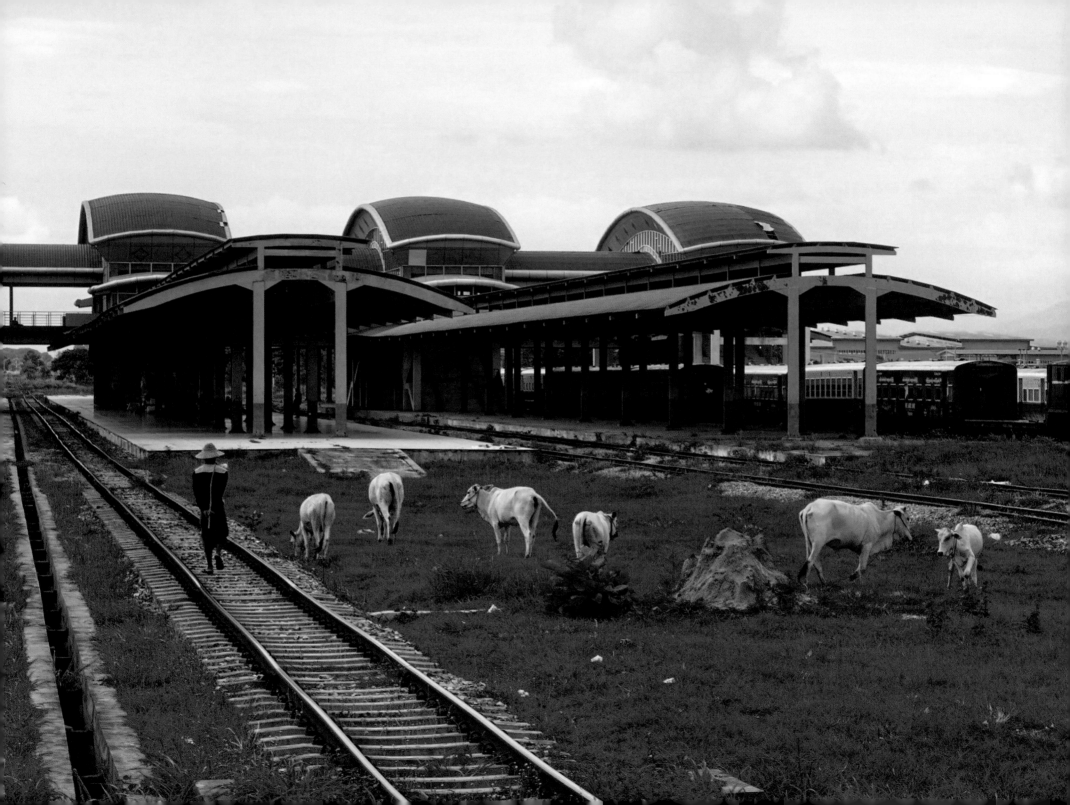

LEFT:

Naypyidaw Station, Myanmar

Since 2005 the new city of Naypyidaw has been the country's capital. The station was built in 2009 and is a stopping point on the main line between Yangon and Mandalay. Five trains run each way daily between here and Yangon.

ABOVE:

Myanmar Railways

Trains cross at a station on the Mandalay–Yangon line. The locomotive is a French-built Alsthom diesel-electric Bo-Bo-Bo type of 1957 vintage. Myanmar has an extensive railway network, most of it in poor condition. Large-scale renovation plans have been announced.

PREVIOUS PAGES:

Janakpur Station, Nepal

This is the terminus of a line from Jainagar in India, and at present Nepal's only passenger railway. Built to a 762mm (2ft 6in) gauge in 1937, it was primarily intended to carry timber. Since 2018 it has been widened to the Indian gauge of 1676mm (5ft 6in), and new extensions are under construction.

Thai-Burma Railway, Kanchanaburi, Thailand
Tourist traffic helps maintain the line and trains on the Burmese–Thai Kanchanaburi line, the notorious 'Death Railway' constructed by prisoners of war and forced civilian labour in World War II. Its grim origins are hard to forget despite the scenic jouney.

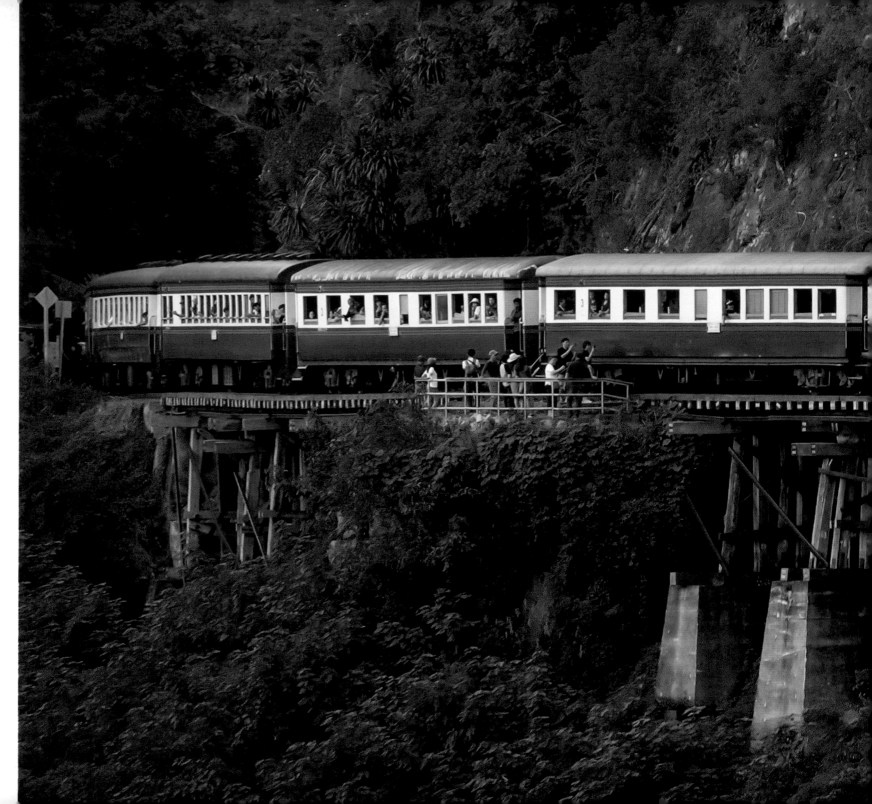

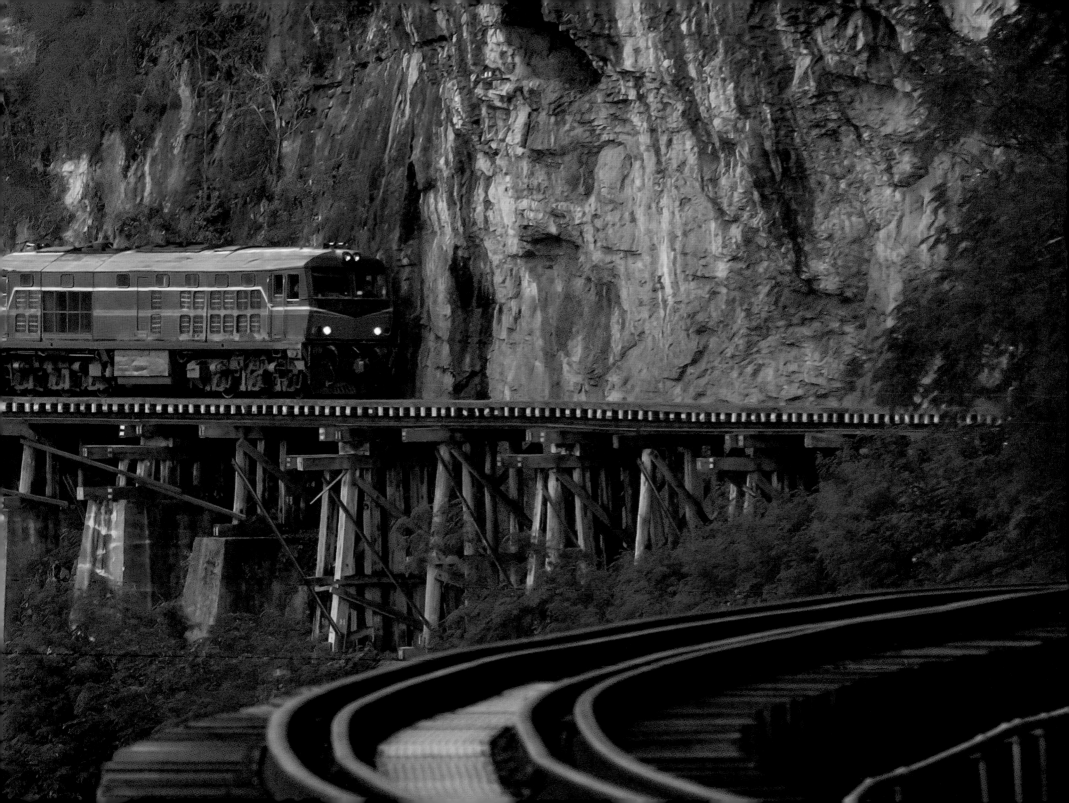

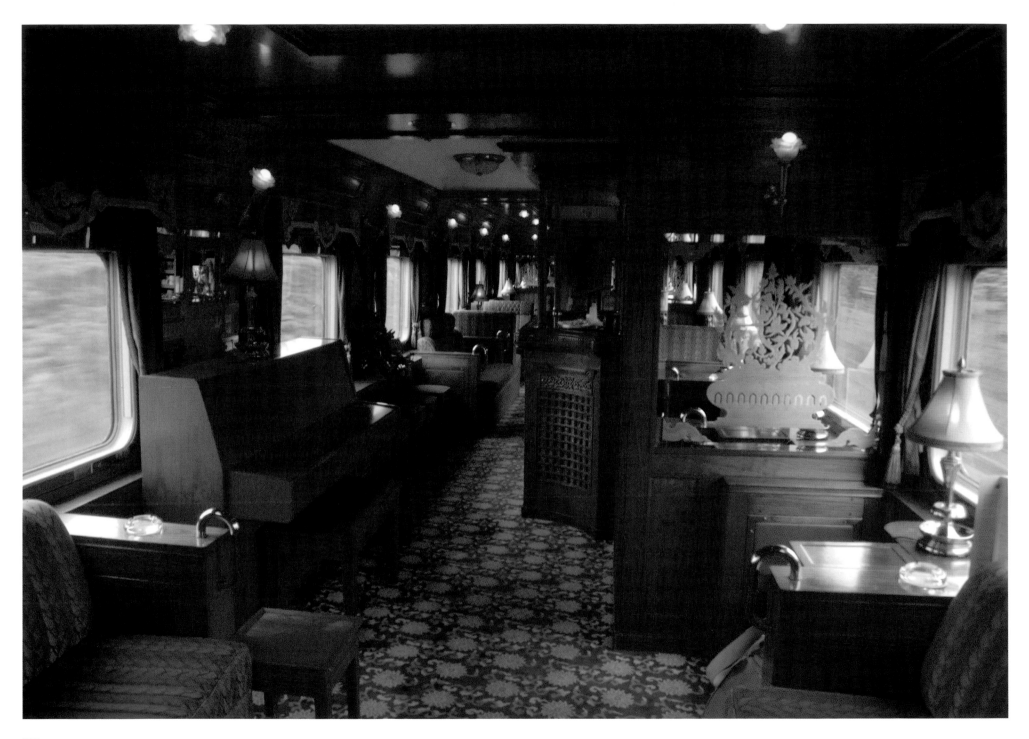

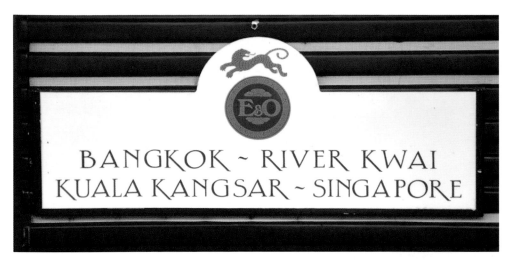

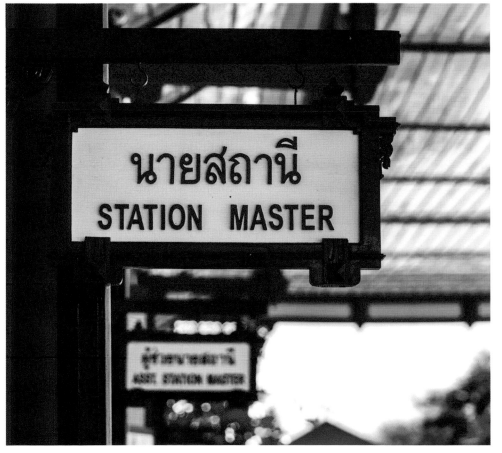

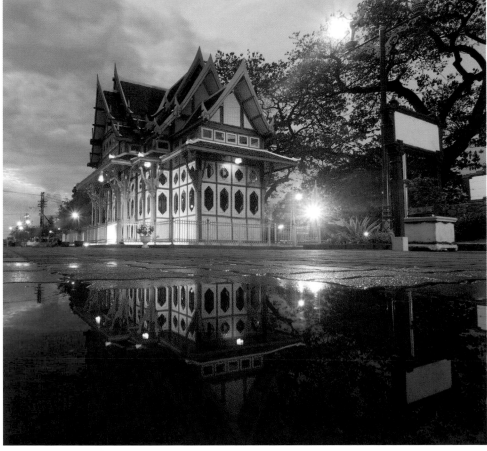

OPPOSITE AND TOP LEFT:

Eastern & Oriental Express, Singapore

Operating luxury trains from Singapore through Malaysia and Thailand, here is another contender for the world's finest cruise train. Its carriages, originally built for use on sleeper trains from Auckland to Wellington in New Zealand, have been refurbished to high standards, and two 'presidential suites' are available on each train.

BOTTOM LEFT AND ABOVE:

Hua Hin Station, Thailand

Its style reminiscent of a Thai temple, Hua Hin station owes its splendour to King Rama VI, who had a royal waiting room here, and to the town's status as a high-class seaside resort. It stands on the Bangkok–Sungai Kolok line, about four hours' journey from Bangkok.

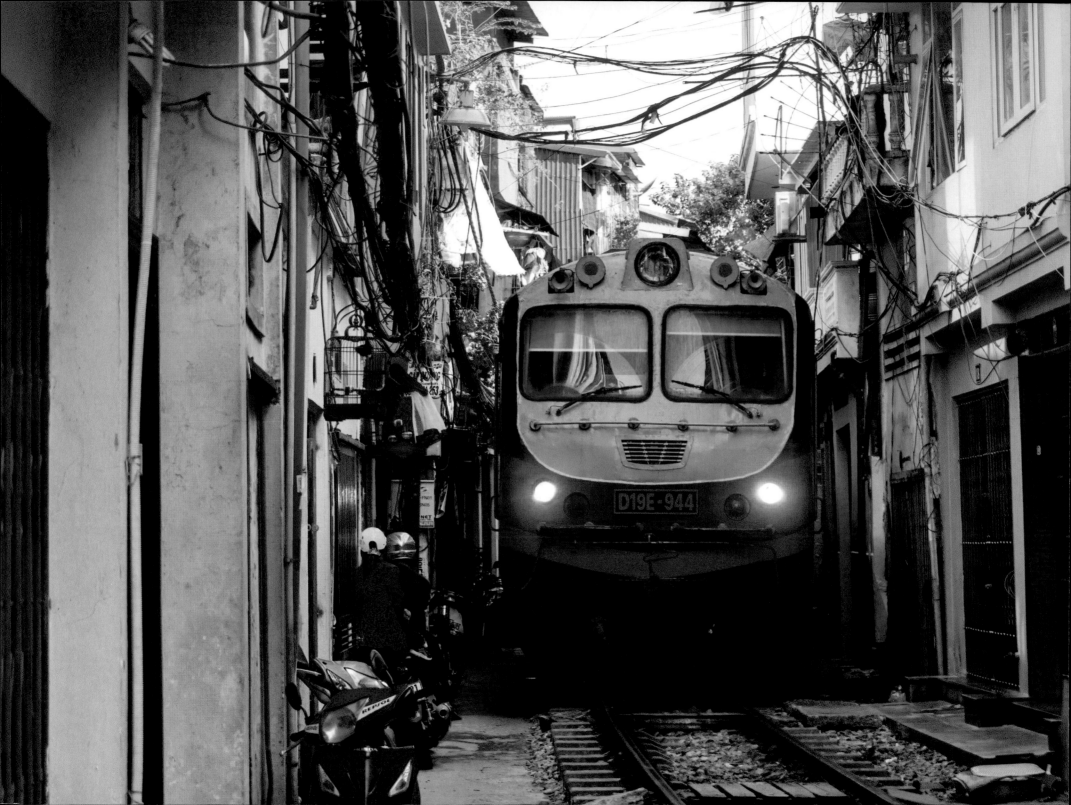

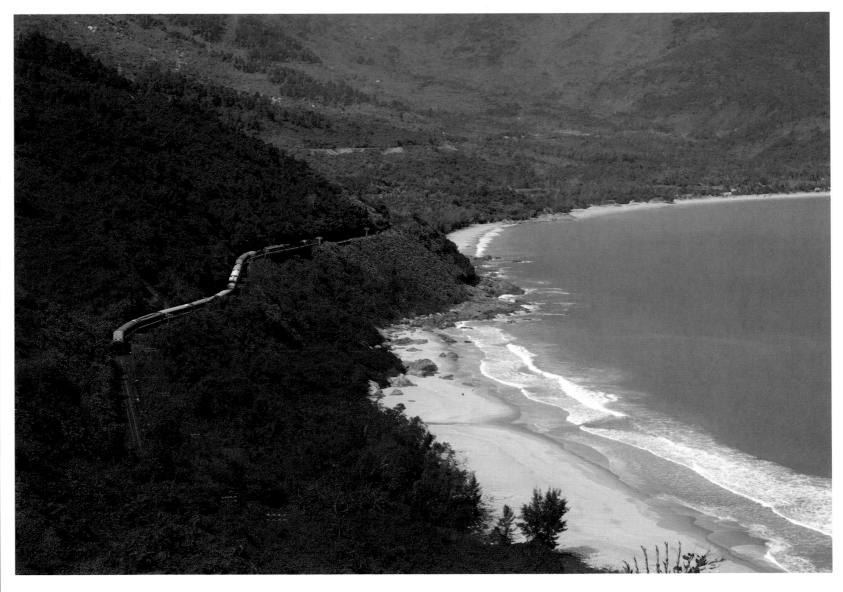

LEFT:
'Train Street', Hanoi, Vietnam
Known to visitors as 'Train Street', this thoroughfare in Hanoi's Old Quarter sees a long-distance train squeeze past twice daily, a popular venue for tourists. It is the train from Hanoi to Ho Chi Minh City, running 1600km (990 miles) on the single metre-gauge track between the two cities.

ABOVE:
Hue–Danang Line, Vietnam
Between the Annamite Mountains and the sea, a northbound train from Danang to Hue runs above Lang Co Beach on its way towards the Hai Van Pass through the mountains. The journey takes around three hours.

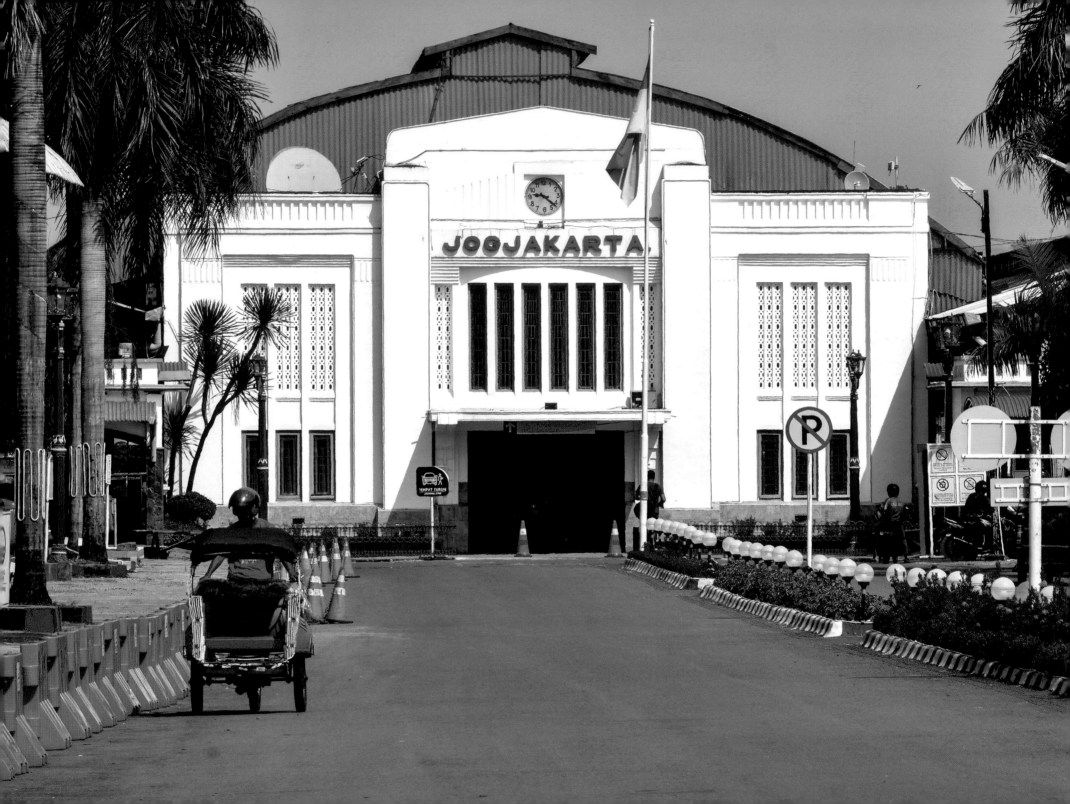

OPPOSITE:
Jogjakarta Station, Java, Indonesia

An unapologetically corrugated iron train shed rises behind the white stuccoed entrance to the main terminal, also known as Tugu Station, in this royal city and former Indonesian capital. Long distance trains run east and west between here and most major cities in Java.

RIGHT:
Rewulu, Java, Indonesia

Is that locomotive moving? An apparently serene lady motorcyclist rides over a rail crossing in front of a Indonesian Railways GEU20C engine. Rewulu is the site of an oil terminal and the train may be stationary.

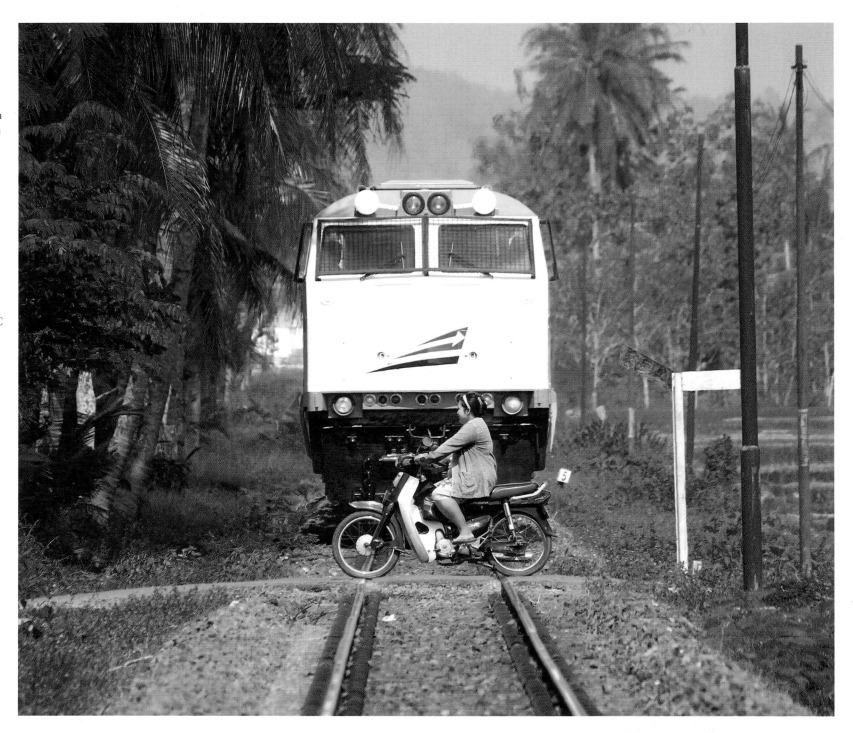

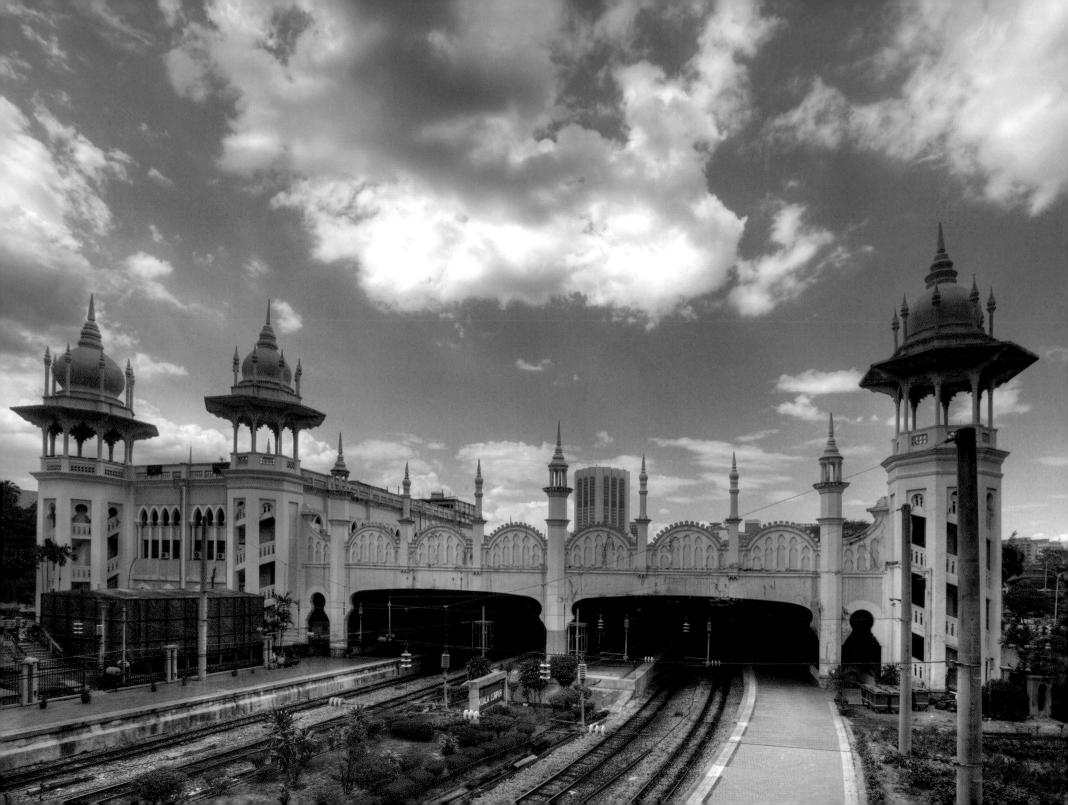

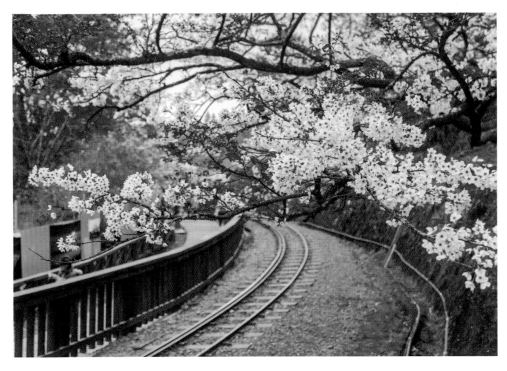

OPPOSITE:
**Old Main Station,
Kuala Lumpur, Malaysia**
With its fragile-looking
domes, spires and
balustrades, Kuala Lumpur's
former main station is
unmistakable. The oriental-
style building was completed
in 1910 under British rule.
The new off-centre Kuala
Lumpur Sentral has drawn
off most of the traffic.

TOP AND BOTTOM LEFT:
**Alishan Forest Railway,
Chiayi County, Taiwan**
Running for 86 kilometres
(53 miles) in Taiwan's
mountainous centre, this
762mm (2ft 6in) gauge line
was opened in 1912 as a
logging railway, bringing
hardwood timber down to the
coast, but now is operated as
a tourist attraction. Visitors
come to see cherry blossom
in spring, to view the sunrise
over the mountains, to escape
the summer heat and admire
scenic views all year.

ABOVE:
**Alishan Forest Railway,
Chiayi County, Taiwan**
Though the Alishan
Railway has vintage steam
locomotives for special tours,
its carriages are modern,
worked by diesel locomotives
on a push-pull system,
making traverse of the several
zigzags on the route much
easier, as it rises to the 2216m
(7313ft) summit level.

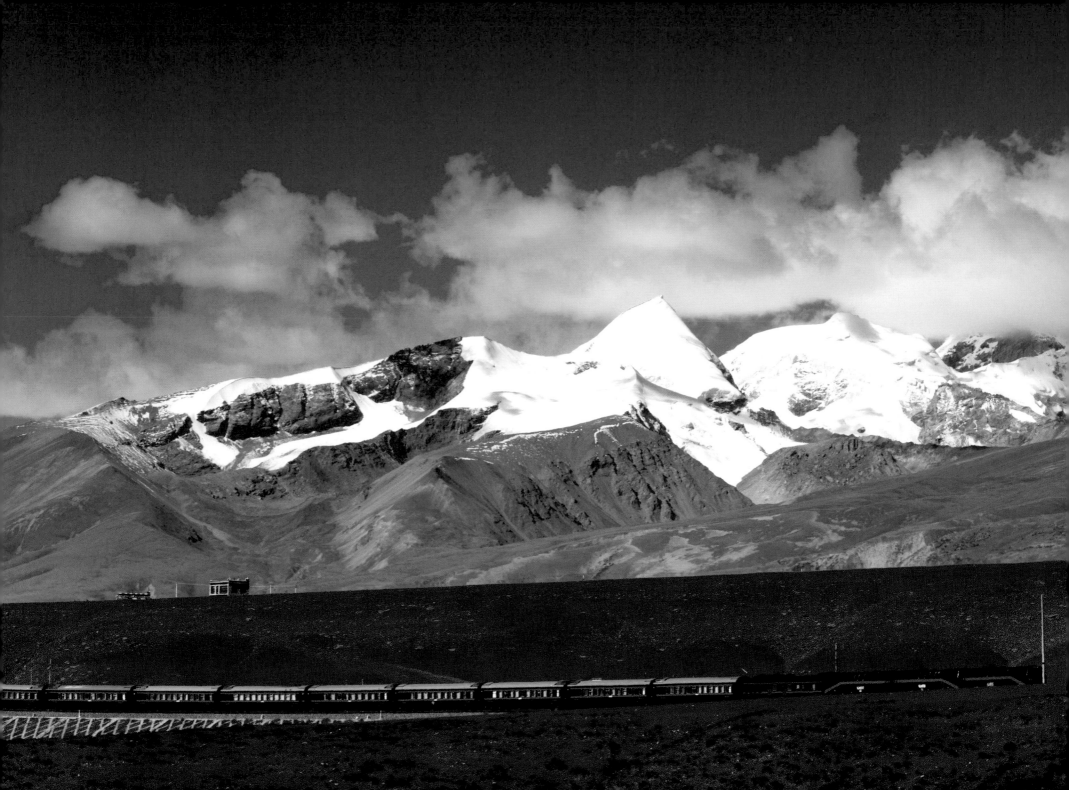

OPPOSITE:

Qinghai–Tibet Railway, Tibet, China

Below the Kunlun Mountains, a train climbs towards the highest railway summit in the world, the Tanggula Pass at 5072m (16,640ft). The 1956km (1215-mile) line opened in 2006, linking Lhasa with Chinese cities including Beijing, Shanghai and Guangzhou. From Lhasa a further line, opened in 2014, leads to Shigatse and, ultimately, Nepal.

TOP RIGHT:

Qinghai–Tibet Railway, Tibet, China

A train near Damxung on the Qinghai-Tibet line. Both 'soft' and 'hard' sleeper classes are available. While the carriages are not pressurised, additional oxygen is pumped in on the stretch between Golmund and Lhasa. The trains also carry medically trained staff.

BELOW LEFT:

Qinghai–Tibet Railway, Tibet, China

A party of Buddhist monks look out at the passing scene on this remarkable railway, of which 550km (340 miles) are laid on high-altitude permafrost terrain.

BELOW RIGHT:

Golra Sharif Railway Museum, Islamabad, Pakistan

At Golra Sharif Junction, such trains as the Mehr Express (Multan–Rawalpindi) and the Kohat Express (Rawalpindi–Kohat) can be caught, but adjoining it is a trip into Pakistan's railway history, opened in 2003 and extended in 2018, with a wealth of artefacts, as well as historic carriages and locomotives.

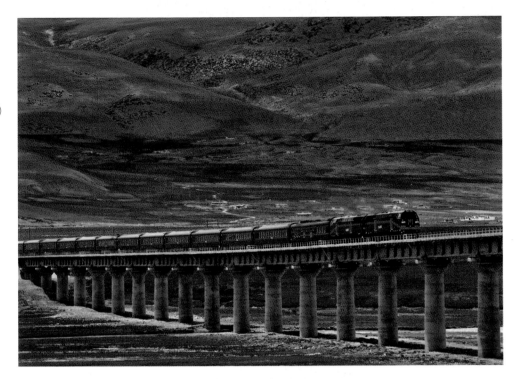

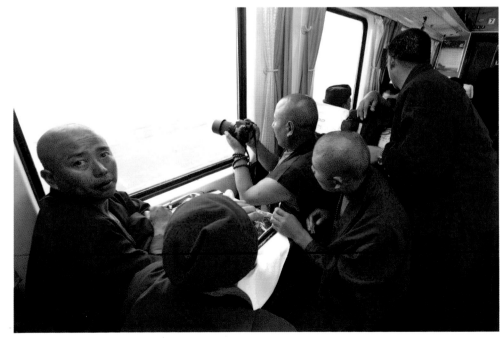

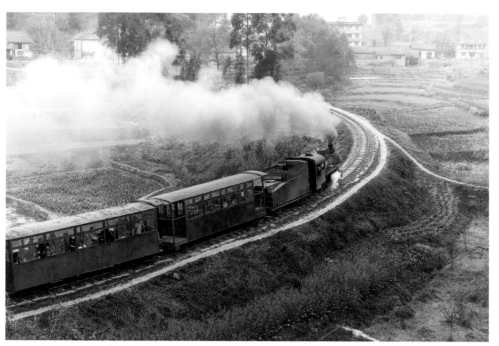

LEFT:

Jiayang Railway, Sichuan Province, China
A preserved line of historical and social interest, built to serve the now closed Jiayang coal mine and its community, and still using the original rolling stock, systems and equipment. A sole concession to modernity is the inclusion of sightseeing carriages on some trains.

BOTTOM LEFT:

Kunming Station, Yunnan Province, China
One of China's ultra-modern showpiece stations, opened in 2016, Kunming is the terminus of high-speed lines from Shanghai, Nanning and Yuxi, making it the transport hub for a vast region of southern China.

BOTTOM RIGHT:

Guizhou Province, China
The Shanghai–Kunming railway, also known as the Huku Line, cuts across a landscape patterned by cole flower fields near Anshun. Grown for nutrition as well as appearance, this flowering vegetable is a member of the *brassica* genus.

OPPOSITE:

Tianjin West Station, Hongqiao District, China
Designed by a German-Chinese team, this futuristic station was opened in 2011. It combines a halt on the Beijing–Shanghai high-speed line with links to regional train services and to the city's underground lines. The vast roof generates the station's electricity through solar panels.

昆明站欢迎您
Welcome To Kunming Railway Station

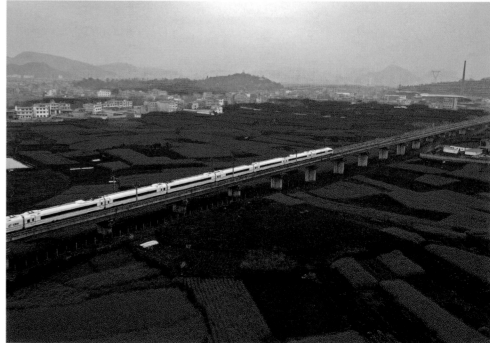

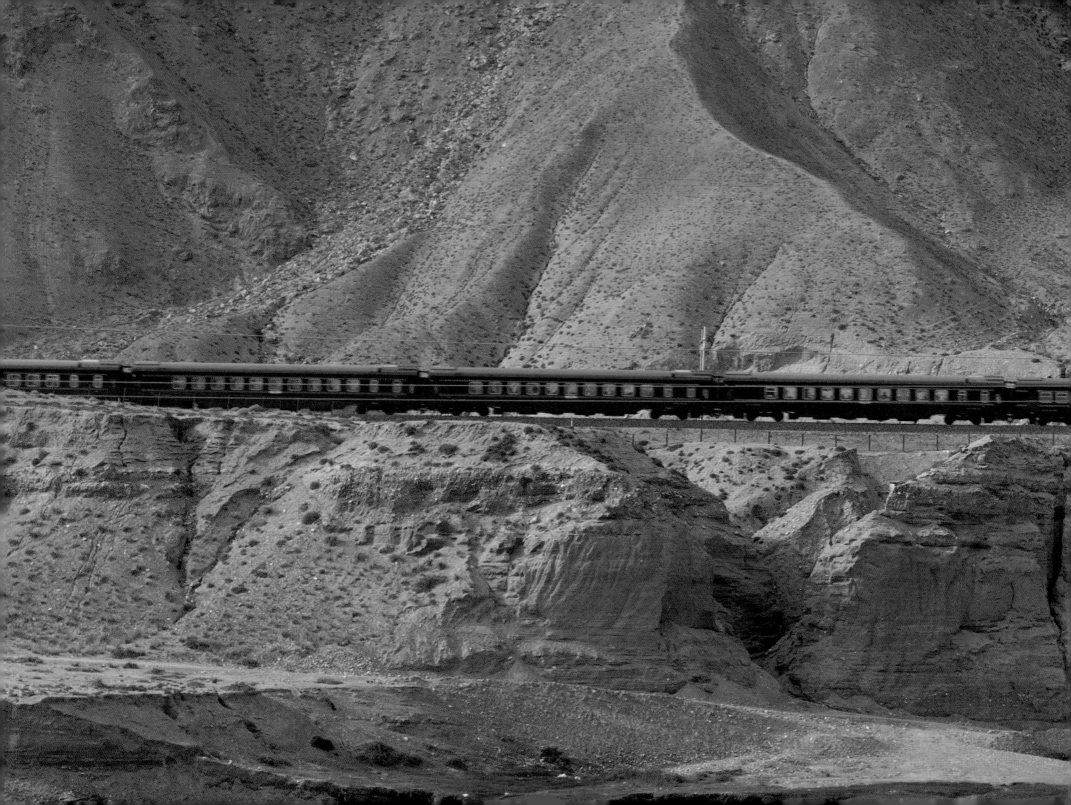

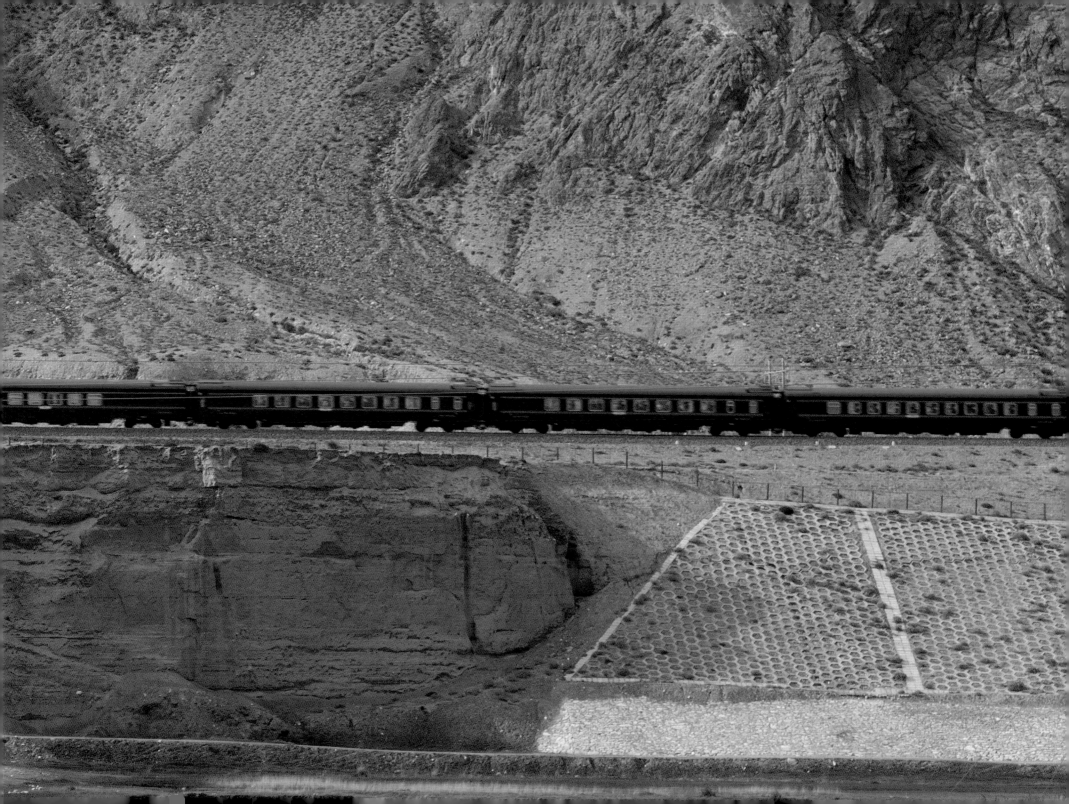

PREVIOUS PAGES:

Qinghai–Tibet Railway, Tibet, China
To reach the Tibetan plateau, the Lhasa railway has to pass the barrier of the Kunlun Mountains. The Kunlun Pass is at an altitude of 4767m (15,731ft).

LEFT:

Kanazawa Station, Ishikawa Prefecture, Japan
Completed in 2005, Kanazawa Station blends modern architecture of a high standard and traditional features of Japanese design. It accommodates the extension of the Hokoriku Shinkansen high speed line from Tokyo.

OPPOSITE:

Kanazawa Station, Ishikawa Prefecture, Japan
In the station's eastern plaza, the Tsuzumi-Mon 'Drum' Gate's design is based on that of hand-drums used in Japan's traditional *noh* plays. Kanazawa is a centre of *noh*. Welcoming visitors, the gate is regarded as a work of art in its own right.

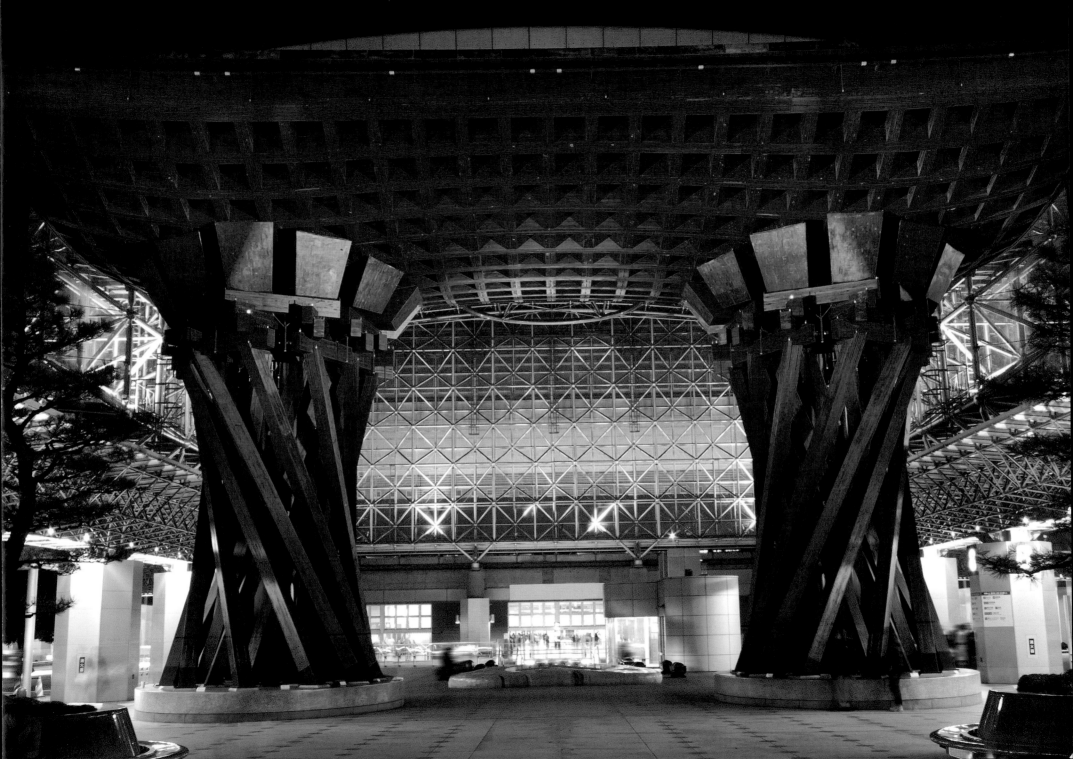

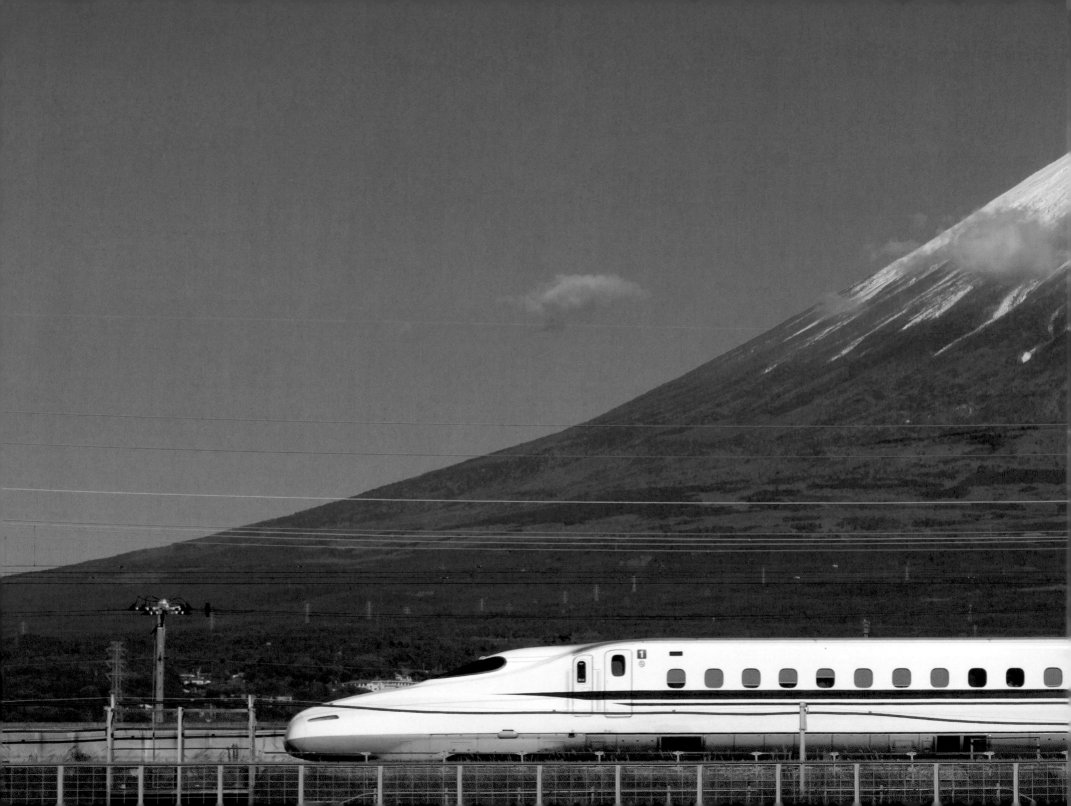

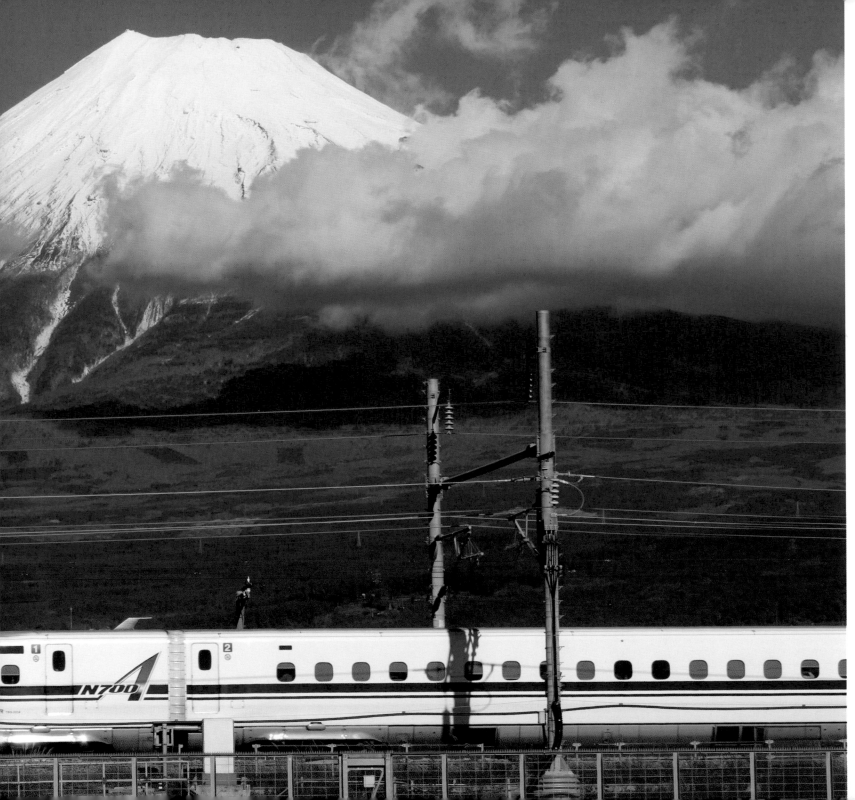

LEFT:

Mount Fuji, Japan

Passengers on the Shinkansen 'bullet train' heading for Nagoya and Kyoto from Tokyo prefer to have right-hand seats to see Mount Fuji as the train speeds past at 320km/h (200mph). The train was inaugurated in 1964 and took four hours: now the fastest service takes two hours, 20 minutes.

OVERLEAF:

Trans-Australian Railway, Nullarbor Plain

'Nullarbor' means 'no trees': not quite the case here, but it expresses the nature of this line, which has the world's longest straight section of railway, 478km (299 miles) across desert and scrubland. The 'Indian Pacific' transcontinental train takes four days to make the journey between Sydney and Perth.

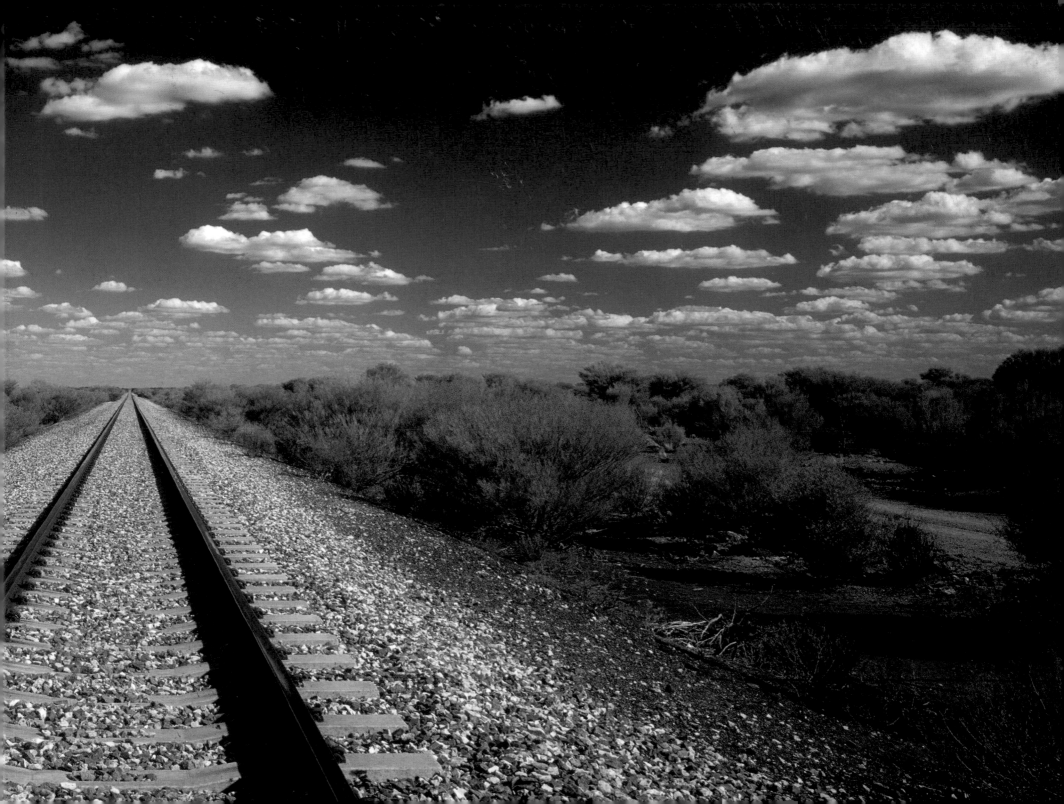

Picture Credits